BUILT TO THRILL

G. P. PUTNAM'S SONS

NEW YORK

BUILT TO THRILL

More Classic Automobiles from Clive Cussler and Dirk Pitt

CLIVE CUSSLER

PHOTOGRAPHS BY
DAYNA CUSSLER AND JASON TOFT

PUTNAM

G. P. PUTNAM'S SONS
Publishers Since 1838
An imprint of Penguin Random House LLC
375 Hudson Street
New York, New York 10014

Copyright © 2016 by Cussler Museum
Photographs of the 1951 Daimler DE-36 "Green Goddess" Drophead Coupe, 1951 Hudson Hornet Convertible Brougham,
1951 Talbot-Lago T26 Grand Sport Record, 1955 Packard Caribbean Convertible, 1957 Chrysler 300C, 1957 Dodge
Custom Royal Lancer Super D-500 Convertible, 1957 Lincoln Premiere Convertible, 1957 Pontiac Star Chief Safari
Station Wagon, 1958 Cadillac Eldorado Biarritz Convertible, 1958 Imperial Crown Convertible, 1959 Buick Electra 225
Convertible, and 1959 Edsel Corsair Convertible by Ronnie Bramhall © Cussler Museum
All other photographs by Dayna Cussler and Jason Toft © Cussler Museum. All cars were photographed in and around
Arvada, Colorado, home of the Cussler Museum, http://www.cusslermuseum.com. Photographs edited by Dayna Cussler.

ISBN 9780399184192

Manufactured in China
1 3 5 7 9 10 8 6 4 2

My deepest appreciation and gratitude to those whose dedication

to my passion keeps it all alive.

Dayna Cussler	*Keith Lowden*
Teri Cussler	*Wade Klein*
Jason Toft	*Ron Posey*
Amie Knutson	*Brian Irving*
Dirk Cussler	*Ronnie Bramhall*

CONTENTS

IT DOESN'T TAKE MUCH TO LOVE OLD CARS

Living in Southern California during the nineteen forties and building a hot rod out of a 1936 Ford sedan, I fancifully developed a love for old classic cars. Not long after, I bought a black 1925 Auburn limousine for $18 that my buddies and I drove to the football games, dressing like gangsters, wearing overcoats and with fedoras pulled over one eye. We would sneak past the security guards carrying beer and wine, hidden in a violin case.

The next car I set my sights on was a bit pricier. I recall finding a magnificent old 1915 Renault taxicab in the back of a garage and begging my dad to loan me the $50 the owner was asking. Good ol' Dad thought I was crazy and refused to loan me the money. In another instance, I tried to buy a beautiful Pierce-Arrow limousine, but the owner wanted more than I could afford, and he took it out to his ranch, where he cut off the rear end and used the old car as a pickup truck, an occurrence that was quite common in those days.

Years later when driving through the Colorado countryside, my wife Barbara said, "Look! There's a 1946 Ford Club coupe like I had in high school." I paid $400 to the farmer and drove it home, where my son and I restored it in the street. This was the first car of my collection.

It still sits among the more exceptional additions that came through the years.

After the Dirk Pitt books became bestsellers, I could afford to buy the more exotic examples of classic autos. I purchased a 1955 Rolls-Royce that my wife liked because it was new the year we were mar-

ried. Then came a 1926 Hispano-Suiza Cabriolet that I bought at my first classic car auction after I had three martinis. As more cars were added, I had to buy a warehouse. One side holds the classics from the nineteen twenties and thirties, while the other side displays mostly fifties convertibles.

When I was unable to save the beautiful Pierce-Arrow from mutilation, I never dreamed that, one day, I would own a hundred exotic cars just like it, or that I'd rescue fifty of them by having them restored to the condition they were in originally when sitting on the dealers' showroom floors.

Owning and cherishing collector cars has boomed in the last seventy-five years. In the forties, used Duesenbergs could be bought for as low as four hundred dollars. Now they're selling at auction from one to four million dollars. First, there was a fascination for antique cars, then came the vintage cars like the Model T Ford, and a hundred other autos followed. Next, classic cars became everyone's desire. Today, it's the exotic sports cars from Ferrari, Aston Martin, Cobra, and, interestingly, Lamborghini—which also produces tractors—that are drawing younger collectors.

Someday, they'll all be looked upon as mechanical masterworks of art and receive the admiration that is given to van Goghs and Picassos.

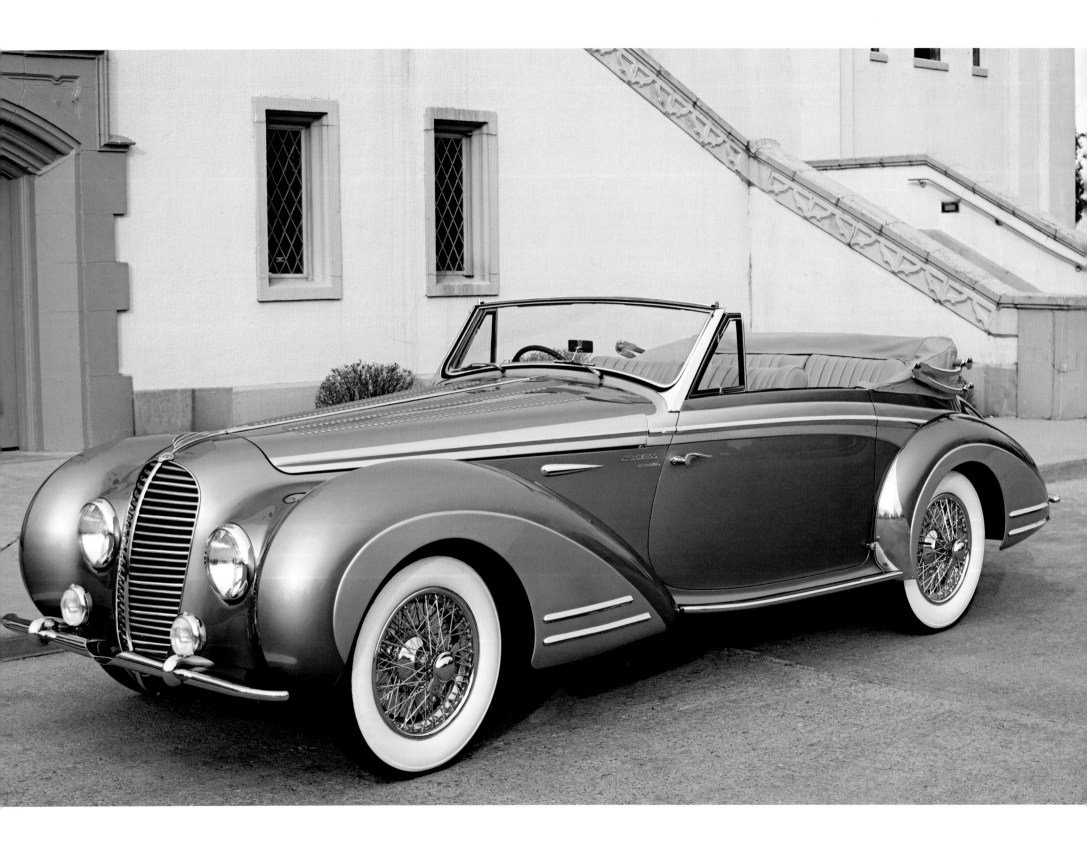

1948 DELAHAYE TYPE 135 CABRIOLET

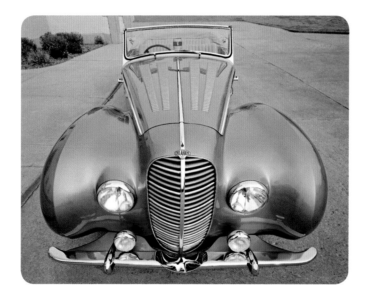

You may not recognize this Delahaye from my first automobile book, *Built for Adventure*, back when the car was painted a bright red. Now it's been vastly improved with a new, sleek two-tone color combination. It's been transformed into one of the most beautiful cars in the museum, and it's the only one out of my collection that is featured in both of my car books.

The 1948 Delahaye Type 135 was not only a car that achieved great success, but produced some of the most beautifully designed bodies and refined interiors. With creative en-

gineering, it achieved enormous success on the prestigious racetracks of Europe. They won the Monte Carlo Rally, Le Mans, and many of the Grand Prix races during two decades, culminating with over a hundred victories.

Delahaye was exceptional for both its speed and elegance. It was truly the darling of master artists and their wealthy clientele, who expected and demanded a style that radiated an image of prosperity and good taste. Not only magnificent to look at, Delahayes also had the power to do over 90 miles an hour at top speed.

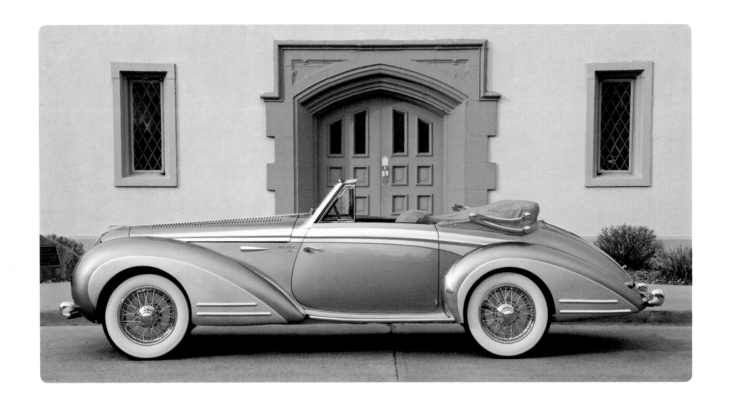

This car is a convertible whose coachwork was created by Henri Chapron, a master of rolling sculpture. On the exterior there are 184 louvers on the hood, covering the finely detailed triple-carburetor engine.

The name on the rear deck of this Type 135 declares the real glory of the marque: "Delahaye Competition." She runs smooth on a rough highway and drives quietly, except for a nice hum from the exhaust.

I purchased the car ninety percent restored, top to bottom, from a famed restoration shop in New York. In 2010, I gave it a beautiful makeover, with a stunning color combination of paint by Matt Halverson. I also treated the car to new upholstery. The interior is pure luxury, a feast of understated Deco flourishes.

It was the car featured on the back jacket of the Dirk Pitt adventure *Crescent Dawn*.

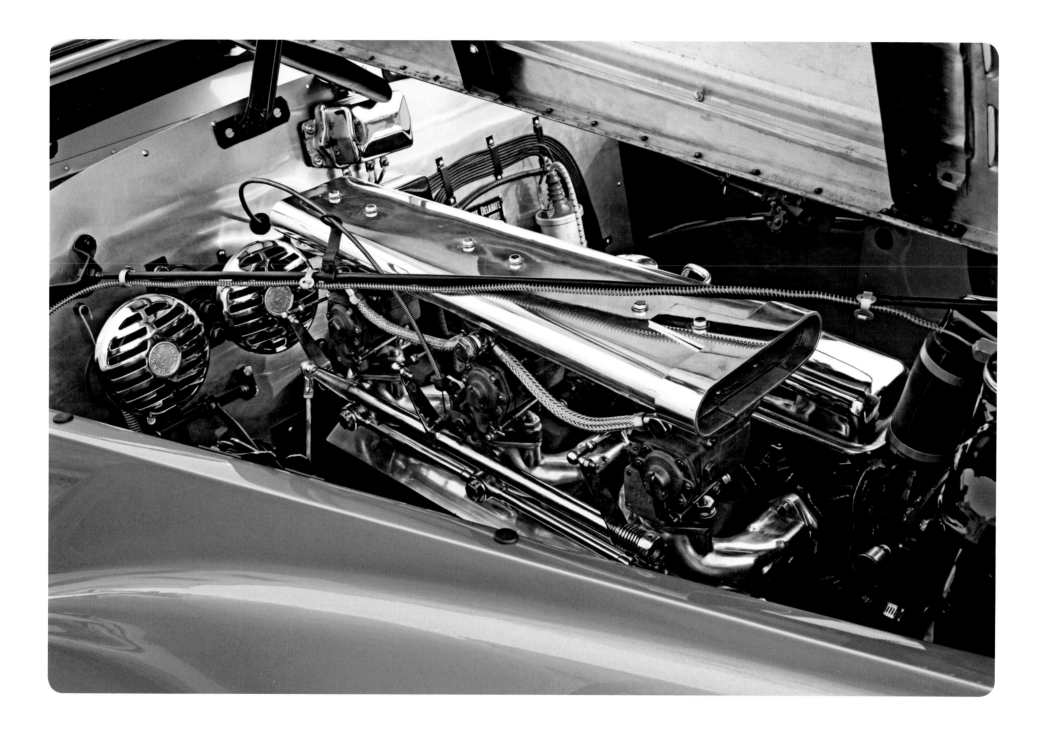

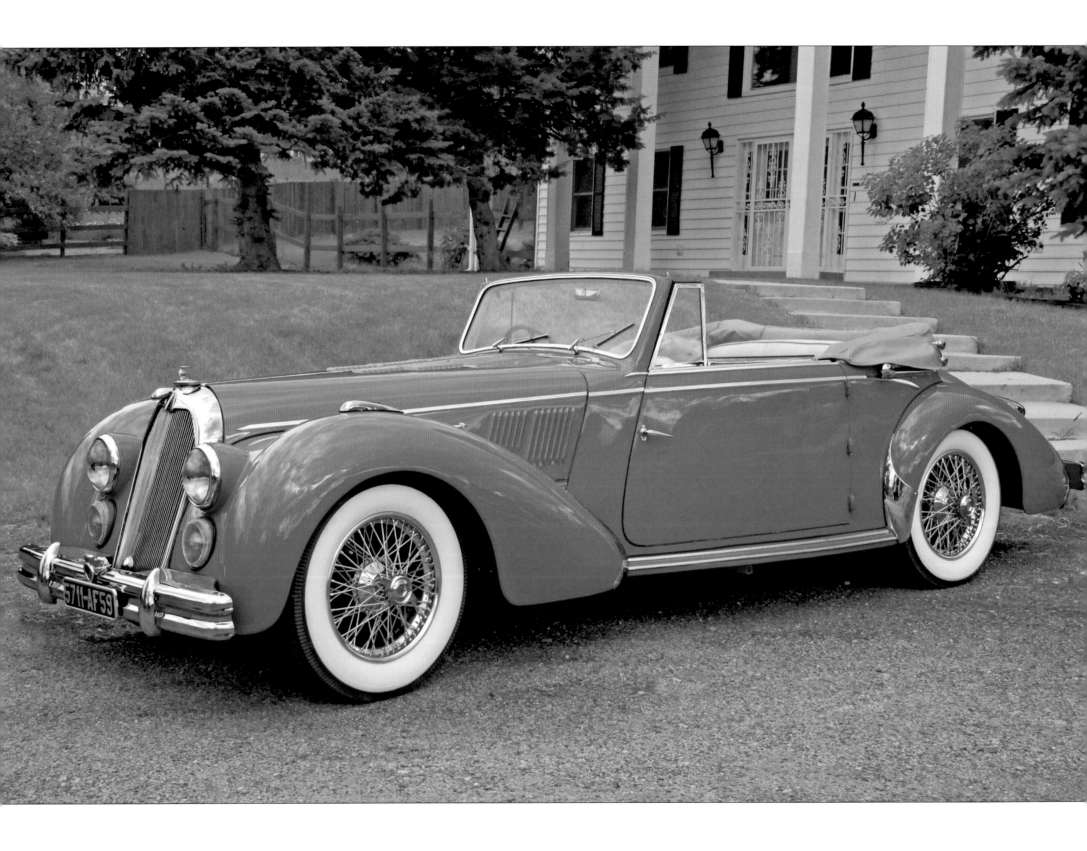

1948 TALBOT-LAGO T26 RECORD CABRIOLET

Talbot-Lago is known for their distinguished passenger and high-performance racing cars. Talbot-Lagos were luxurious, coach-built vehicles, comparably priced and of the same era as other renowned French companies such as Delahaye and Delage. Now these marques are lovingly restored to museum-quality and exhibited with great pride, receiving countless awards at Concours d'Elegance worldwide.

This T26 Record Cabriolet was designed for Antonio Lago by his good friend Joseph Figoni of Figoni & Falaschi. Unlike some

other Talbot-Lago cars that have exotic teardrop styling, this model has beautiful, no-nonsense coachwork that is not only striking to the eye but shows off a solid yet sophisticated charm. The Cabriolet is grandiose, although somewhat dated in style. After the war, French car manufacturers struggled to find their footing in the marketplace. Materials to build cars were in short supply and controlled by the government. Luxury motorcar builders such as Talbot-Lago, Delahaye, and Delage received a special dispensation from the French government to receive the materials that they needed

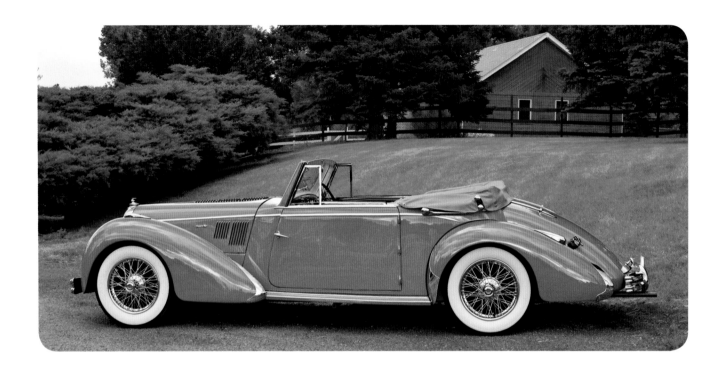

to build their *véhicules de classe exceptionnelle*—"high-class vehicles"—for their well-heeled clientele. As such, the style of this Cabriolet is still distinctly late thirties in inspiration and execution.

Quite comfortable, this car exudes an old-world charm from an era predating its actual year of manufacture. Nothing was spared in creating the leather interior. The workmanship is an example of sheer quality.

Never mass-produced, the engine is a masterpiece precisely crafted for both speed and luxury on the highways. Antonio Lago designed the new twin-cam, six-cylinder, high-performance 4.5 liter power plant

that is the heart of the T26 Record. The Talbot-Lago Record chassis was named for its enviable top-speed records; it can hit over 100 miles per hour, with power transmitted through a four-speed manual transmission.

The T26 models are quite rare; only 750 examples were constructed. Few automakers were as blessed with such exquisite coachwork, created by the world's greatest coachbuilders. Talbot-Lagos were far more than ordinary transportation, and they are quickly becoming recognized as grand masterworks of art.

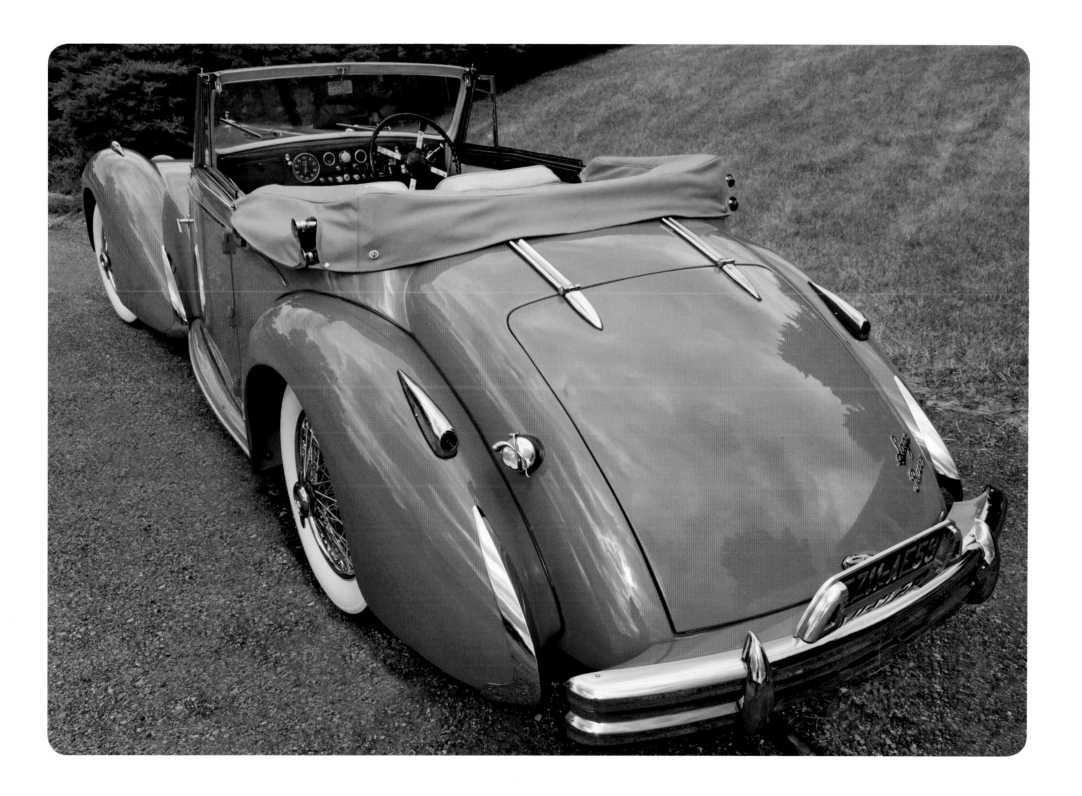

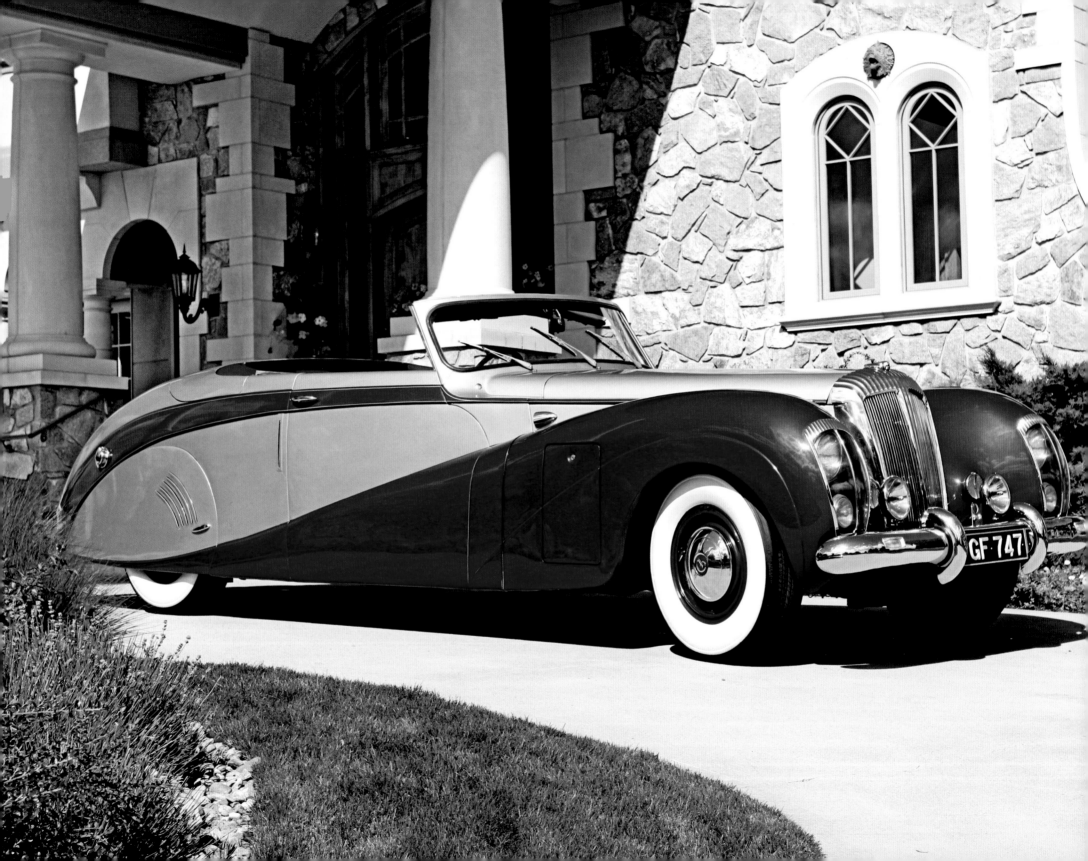

1951 DAIMLER DE-36 "GREEN GODDESS" DROPHEAD COUPE

One of the most exotic cars ever built has to be the Daimler DE-36, a series of mammoth monsters known as the Green Goddesses. This immense luxury motorcar earned its eternal moniker when it made its debut in 1948 as a coupe in a glorious jade green hue. The exclusive production run of only seven drophead coupes, made between 1948 and 1953, was actually available in all different colors, although each individual car is referred to as a "Green Goddess."

Only four of these rare cars are still in existence.

This massive Daimler is one of the most opulent and prestigious vehicles ever built. Then, as now, these highly unique cars nearly defy description. The chassis upon which the huge two-door coach-built body was mounted was normally the chassis for the Daimler limousine. At over 20 feet long and almost 7 feet wide, the original Green Goddess weighed a colossal 6,000 pounds. Coachwork was by Britain's finest coachbuilder, Hooper & Company, creating a magnificent flowing body, with their trademark flat sides over the rear fenders. A feature that contributed to the clean look was the hydraulically operated convertible top, which disappeared under a painted aluminum panel, one of the first applications of such a design.

The big, twin-carbureted, 5.4 liter straight-eight engine moved the three-ton Goliath along the road at a surprisingly respectable 85 miles an hour. Behind the tiller of this Leviathan, the passing landscape must have appeared small and rather plebeian. The driving experience has, however, been referred to as silky smooth. Extensive use of hydraulics was a luxury touch, powering the top mechanism, the metal tonneau cover, as well as an ingenious jacking system at all four corners of the car, facilitating easier roadside repairs. Flush, streamlined

wheel skirts at the rear are spring-loaded and easily swing up and out of the way, much like a garage door, for easy access to tires, brakes, and suspension. The huge front fenders are so immense they have recessed, hidden storage areas for tools or luggage.

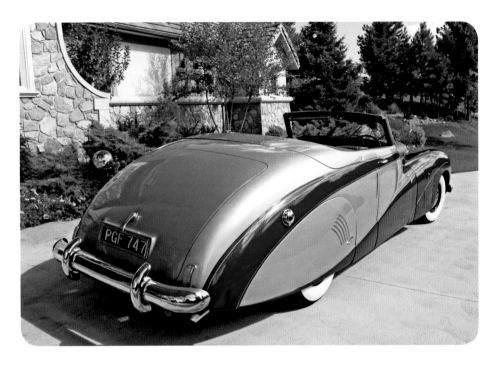

This color combination and design is original to this car. The paint had begun to fade, so I had the body stripped down and repainted. I purchased the car in 1980, and everything, including the upholstery, is original except, of course, the new paint job. The interior of this car is quite unique with an extra-wide leather seat in the front to accommodate three passengers quite comfortably, while the rear two passengers are luxuriously coddled in armchair, theater-style seats as plush as those in a drawing room. These are actually positioned slightly up and offset behind the front seats. This feature affords the rear passengers an unobstructed view of the road ahead.

Dirk Pitt drove this Green Goddess in my book *Cyclops*. I believe that someday soon the four remaining Goddesses will become even more highly regarded by collectors for their distinction, beauty, and undeniable rarity.

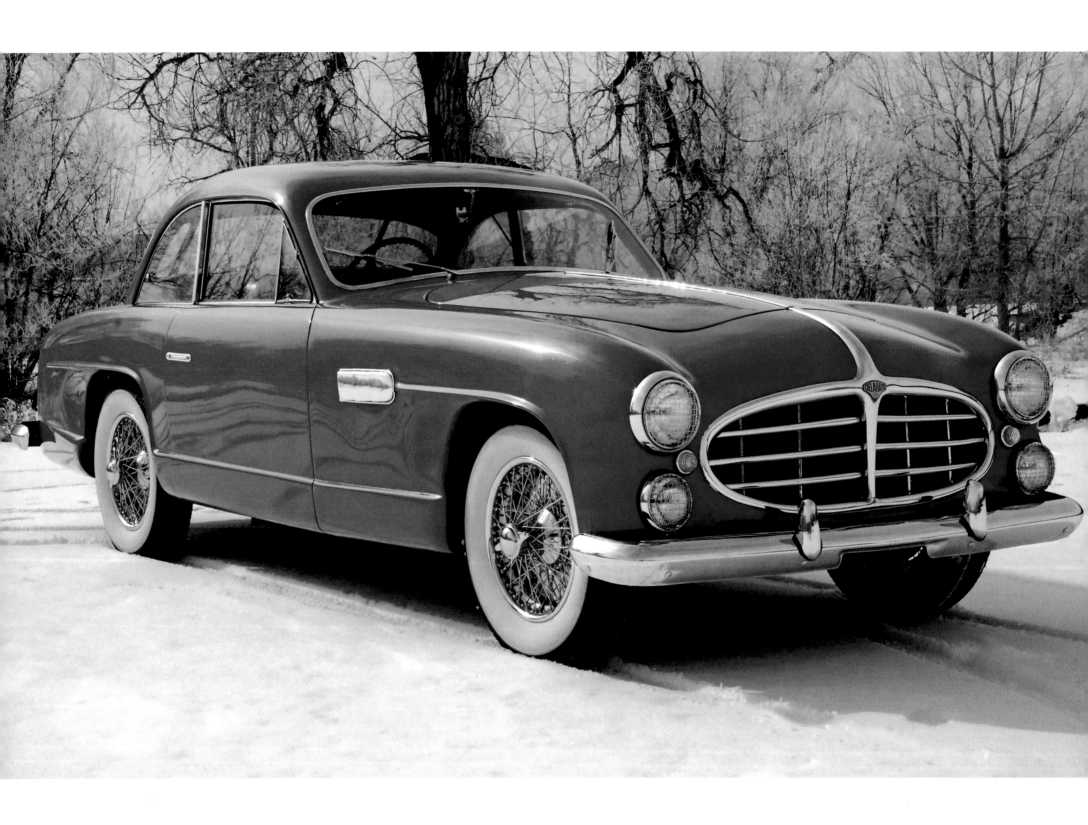

1951 DELAHAYE TYPE 235

After the success of Delahaye's pre–World War II Type 135, its final model was introduced in 1951 at the Paris Salon, with hopeful fanfare, to carry the grand marque through the fifties. Alas, the Type 235 Delahaye instead became their swan song.

After the war, Delahaye and other respected luxury marques had challenging times. Luxury coach-built cars were low priorities for most people, even the affluent, and Delahaye's survival was at stake. When first introduced, all Type 235s from 1951 and 1952 were sold only as bare chassis, as Delahaye never tooled up after the war to build the bodies for these vehicles. The coachbuilder of this Delahaye coupe was Philippe Charbonneau, who created a number of the 235 custom bodies.

These first Delahaye cars of the postwar era continued to rely on technology from bygone times. The design was simple, with a rounded front end and heavy oval grille, the body a combination of steel and aluminum. The engine was basically a jazzed-up Type 135, with additional horsepower but the same cubic displacement. As was standard practice for French and English vehicles of the period, this car had traditional right-hand drive, with a French Cotal electrical preselector, semiautomatic gearbox. The 3.6 liter, overhead-camshaft, in-line six-cylinder engine was from the earlier Type 135MS, yet, with triple Solex carburetors, the Type 135 motored smartly to over 100 miles per hour.

In 1953, Delahaye finally adopted a standardized factory body and interior, resulting in a thirty percent savings advantage for the buyer,

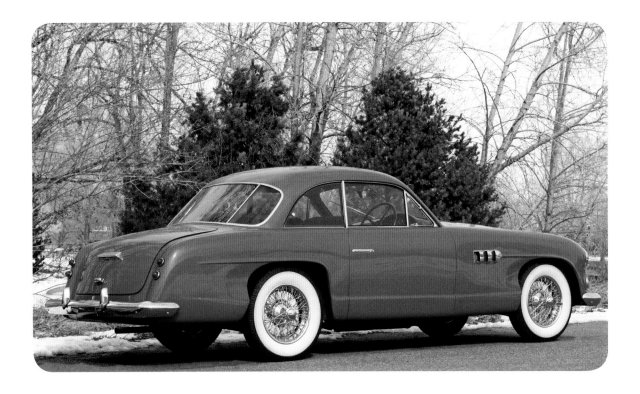

but it was too late. Times and tastes had changed. For all of its luxury and understated sophistication, the Type 235 could not save Delahaye, and the last one appeared in 1954—ironically, again at the Paris Salon. Only eighty-four Type 235 cars were built between 1951 and 1954; today, there are less than twelve left. It was the end of the road for the company that had made some of the world's classic automobiles.

I saw this particular Delahaye on the grounds of the huge meet at Hershey, Pennsylvania, in 1985 and bought it from Washington, D.C., dealer Ed Waterman. A former owner, Mickey Mishne, wrote a nice letter and sent a photo of the car rounding the Tetre Rouge corner at Le Mans during the Rallye Sablé-Solesme. I restored the car, which is quite rare. Though a bit underpowered, it drives with pleasurable ease.

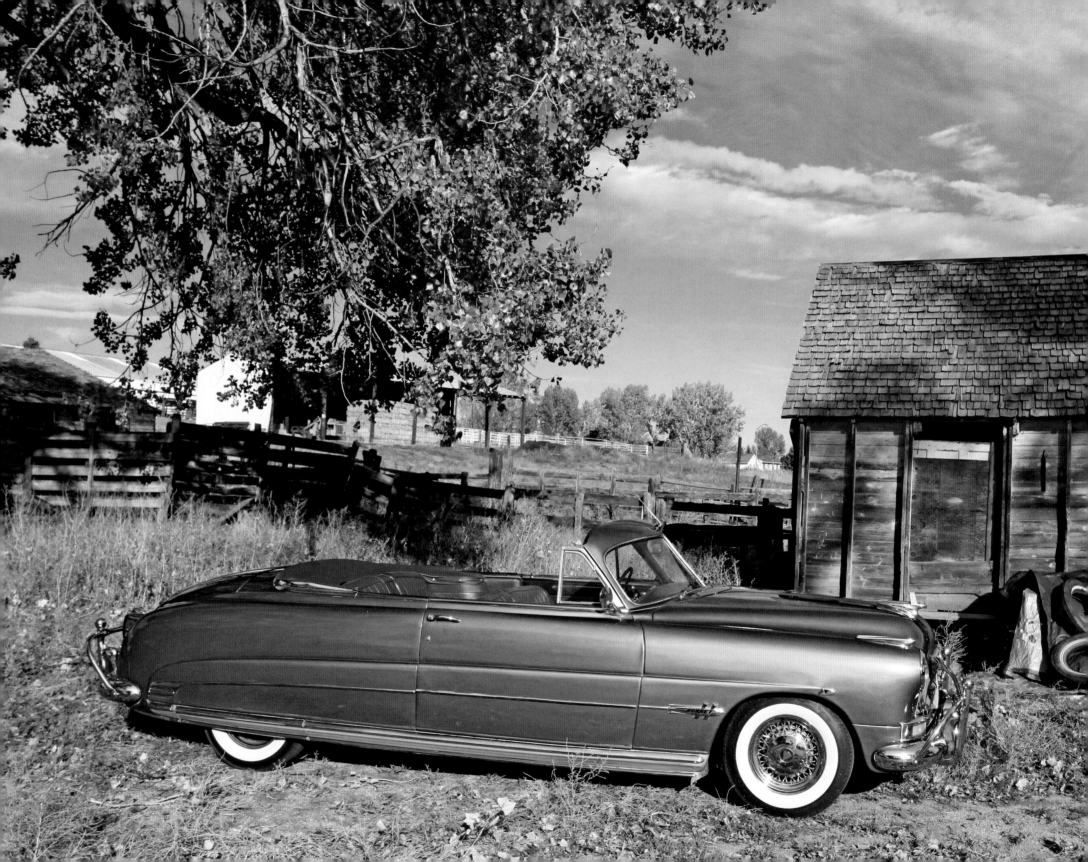

1951 HUDSON HORNET CONVERTIBLE BROUGHAM

The Hudson Motor Car Company, the namesake of J. L. Hudson, founder of Hudson's Department Stores, started producing cars in Detroit in 1909. At one time, Hudson was the third-largest American car company—with only Ford and Chevrolet producing more vehicles.

Hudson's big event for 1951 was a powerful new 308-cubic-inch engine, the largest six-cylinder L-head ever offered. It gave the Hornet 145 horsepower. And with its "stepdown" frame and low center of gravity, Hudsons proved unbeatable in stock car races across the country for the

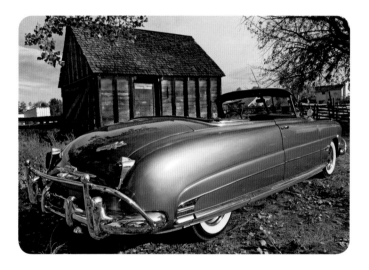

next three years, beating the big V-8s from the other automotive companies.

In the hands of early racers and tuners, the stock Hudson engine was capable of even more power—Hudson's most famous stock car racer, Marshall Teague, claimed he hit 112 miles per hour from a NASCAR-certified Hornet. To say Marshall Teague and his "Fabulous Hudson Hornet" were dominant in his era would be an understatement—his lifetime winning percentage was eighty-three!

Today, nearly every auto manufacturer, domestic or foreign, still

uses a version of Hudson's stepdown body construction, where you step down over the door sill and place your feet on the floor beneath the frame. Because of this new feature, Hudsons were lower and wider. This and the almost fully enclosed rear wheels gave the cars a low-slung, streamlined look.

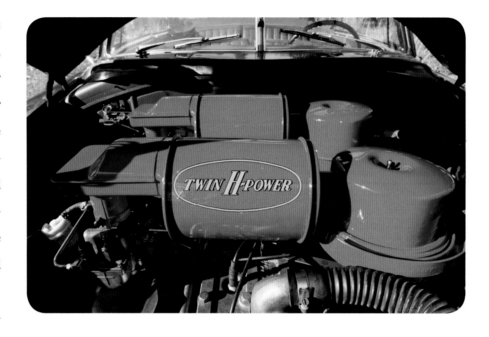

Hudson was an early innovator of strong cars, overengineered and overbuilt. Slamming a door on a Hudson was literally like closing the door of a bank vault. For a midpriced car, the interior was quite plush, with quilted recessed panels and wood-grained doorframes—yet leather interiors were used only in the convertibles and upscale Broughams. Another 15 horsepower could be added by what was called Twin H-Power, their term for dual carburetors—a special dealer-installed option.

The Hudson you see here is listed as a "Convertible Brougham." It has myriad optional accessories, such as the huge chrome fender overrider bars, factory wire wheels, as well as Twin H-Power. This particular car is impressive, as it is original right down to its paint and upholstery. It is exceptionally well-detailed and is an excellent driver, running on the freeways with the best of them.

I purchased the car at the Kruse auction in Auburn, Indiana. The previous owner drove it in from New Jersey. This model is quite scarce and has become a very desirable collector car.

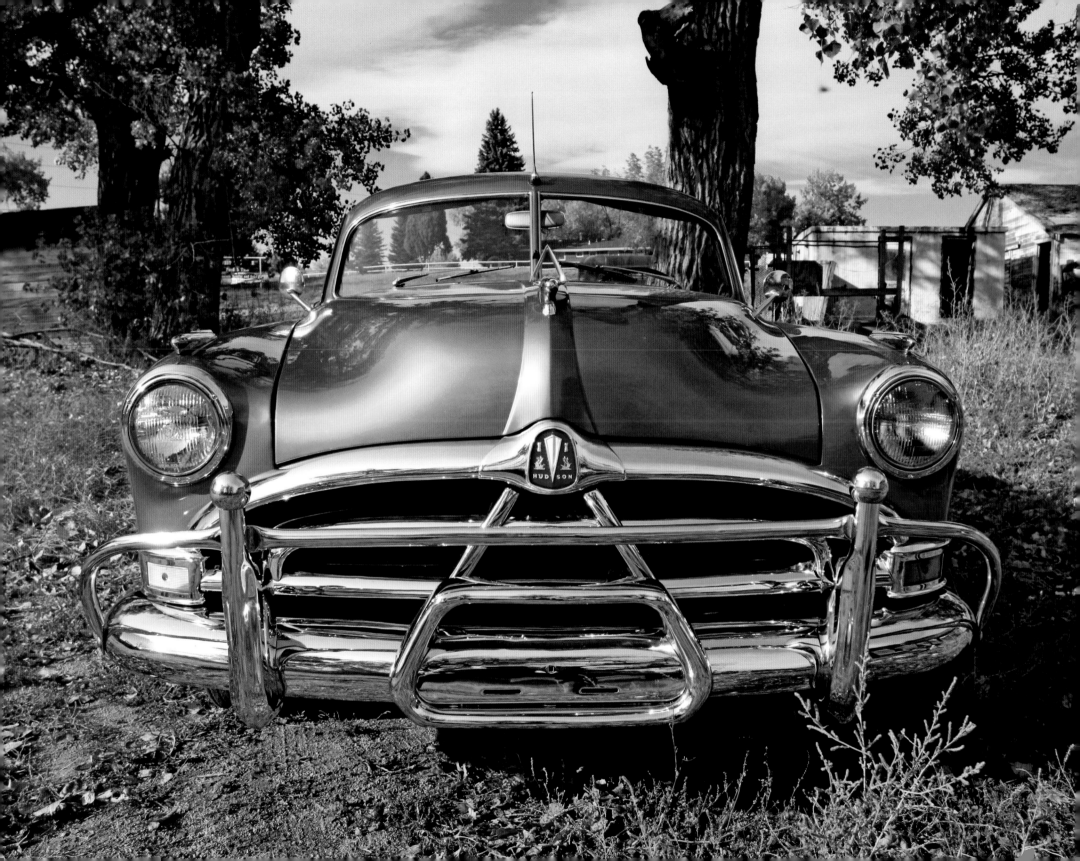

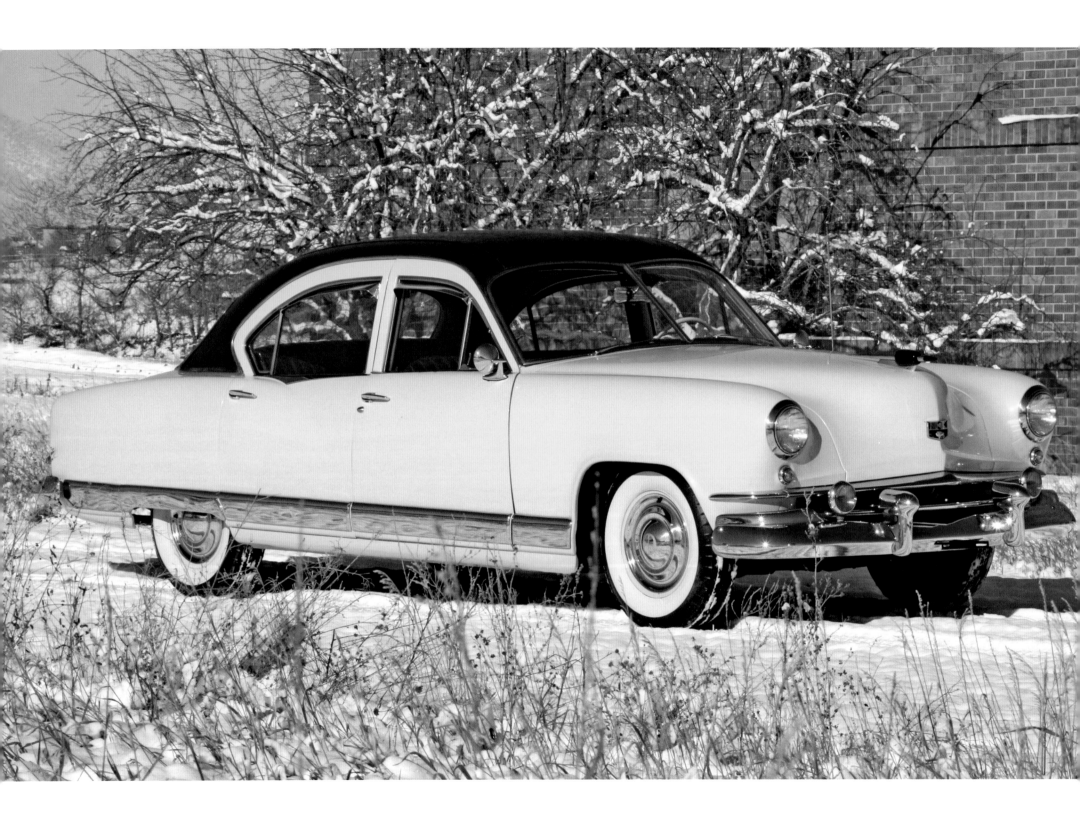

1951 KAISER GOLDEN DRAGON

Kaiser-Frazer built some pretty good cars when they were in business, from 1946 until 1955. They were nicely designed and styled, with a reputation for reliability. Their main setback was the little, underpowered straight-six Continental Red Seal L-head engine. It only put out 100 horsepower. And, unfortunately, Kaiser-Frazer was never able to acquire a V-8, a factor that eventually dealt sales a death blow.

In an effort to provide a car created to fill an upper-medium price bracket, Kaiser introduced the famed Dragon series in 1951. This was a particularly glamorous model, with a nicely integrated grille. There were two removable armrests, and two hundred extra pounds of insulation to make them run quieter than other models.

The first series, Golden Dragon, had a very unique, imitation animal-hide-textured vinyl interior and padded vinyl roof that Kaiser named "Dragon skin" so as not to mislead or offend the public that it was real alligator hide, which it resembled. This one is a second-series model, with Arena Yellow paint and black animal-textured "sport topping." Its matching roof, interior, and headliner vinyl option became known as "Dinosaur," also to further the perception of Kaiser not using real animal hides. No dinosaurs or dragons were harmed in the manufacture of these cars.

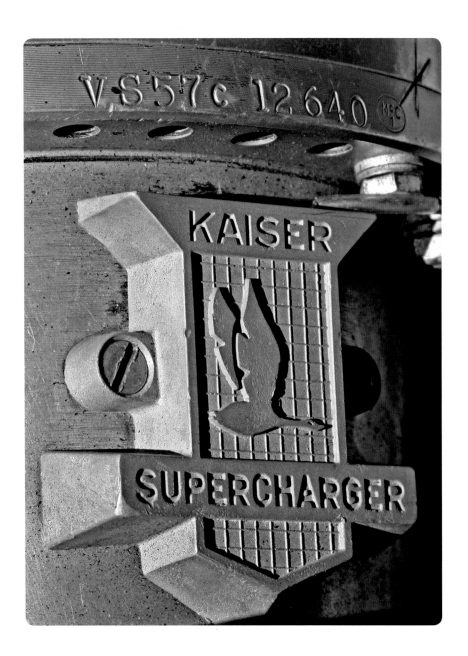

This example of a Golden Dragon is one of the very few in existence. I found it in Florida, bought it, but before it could be shipped a hurricane struck. Luckily, though flooded, the owner's garage withstood the onslaught and the Dragon came through unscathed.

I got carried away, which is what so often happens, and gave it a blue-ribbon restoration. Not only does she have a factory Kaiser supercharger but also a spare tire cover.

She has to be one of the finest Golden Dragons in existence. Not in demand, perhaps, but a very unusual car that is rarely seen.

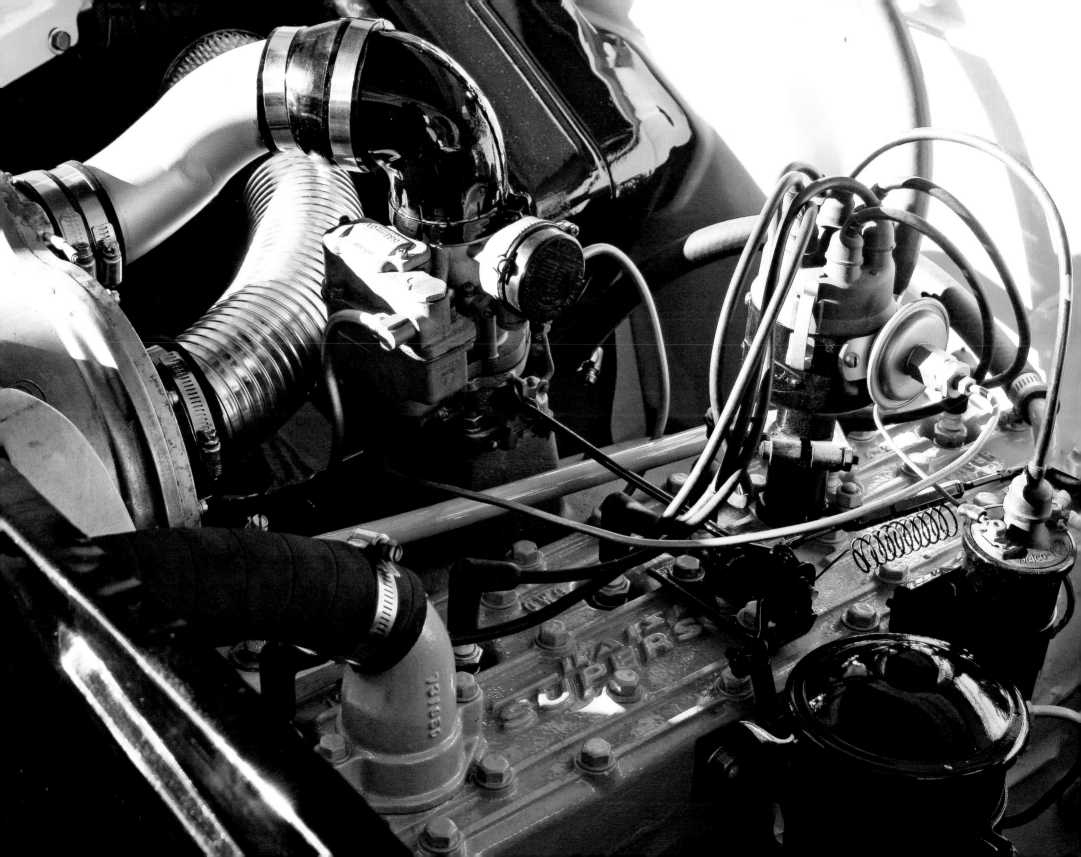

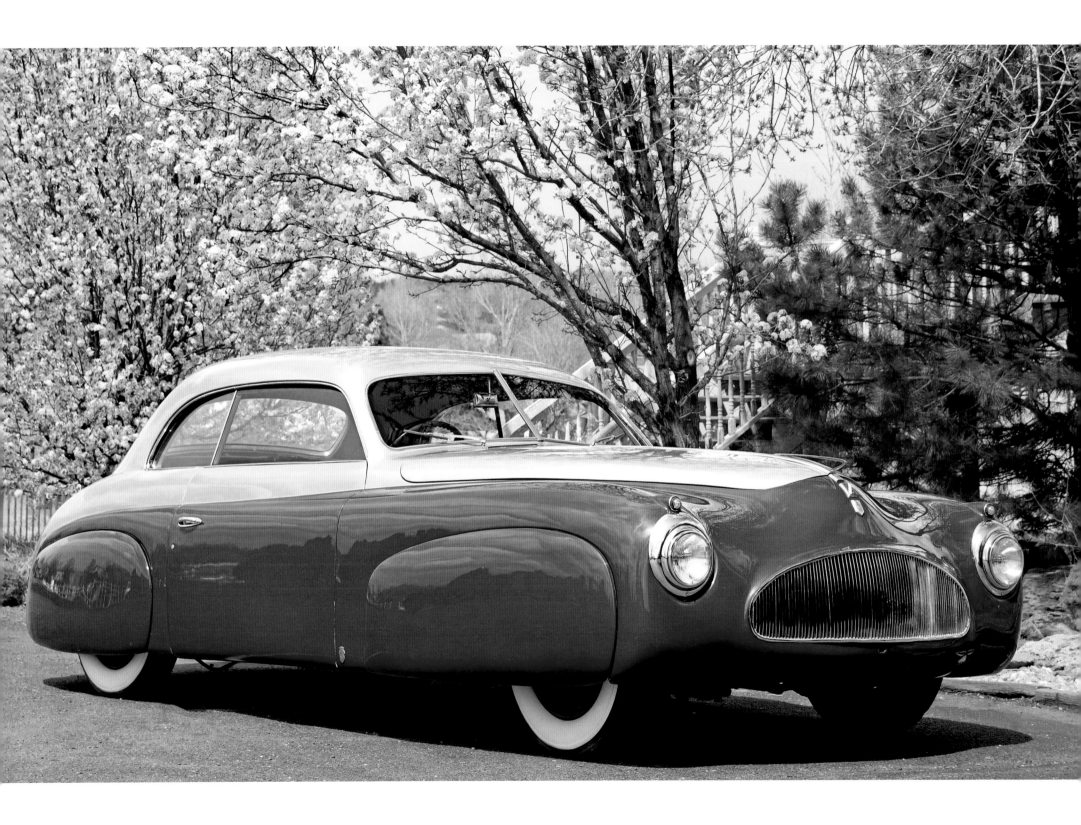

1951 TALBOT-LAGO T26 GRAND SPORT RECORD

The Talbot-Lago shown has a body by Ghia that was called a Pillarless Saloon. Not one of the prettier examples, in my estimation, but a most erotic car nonetheless. Ghia produced some unusual coachwork, especially of similar streamlined designs for Delahaye, but this one for a Talbot borders on the bizarre. This one-of-one-ever-built motorcar was featured in an *Automobile Quarterly* issue on rare coach-built Ghia bodies. It is a very interesting design exercise by a coach-builder known for setting trends, and this unusual car was commis-

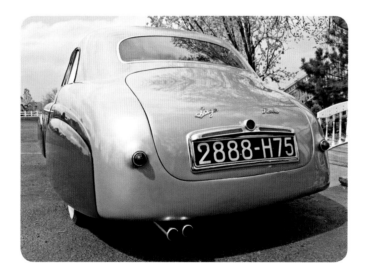

sioned by quite a unique person—a king, in fact.

According to Talbot expert and historian Richard Adatto, this one-off T26 Grand Sport Record once belonged to King Farouk, the last monarch of Egypt. After studying this Talbot-Lago from stem to stern, there is no doubt that the king had eccentric and extravagant tastes in the extreme.

Intended to be the ultimate in modern streamlining, the Ghia's coachwork for King Farouk leaves the car with no bumpers. Even the fenders are skirted over. They swing out

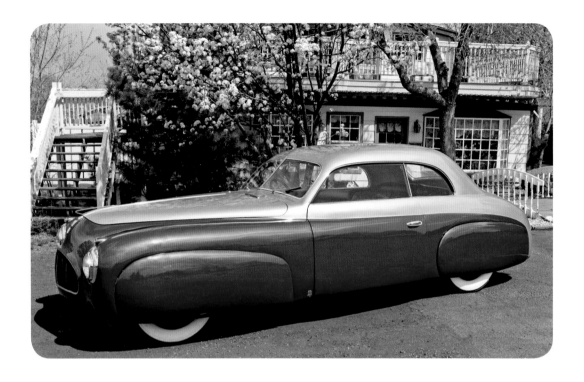

on hinges when a royal tire has to be removed. The grille is pretty, but, between the wide fenders and narrow hood, it has the look of a large-mouth bass. Unlike American cars of the period, it is totally smooth and free from chrome. Only the grille and bezels around the headlight gleam. It is a striking car in its own right, and its power plant is a 4.5 liter, in-line six-cylinder engine with aluminum cylinder head and twin carburetors—a direct descendant of the successful Talbot-Lago Grand Prix car.

What one does not realize until sitting in this car is its extreme width. The body style is almost an illusion. It appears standard size but, in reality, is much larger. Upon acquiring the car, it seemed so wide that I thought four people could actually be seated across the front seat. I now realize that the car was meant to seat the three-hundred-pound monarch and his special guest. A ride fit for a king!

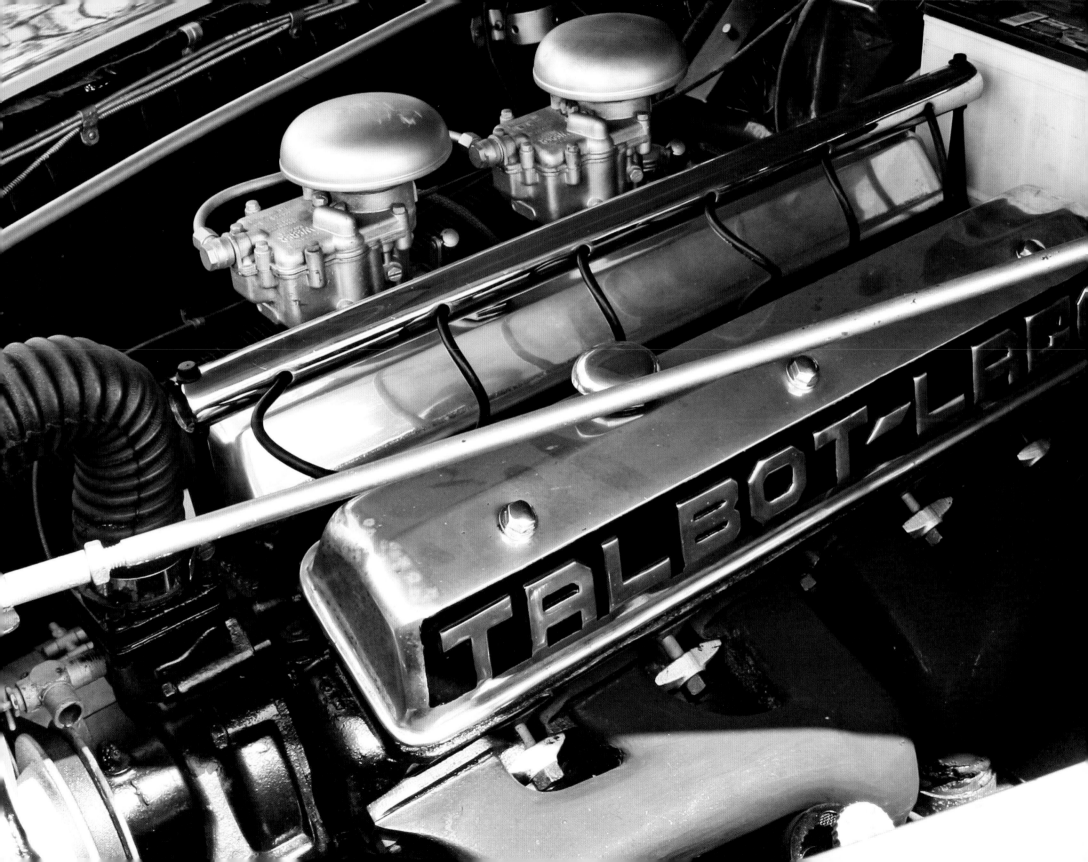

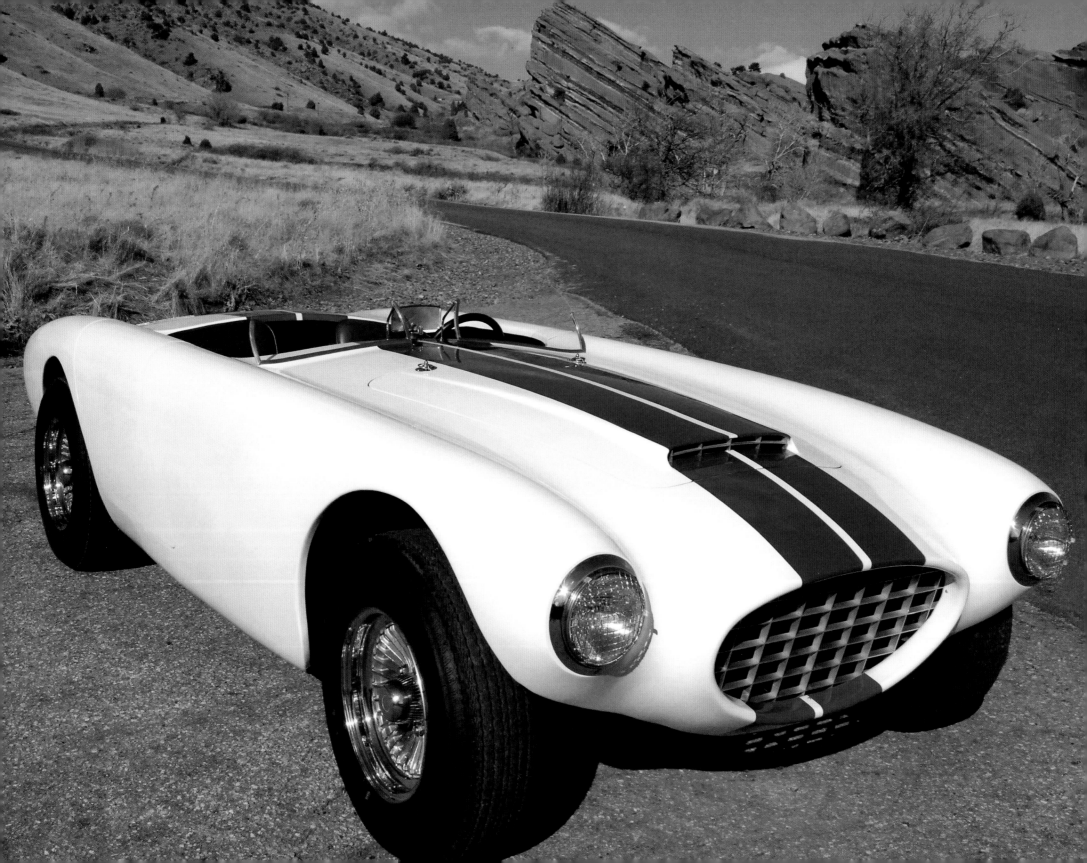

1952 METEOR ROADSTER

The Meteor was a specially constructed fiberglass-bodied roadster with a custom frame. It was designed by aerospace engineer Dick Jones in Southern California in late 1952. Jones was the archetypical California hot-rodder, designer, and engineer. His first Meteor prototype was shown in 1953, at the Petersen Motorama, in Los Angeles. The Meteor was recognized by both *Road & Track* and *Car Craft* magazines. It is an extremely rare and interesting vehicle. The car you see here has a formidable four-carburetor 1952 DeSoto Firedome Hemi engine in it. It is a very fast car.

Handcrafted production ran from 1953 to 1955 in Southern California and then from 1955 to 1961 in the Denver, Colorado, area when Jones and family relocated. According to none other than Dick Jones himself, only two complete factory-built Meteors were made and about twenty-five finished bodies were sold. To demonstrate his car's racing potential, in '56 Dick Jones took a second-place finish in his Meteor at a hill climb race near Golden, Colorado.

Sometime in 1985, this car was advertised in the newspaper as a Cunningham, an exclusive and respected American car company with undisputed racing heritage that produced some extremely rare, beautiful, and valuable sports cars for the street. Intrigued, I took a look at it. It was no Cunningham but instead an unknown fiberglass-bodied Ford chassis with a 1952 Hemi engine in it. I bought it and eventually restored it, painting the body in the distinctive Cunningham American racing colors of white with a blue stripe down the middle. A friend, Dave Anderson of Tulsa, a fiberglass manufacturer and sculptor, examined the car and stated that whoever put it together knew what they were doing. The fittings were first-rate. But, at this point, I still didn't know exactly what the car was. One day, I was talking over the phone to a newspaper auto editor and mentioned I owned this strange fiberglass sports car with no name. He asked, "Is the cockpit fairly large?" I said, "Yes." Then he instructed, "Describe the grille." I replied, "It looks like an ice cube tray." Then he said, "Oh my God, you've got a Meteor."

By an incredible coincidence, Dick Jones, the creator of the Meteor thirty-three years before, was still living in Denver. When contacted, he came out and stared, astounded, at the car, and tears came to his eyes. "This is the first of my cars I've ever seen that was restored." I was proud to share it with him. The car is believed to have always been in Colorado, just like its designer. Since his poignant visit, Dick Jones was able to track down three more of his Meteors before he passed away, sadly, in 2010.

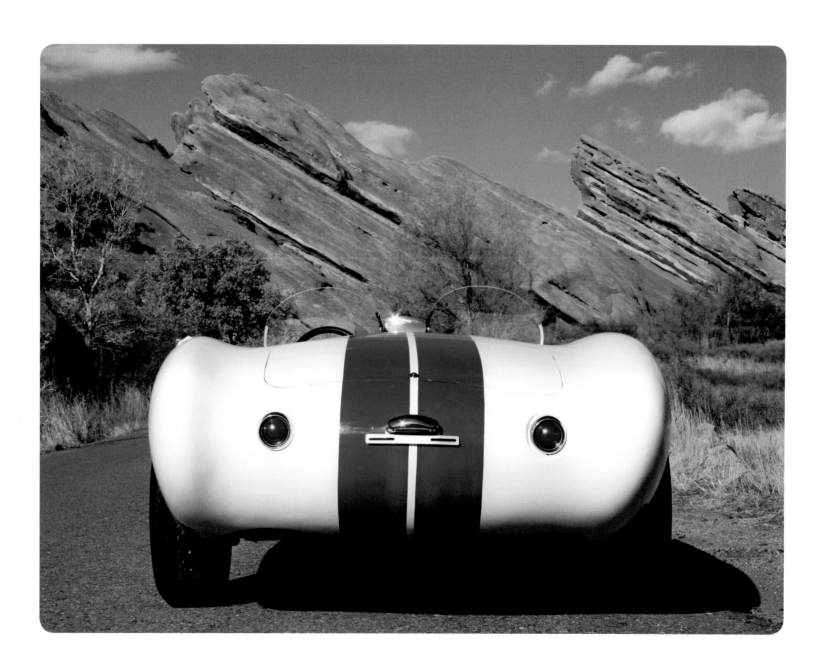

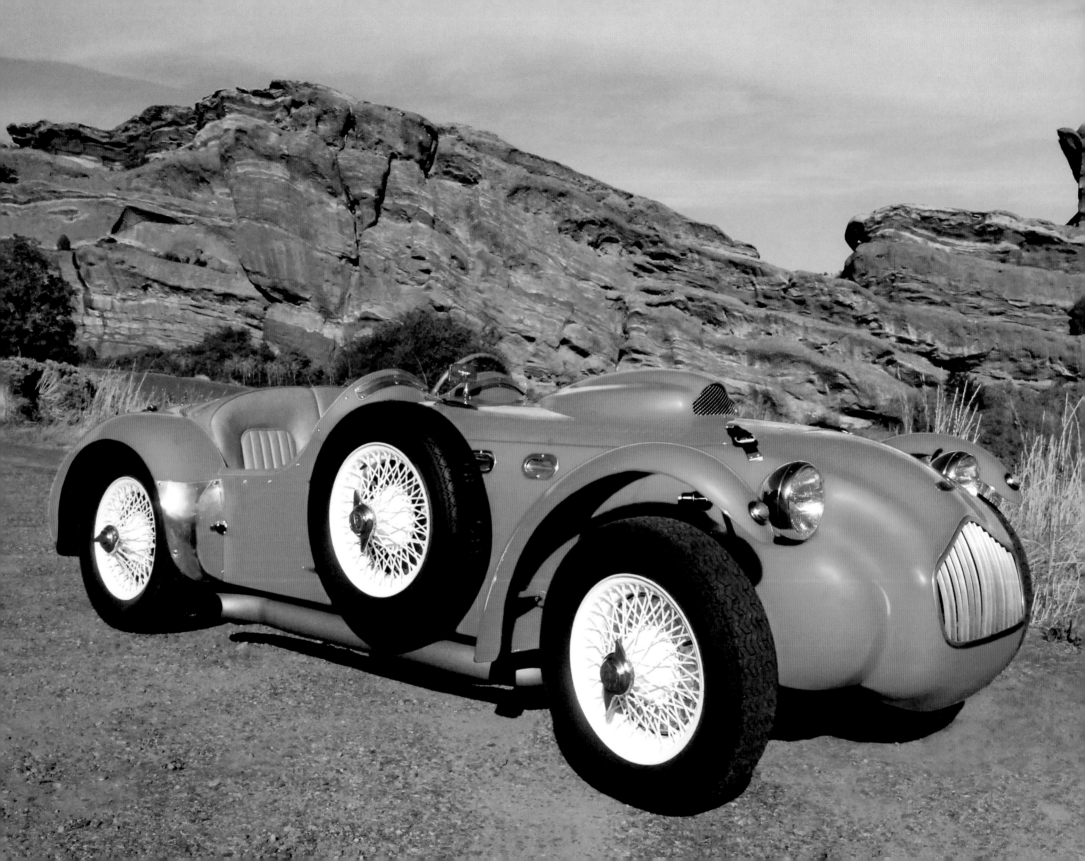

1953 ALLARD J2X

You're sitting in the stands during a sports car race and all the sleek machines speed past with a high-pitched howl. Then comes a thunderous bellow as an Allard roars past. One wheel lifting in the turn, the rear end crouched as if to spring—and that's the car leading the race!

To drive one of these powerful monsters in competition was not for the weak of heart. Allards weren't the most elegant cars that ever graced a racetrack, nor were they the most stylishly built, but if they had one good characteristic it was a habit of winning

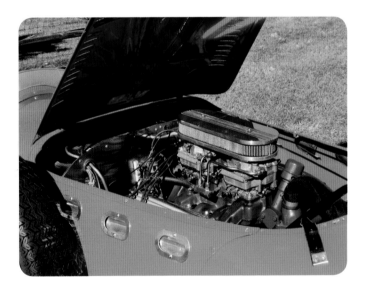

races. Built by Sydney Allard in England, they were a true British hot rod.

With their flimsy, thin aluminum body, motorcycle fenders, and spare tire clamped to the side, the brutal Allards seemed woefully out of place next to the sleek Jaguars and Mercedes. But the quirky Allard J2X could really go. With a chassis specifically designed to accept big, muscular American engines, Allards were powered by Mercury V-8s, Cadillac overhead V-8s, and even Chrysler Hemi V-8s. They were tweaked by the best American speed-equipment makers of the time. Dry weight

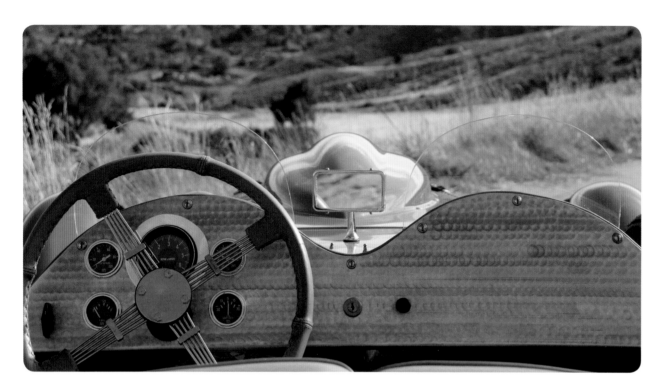

proved design, resulting in even better handling and more cockpit room for the driver, dominating early fifties sports racing.

According to the *Allard Register*, this J2X left the factory in England in August of 1953. We have the original factory-build card. The car was shipped to San Francisco and was raced by John Barneson at the famed Pebble Beach Road Races each year from 1953 to 1955. The car was subsequently loaded on a ship and taken to Japan, where the owner, an officer in the Air Force, drove it for

was usually around 2,000 pounds even with the muscular American V-8 behemoths. Allard made the J2X from 1951 to 1954 and only eighty-three were made, making the car quite rare.

Sydney Allard established a testament to his car's potential while making his mark in racing history at the prestigious Le Mans twenty-four-hour endurance race in 1950. He and a co-driver won a first-in-class victory and third overall finish in an earlier Cadillac-powered Allard J2 model. The J2X model shown here was an im-

several years before sending it back to the States. From there, the history grows dim until I bought it in Seattle, Washington, sometime in 1985.

Then the fun begins. After two weeks, I asked my partner if the car had arrived yet from Seattle. He shook his head. Another week. "Where's my car?" He shrugged and said, "It's coming." Finally, after a month, I demanded to know the status of the Allard. He finally confessed, "I've got good news and bad news."

Naturally, I wanted the bad news first. It seemed the truck along with my Allard, a Duesenberg, and two other classic cars was missing. "So what's the good news?" I asked. He grinned. "I insured it for twice what you paid for it."

The truck, with the cars intact, was found at last at a truck stop in Wyoming, where it had sat for over a month. It seems the driver had overstayed in Reno, Nevada, gambled, and found a girl on the loose. The two of them got as far as Cheyenne, when the driver figured he was going to be fired, simply took the girl and walked away from the truck.

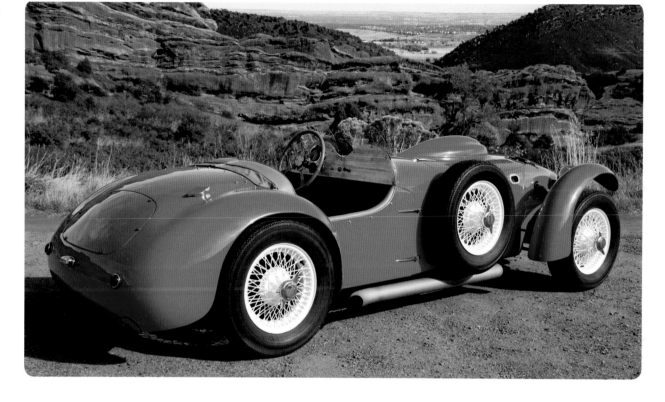

The Allard finally arrived in good, original condition. My old Air Force buddy Dave Anderson cleaned up the aluminum body and primed it. Then the chief mechanic for Jolly Rancher candy's top fuel dragster rebuilt the original Cadillac engine with a three-quarter race Iskenderian cam and other goodies, such as a dual four-barrel carburetor manifold. I refused to chrome the wire wheels, as some

Allard owners have done, feeling it looks too gaudy for a car built for racing.

The J2X is a wild and fun driver; almost like riding and steering a four-wheel motorcycle, it roars and leaps like a tiger. One of my favorite cars to drive in our collection—and Dirk Pitt thinks so too. He drove it in a daring race in my book *Shock Wave*.

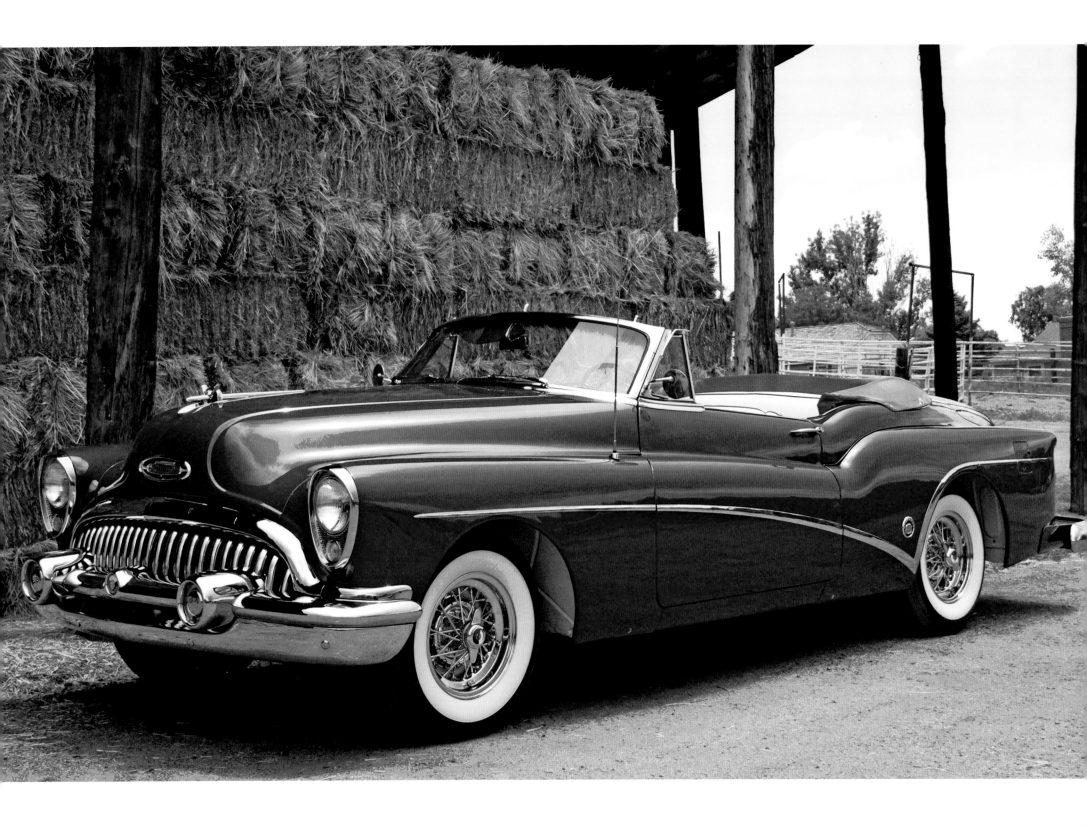

1953 BUICK SKYLARK CONVERTIBLE

The Skylark convertible, a very special custom model to commemorate Buick's fiftieth anniversary, was popular right from its debut at the now-legendary General Motors Motorama car show. It was designed to be different from the other Buick models. GM pitched the car as a factory-built sport custom. And custom it was!

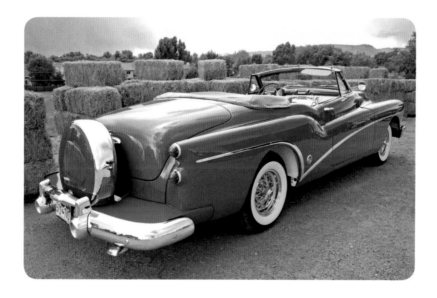

and lowered to notch the beltline and profile of the Skylark for a more modern look. The side windows and convertible top were also cut down at the factory for a lower profile, which necessitated the typical Buick seat frame and steering column designs be adapted. This was basically a factory chop-top custom, with Buick taking styling cues from California customizers!

The factory started with a Roadmaster windshield, gave it an extra angle of rake, and also cut it down by four inches. The doors of the Roadmaster were split in two and rewelded at a different angle

Buick even went as far as to remove their trademark portholes in the hood to further modernize the new Skylark model and make it a unique styling statement.

The customized profile was a delight to the eye. The styling was classic and quite handsome. The wheelbase was a tidy 121.5 inches, and the trim, sleek body was enhanced by a long chrome spear that arched from the front and curved over the rear fenders. It had the sporty cutout, rounded wheel arches, dramatically accenting standard-equipment Kelsey-Hayes chrome wire wheels, with the painted Skylark emblem in the center, and wide whitewall tires.

The '53 Skylark also introduced several new engineering advances for Buick, not the least of which was the new 322-cubic-inch "Nail-head" V-8 engine, which made 188 horsepower and replaced the old straight-eight engine—a major change.

The 1953 Buick Skylark is considered by collectors the most special and valuable Buick of the period—it was the ultimate styled automobile for years to come. I traded several cars for this beautiful example. It was fully restored by RM Classic Autos, the finest restoration shop in Canada and the U.S. Everything is as it should be for a truly stunning motorcar.

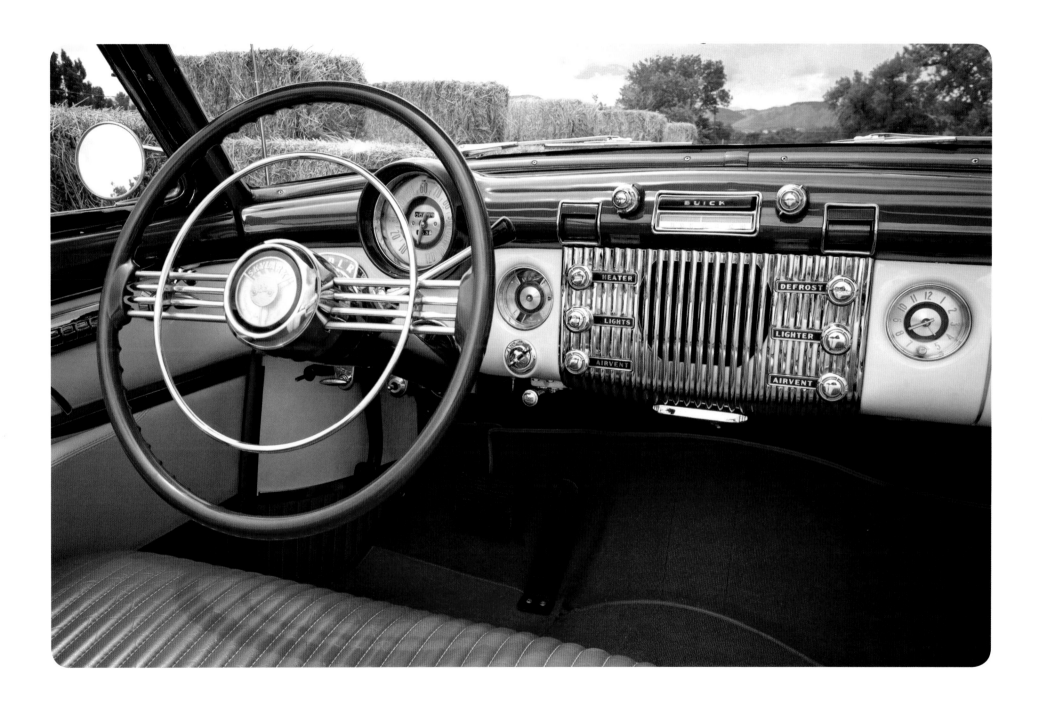

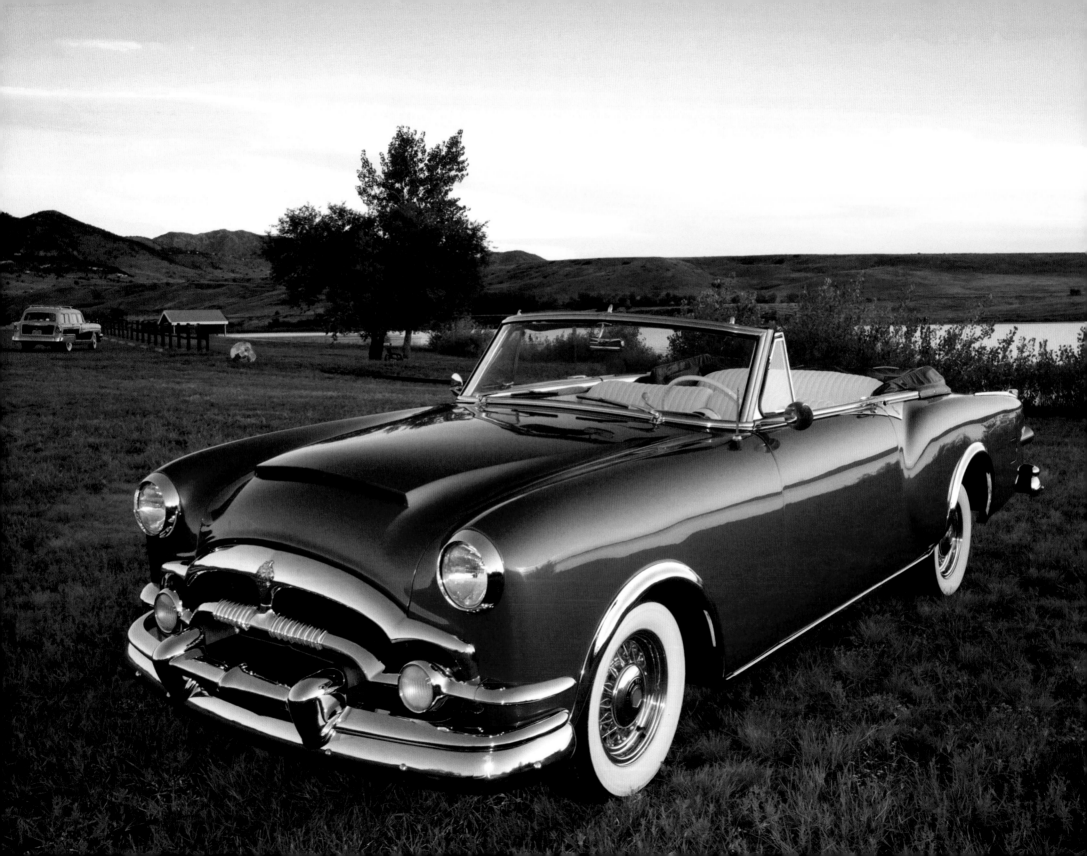

1953 PACKARD
CARIBBEAN CONVERTIBLE

The Caribbean convertible was the top of Packard's line when introduced in 1953. It was only made for three years and in very limited numbers. Packard's mission for survival after World War II was to produce a sportier-looking and -driving car yet still retain Packard's traditionally high level of luxurious appointments. They hoped to shed the public perception for being stuffy, chauffeur-driven cars only for society's elite. The American postwar public wanted to get out on the open road, drive, and have fun. Packard needed a new image, and this was the car to make that happen. But it was not inexpensive. The price tag of $5,210 included every accessory under the sun, and production was limited to 750 cars, which was used as a sales tool to promote its exclusivity.

With a combination of sporty elegance and jaunty grace, even though the solidly built car weighs over two tons, the Caribbean's promise of carefree, top-down fun on the open road included racy wheel-opening cutouts framed in wide chrome arches, chromed rocker panels, and a nicely contoured grille. It also had a long hood with a simulated scoop that hinted at a powerful engine—the 327-cubic-inch straight-eight with 180 horsepower. Other enhancements were a sumptuous leather interior, sporty chrome wire wheels, and the snazzy Continental kit that covered the outside spare tire behind

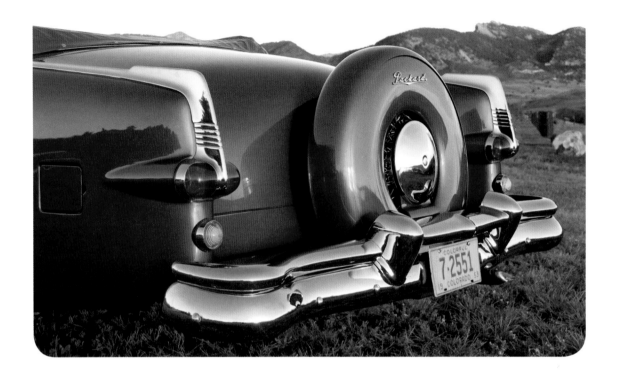

the trunk. The buyer of a new 1953 Caribbean often ticked every available option box when ordering their car.

The one depicted here was originally purchased and owned by a Mr. C. H. Schelloch, who sold it in 1972 to Win Scott. He, in turn, sold it to Don Bittenbender in 1989. I bought the car two years later and commissioned a frame-off restoration. It's correct in every way, with a beautiful, unusual maroon metallic paint job from the factory color chart. It is an excellent driver, but why not? It's a Packard.

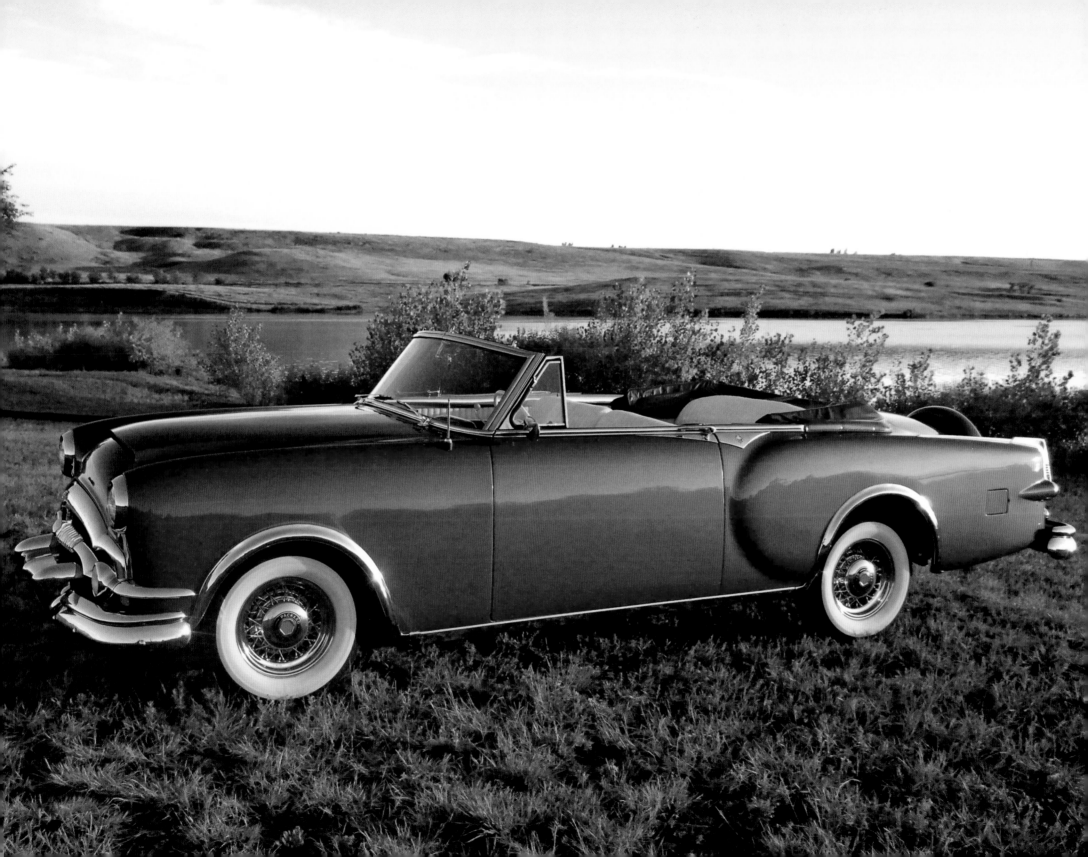

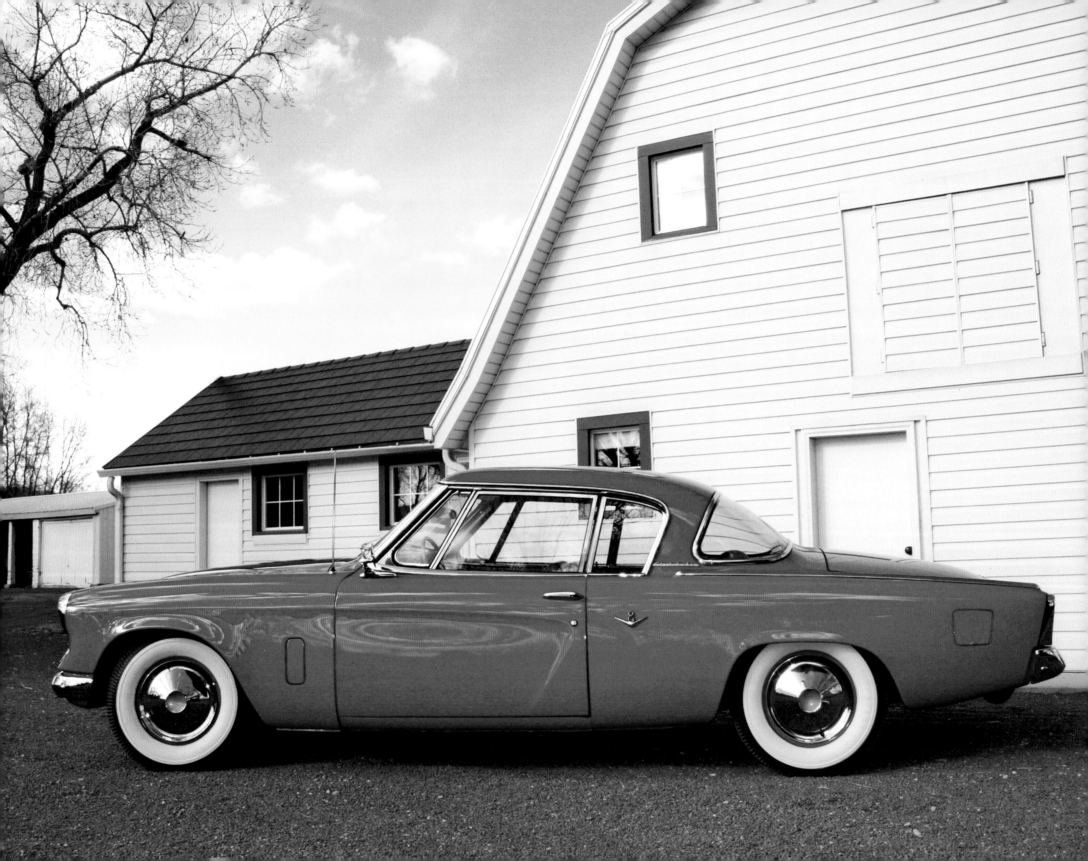

1953 STUDEBAKER COMMANDER REGAL STARLINER

The acclaimed masterworks of automotive art, the legendary "Loewy coupes," exemplify the most aesthetically stylish designs to come out of the fifties, and the decades before. The 1953 Commander remains one of the most forward-thinking, clean, and aerodynamic designs of its era. At only 56 inches from the road to the pillarless hardtop roof, the Starliner Commander was low-slung and, accentuated by a long wheelbase of 120 inches, considered lengthy for a small car. It was a vast departure from other automobiles of the era, with

its long, sloping hood, completely exposed wheels, and sleek body devoid of chrome embellishment. Studebaker touted the machine as "the new American car with the European look," and it proved so popular in 1953 that the model sold nearly four times what the factory had estimated.

The Commander looked good from every angle. Raymond Loewy and his design team were happily surprised when Studebaker put the car into production right off the drawing board without a litany of changes.

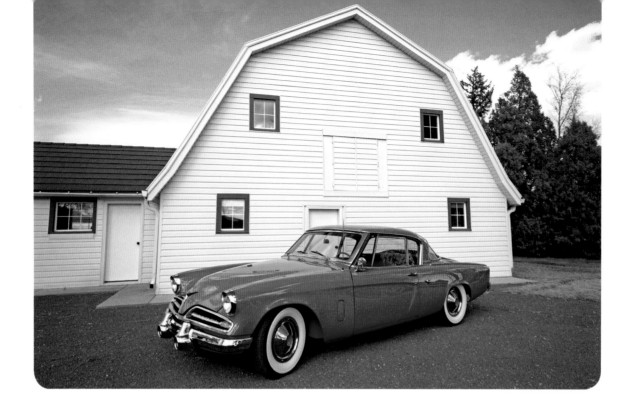

This particular car is a Regal Starliner model, the "Regal" denoting the top-of-the-line trim and V-8 power. The engine was a 232-cubic-inch V-8 with 120 horsepower that moved the light, aerodynamic car smartly along in great style.

Hot-rodders were quick to notice the potential of the wind-cheating design and low center of gravity. Starliners became the body of choice, continuing to this day, at the Bonneville Salt Flats for land-speed-record runs in excess of 250 miles per hour.

I've always loved these cars and finally found one in solid condition. I bought it from a family in California that actually drove it every day. As I do all too frequently, I got carried away and gave it a restoration with nothing spared, every part finished in exacting and prime detail.

She's a beauty, and, in my estimation, one of the most gorgeous production cars ever built.

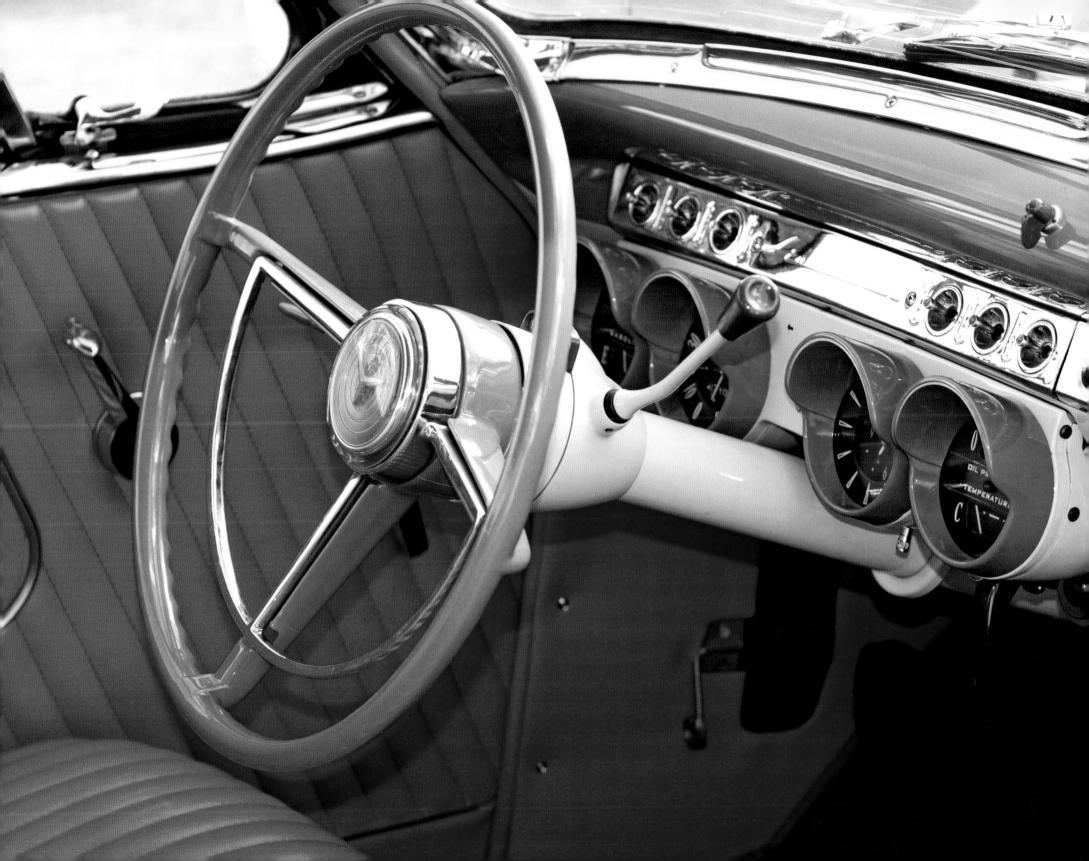

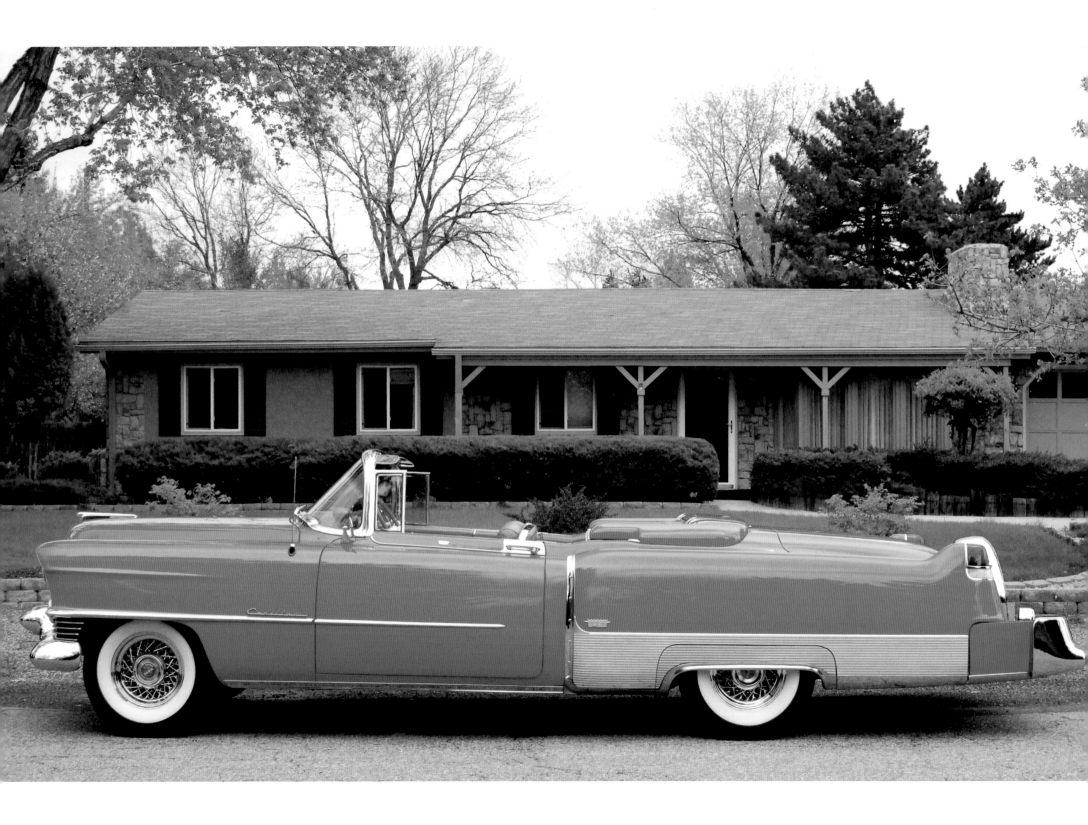

1954 CADILLAC ELDORADO BIARRITZ CONVERTIBLE

The Series 62 1954 Cadillac Eldorado was a dream car that became a reality. Like the legendary myth of El Dorado, the car grew to epic proportions. It was a different breed that would be sold in substantial numbers for $5,738, nearly $2,000 less than the 1953.

Styling was more heroic and heavier than preceding models. The Eldorado received its own rear fenders, with fluted extruded-aluminum side panels at the rear-quarter flanks, popular raised taillight fins, and special saber-spoked wheels. Enhancements

came in the form of four-way power front seats, power windows, and a sensor that automatically dimmed the headlights for oncoming traffic. The car also featured tinted plexiglass sun visors. The big V-8 engine was increased to 332 cubic inches and the horsepower upped to 230.

This is a beautiful car, with red exterior and two-tone red and white leather upholstery. Convertibles had monogram plates on the doors, wire wheels, custom interior trimmings, with the Cadillac crest embossed on the seat bolsters and golden

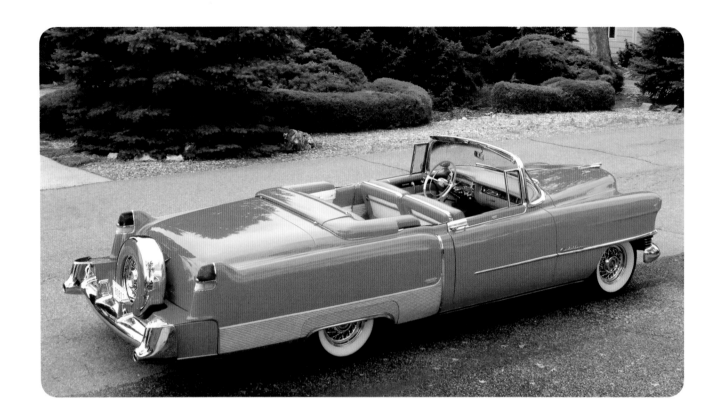

crests centered directly behind the air-slot fender breaks. Pure luxury.

I bought it practically sight unseen at the Barrett-Jackson auction in January of 2000. Unmindful of my usual practice of examining a car I was interested in by checking out every inch, peering under the hood and crawling under the chassis, I bid on this beauty as it came across the auction block without leaving my chair in the audience. I wondered afterward, *What have I done?* but in this situation I was more than pleased to find that it was a beautiful frame-off restoration. For once, I had lucked out. It is a gorgeous car, from tires to top.

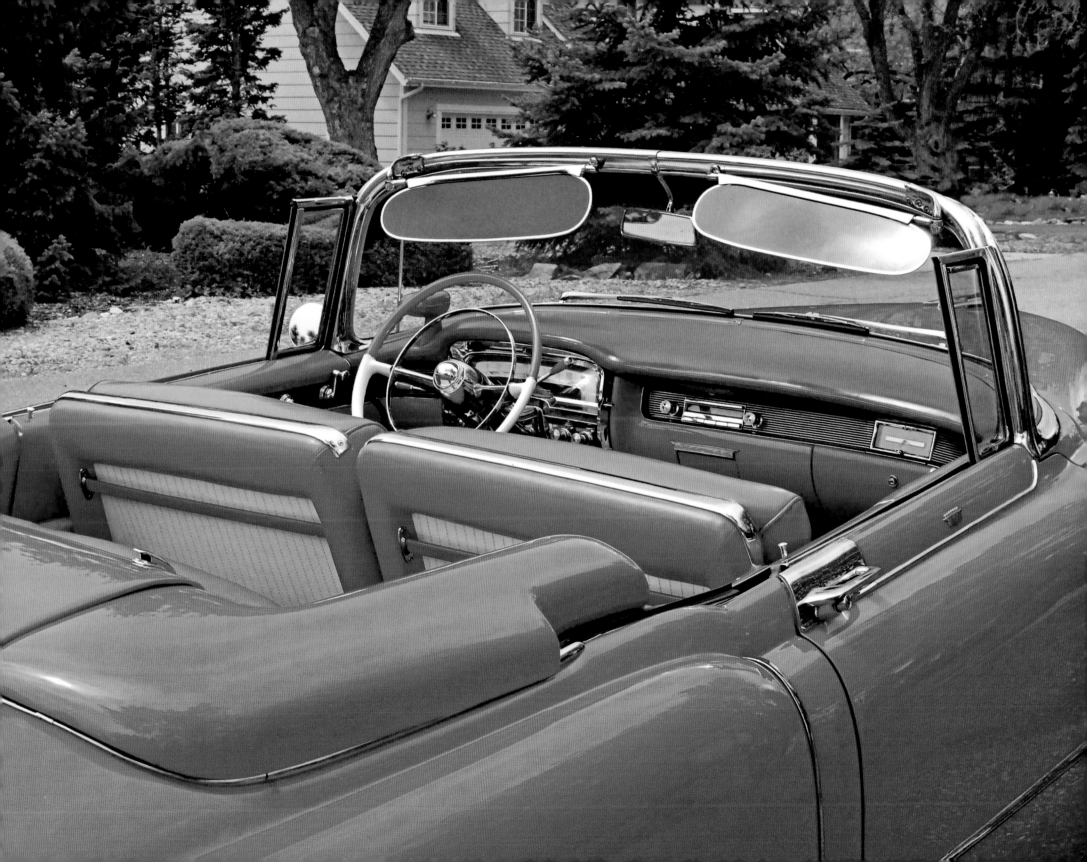

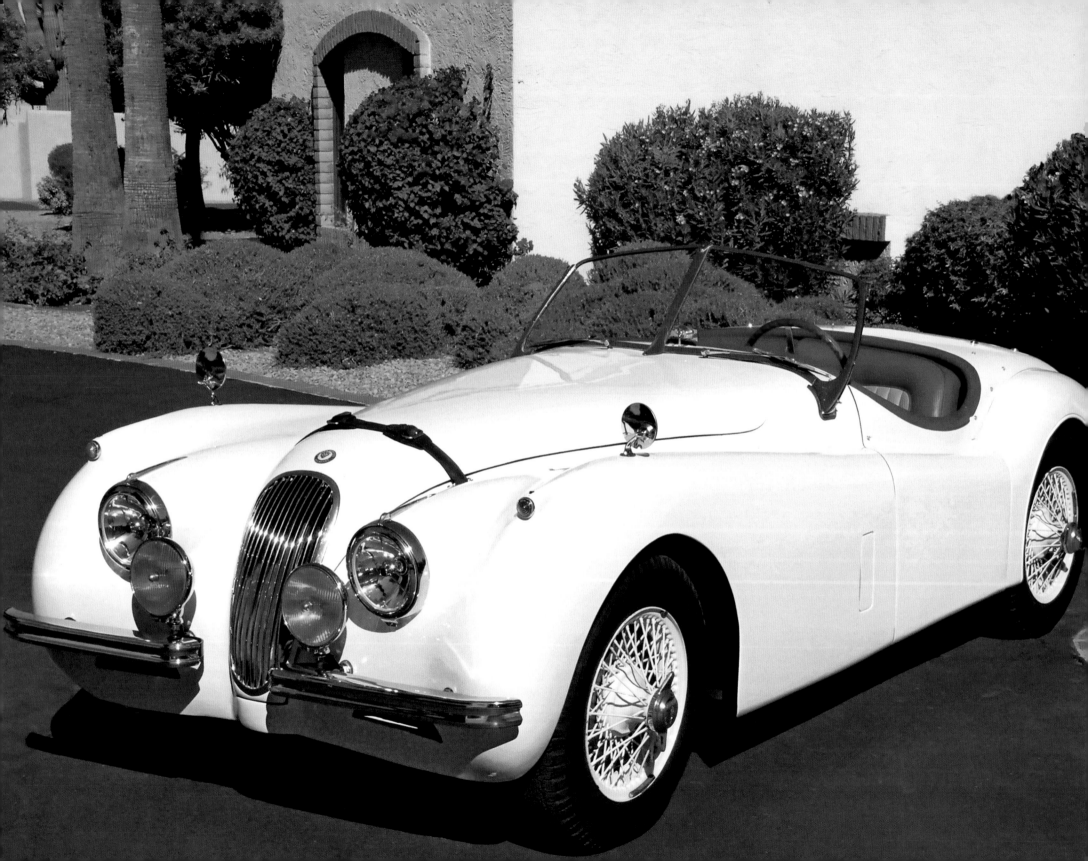

1954 JAGUAR XK120 ROADSTER

've always had a soft spot in my heart for the XK120 Jaguar. When I was an aircraft mechanic in the Air Force during the Korean War, I used to dream of owning one. For three years, I saved every nickel I could spare out of my meager pay. And when I was discharged, the first day I was home my mother drove me to the Jaguar dealership and an hour later I drove out in a brand-new Jaguar XK120 modified roadster with 180 horsepower. The gates of heaven opened the instant the tires crossed the driveway.

Now I was in a league with Humphrey Bogart, Ingrid Bergman, Clark Gable, and Gary Cooper, who all owned one. I courted my wife, Barbara, in that gray sports car with red upholstery. And when I proposed, how could she say no?

The "120" in its name referred to its 120-mile-an-hour top speed, which made the XK120 the fastest production car from 1948 until 1954. During her time in the sun, the Jag won more races than jelly beans in a gallon jar. The Jaguar XK120 had created a racing sensation; it was only succeeded by the mighty Mercedes-Benz 300SL when that car was introduced.

The straight-six, dual overhead aluminum engine put out 160 horsepower in the standard version and 180 in the modified faster model. It could accelerate from 0 to 60 miles an hour in ten seconds. Not bad, for those days. I could never hit a stoplight without a hot rod wanting to drag-race.

No Ferrari, no Lamborghini, no Ford Cobra ever had an exhaust

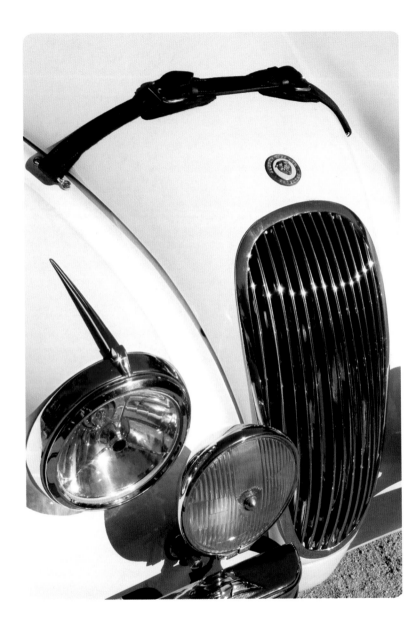

sound that could rival the 120. The blast from the twin tailpipes is unique. No sports car ever built has the rumbling, ratty tone of the 120. It comes as close as any to shattering window glass.

I purchased this car years ago at an Arizona auction. With the Olde English White paint and red leather interior, I still love driving this car all bundled up on a cold evening. There is no greater sensation than the throaty roar of the exhaust as the needle on the tachometer creeps into the red.

I'm pictured with this car on the back jacket of *Built for Adventure*, the previous book of prewar classic motorcars in the Cussler Museum.

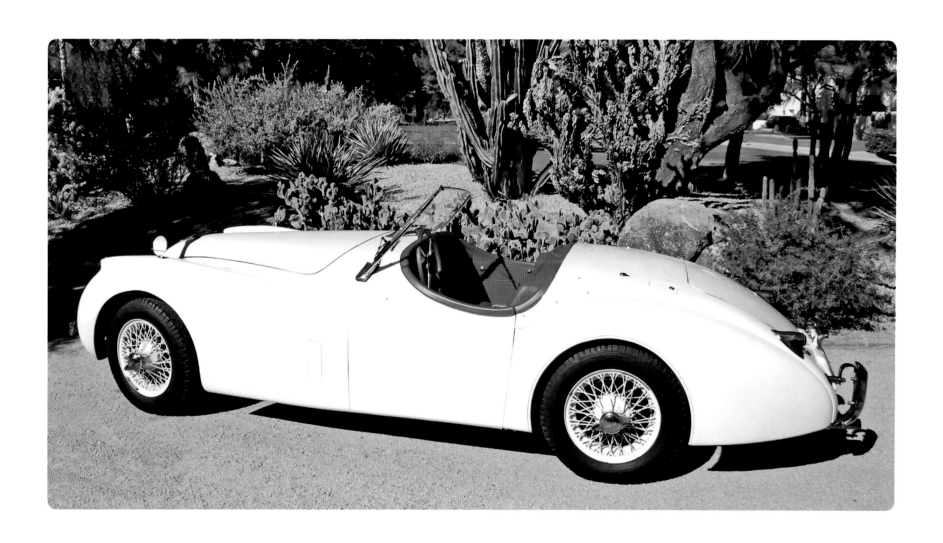

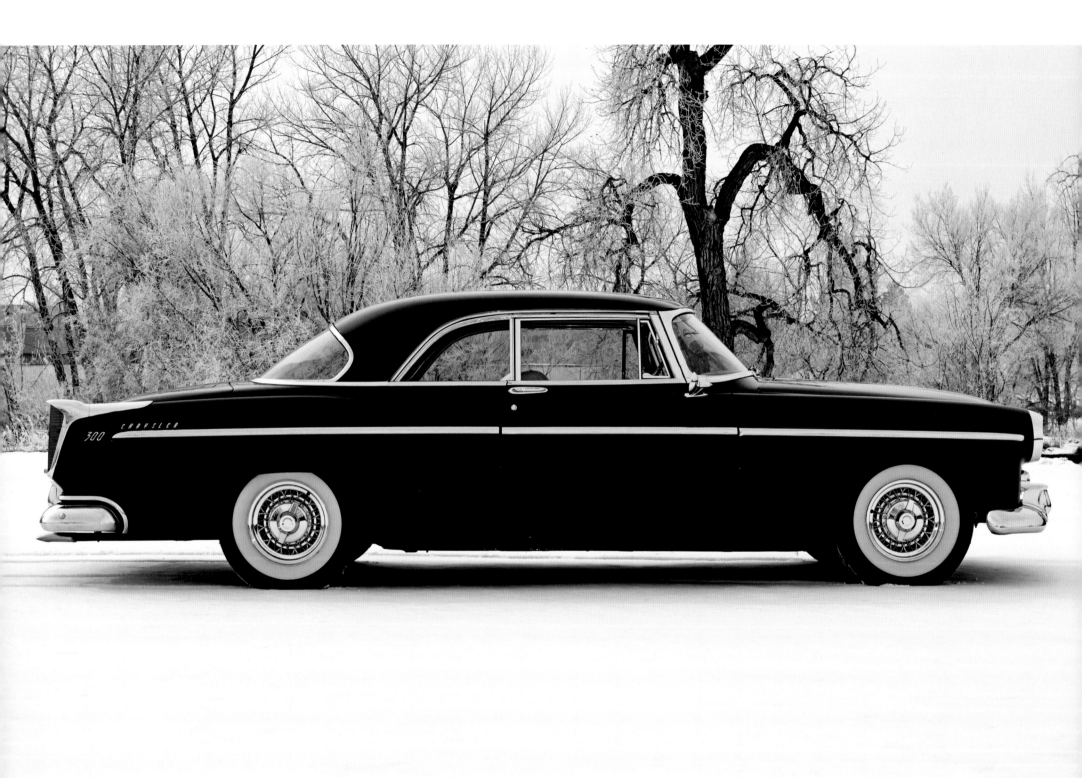

1955 CHRYSLER C-300

Cutting-edge for 1955, the Chrysler C-300, with its phenomenal FirePower Hemi engine, was America's first true muscle car. It came only as a two-door coupe; 1,725 were made, of which a scant 231 are known to survive. It was the first of the so-called letter series Chryslers. It had it all: speed, style, and luxury.

It's distinguished by its powerful 331-cubic-inch/5.4 liter V-8 Hemi engine as standard equipment. Chrysler developed a high-powered, hemispherical combustion-chambered head for the P-47 Thunder-

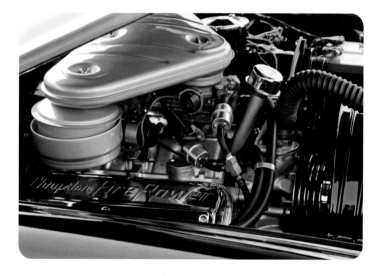

bolt fighter during World War II and they applied their military experience to their first V-8 engine, which became the ultimate muscle for the new hot-rodding era. This iconic engine had dual four-barrel carburetors, a race-profile camshaft, solid valve lifters, special manifolds, and an enlarged dual exhaust system. It was the first factory stock engine to deliver 300 horsepower, which is how the model got its name. It could do 0 to 60 in ten seconds and run 110 miles an hour flat out. Plus, it had an improved suspension, which provided responsive, sporty

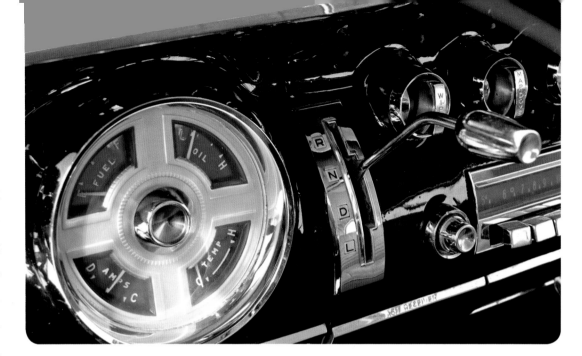

handling. No slouch, the C-300 dominated stock car racing after its introduction, winning the NASCAR Sprint Cup Series Drivers' Championship, one driver dominating thirteen consecutive races, and the AAA Stock Car Championship—both with record speeds.

To satisfy a growing American desire for a sporty, fun-to-drive "image" car, Chrysler offered the C-300 as their high-powered personal luxury car. A 150-mile-per-hour speedometer, racing dominance and successful top-speed record runs at Daytona Beach and Bonneville captivated the imagination of postwar American buyers eager for a new driving thrill.

The C-300 was elegant and aggressive-looking, bringing appearance up to par with performance. Chrysler still stood for quality, comfort, and sophistication. The C-300 also came with a host of luxuries, power everything—steering, the windows, brakes, even movable seats. The interiors had plush, soft leather. Although richly equipped, it handled reasonably well for a big, heavy automobile—and the C-300 was the fastest car on the road.

I had this one restored from the tires up. The engine was bored-out oversize and an Iskenderian three-quarter race cam installed. The original 300 horsepower Hemi now puts out around 330.

I raced her in the drag races at Bandimere, in Colorado, where she turned 80 miles an hour for the quarter mile. A beautiful car that goes like hell.

The car pictured here came out of California, from Richard Carpenter, of the famous recording duo The Carpenters.

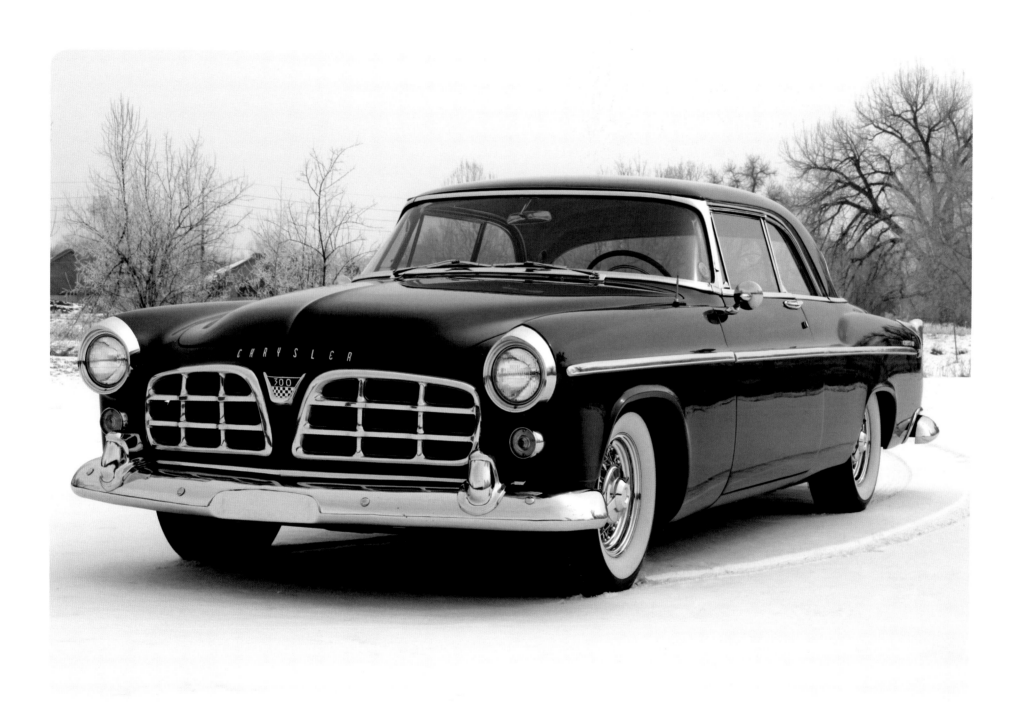

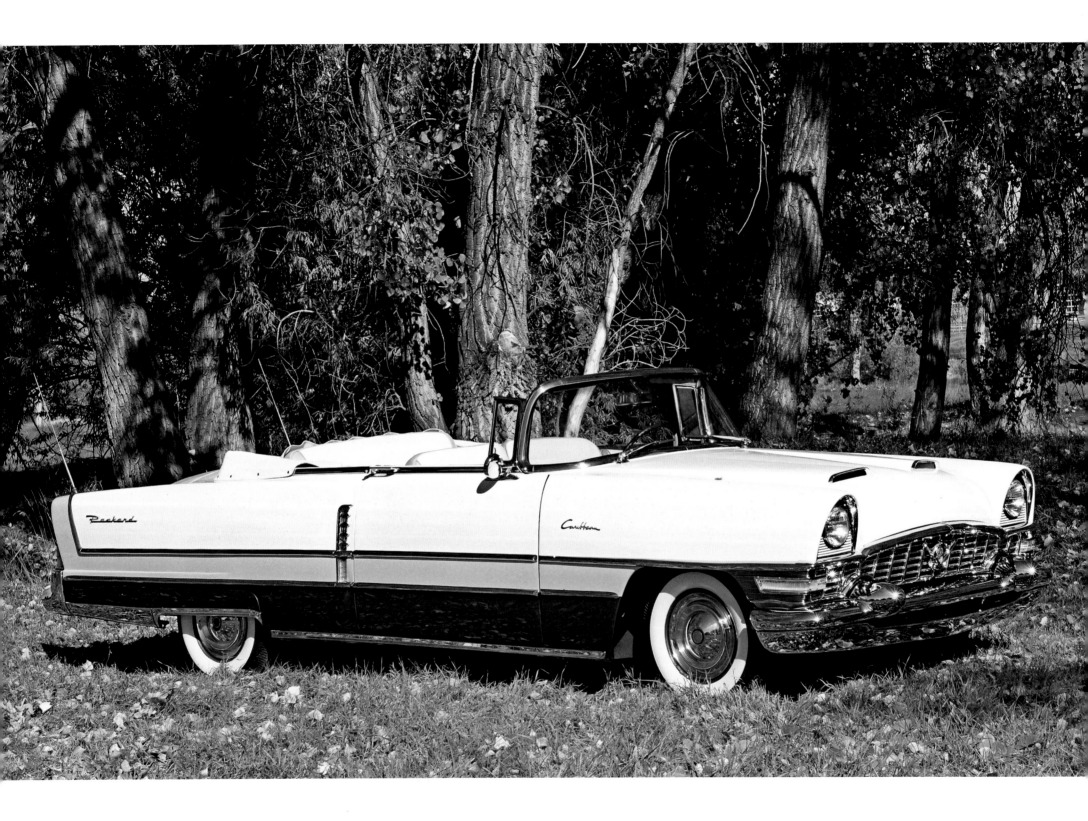

1955 PACKARD CARIBBEAN CONVERTIBLE

The new Caribbean convertible for this year was an impressive car, looking like no other Packard before. It was more massive than earlier Caribbeans; the only thing that remained the same was the 127-inch wheelbase. Only five hundred were built. Many collectors refer to the '55 and '56 Packard Caribbeans as the finest luxury convertibles of their era.

The look of the body changed tremendously from the previous model. Headlights were hooded for the first time; the hood had not one but two scoops; and the rear end was graced with dual exhaust pipes, dual antennas, and a pair of attractive cathedral taillights.

For the more exotic look, the body was available in an array of tricolor paint combinations. The upper half was always white. The middle stripe, set between two chrome strips, had four options, with complementing colors on the lower section. It was a knockout effect. No car has had it before or since.

The company's long tradition with high-quality interiors was maintained with two-tone leather to match the exterior razzle-dazzle. The dash colors also matched the upholstery, the exterior paint scheme giving the interior a look of magnificent opulence.

But the real innovations came from the chassis and from under the hood. The time-honored straight-eight engine was replaced with a 352-cubic-inch V-8 with dual four-barrel carburetors that put out 275 horsepower. There was also a new Ultramatic transmission and a Torsion-Level Suspension that either manually or automatically leveled the car, giving the Caribbean extraordinary ride and handling capabilities. It would adjust for any load and supported a smooth and stable balance.

I bought this car from Gene Epstein of Newtown, Pennsylvania, in 1990. It was well-restored but needed some polishing and fine-tuning to make it into a class act, with its original colors of white, green, and black. She rides like a giant feather and moves right along on the freeway with the latest goers from Europe and Detroit and Tokyo.

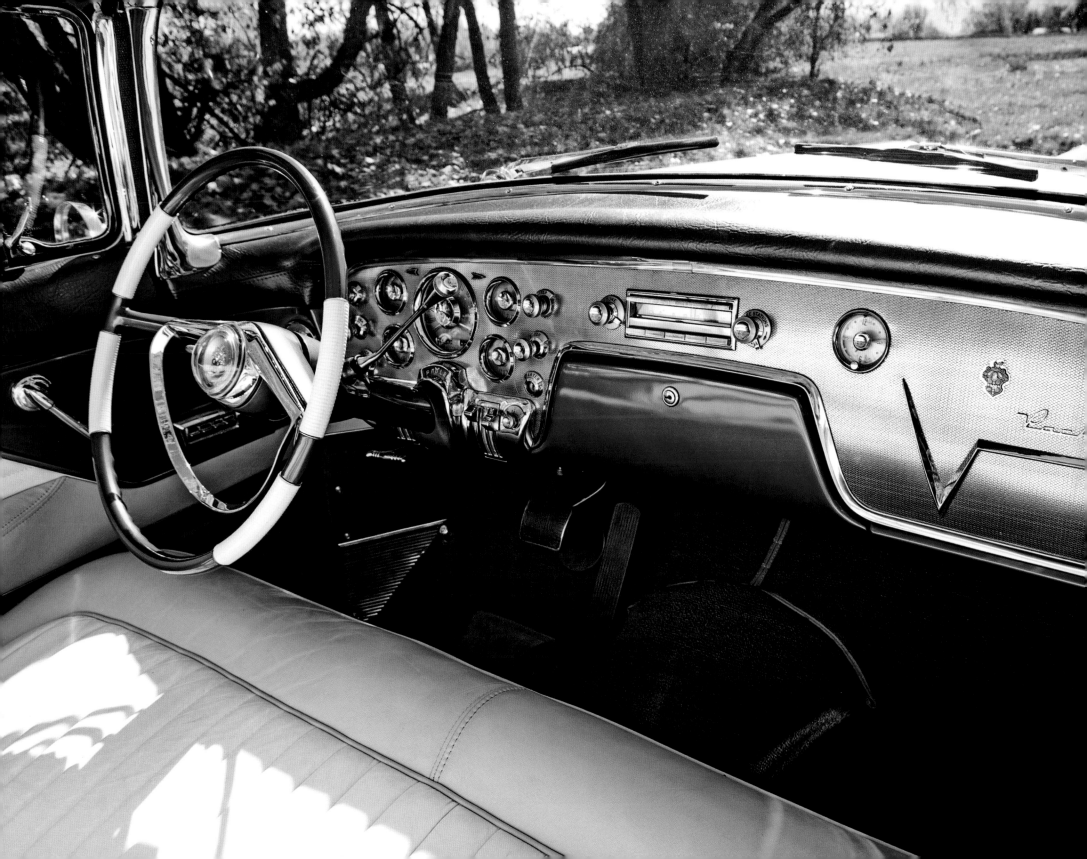

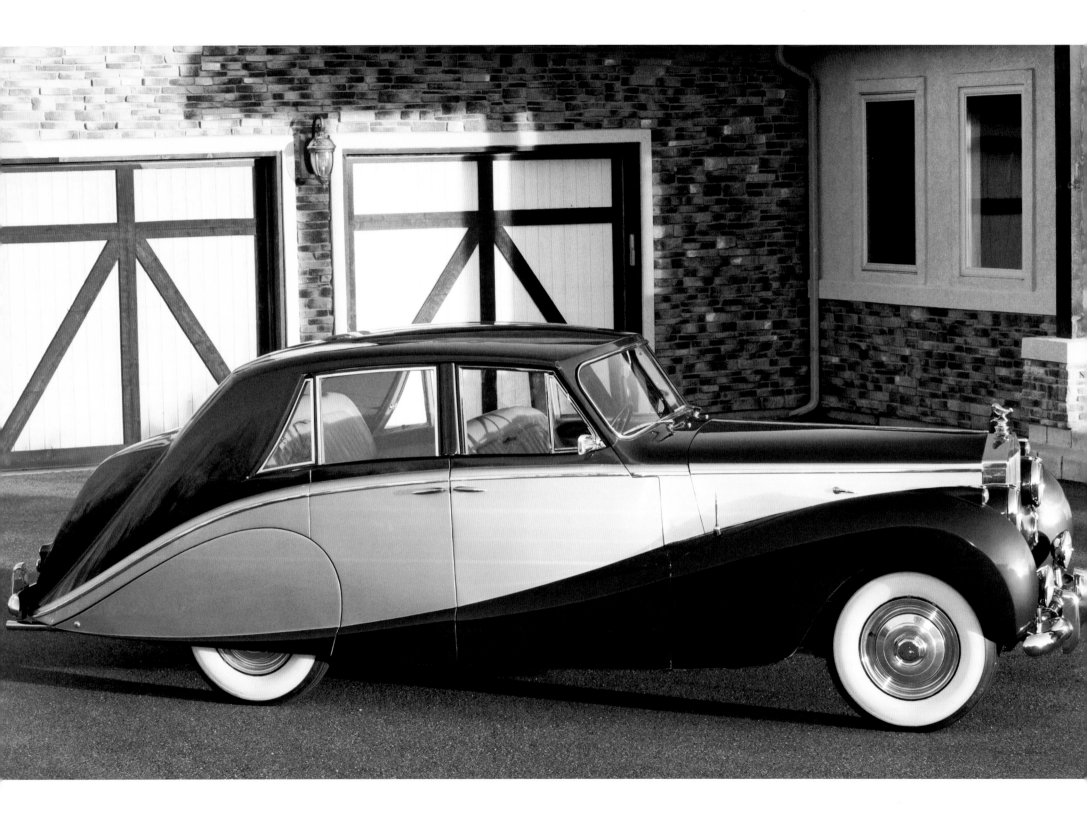

1955 ROLLS-ROYCE SILVER DAWN EMPRESS SALOON

The Silver Dawn was introduced in 1949 primarily for the American market. This was a very different model for Rolls-Royce; the Dawn was not meant to be driven by a chauffeur but by the owner/driver. The Silver Dawn was the first Rolls-Royce with a factory-built body. The particular car seen here, however, was custom-ordered. It has a bespoke body, known as the "Empress Saloon," by renowned British coachbuilder Hooper & Company, who were known for their sleek styling. This special slab-sided body line also has fully enclosed rear wheels, where the rear fenders merge into the doors—a signature design feature that identifies elegant Hooper bodies. It is an exceptional example.

The total number of Silver Dawn cars built came to a mere 760 in its six-year production run; only eleven were Hooper bodies. This rare and luxurious example was the first of only four built in the final year.

The 260-cubic-inch engine put out around 125 horsepower, and it could take the Dawn up to a stately 94 miles an hour. Earlier Rolls export models were left-hand drive with manually operated gearshift, which didn't go over well with American buyers of this ultimate status motorcar. Finally, the marketing people caught on and the Dawn was offered with an automatic transmission.

It was originally ordered by a Mr. D. Kleeman of London, England, who desired a two-tone green paint scheme. He ordered it with extra-soft green leather seating, power windows, and dark walnut burr for the two tables in back of the front seats, window frames, and dash. He drove it for a number of years in the U.K. and had the Rolls-Royce

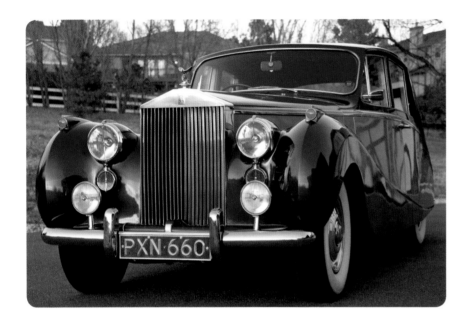

dealer replace the engine in 1968. This car is quite unique, despite being designed for the American market, as it was specially ordered with right-hand drive for use in the U.K.

The car was imported from England in 1971 by Russ Jackson of Barrett-Jackson auction fame. I had the car fully restored, the aluminum body stripped and painted, all the wood restored, and the interior reupholstered in green Bridge of Weir Scottish leather. The rich burled wood and the heady smell of top-quality leather en-

hance the elegant experience. This is a sweet-driving car, and friends are always impressed when we pick them up at the airport in it.

I have a particular affection for this car and the warm memories it evokes for a couple of reasons. As I recall, my wife Barbara and I bought it because it was built the same year we were married. And this is a car I bought to celebrate my first book to be published, *The Mediterranean Caper,* and the end of my days working at the advertising agency.

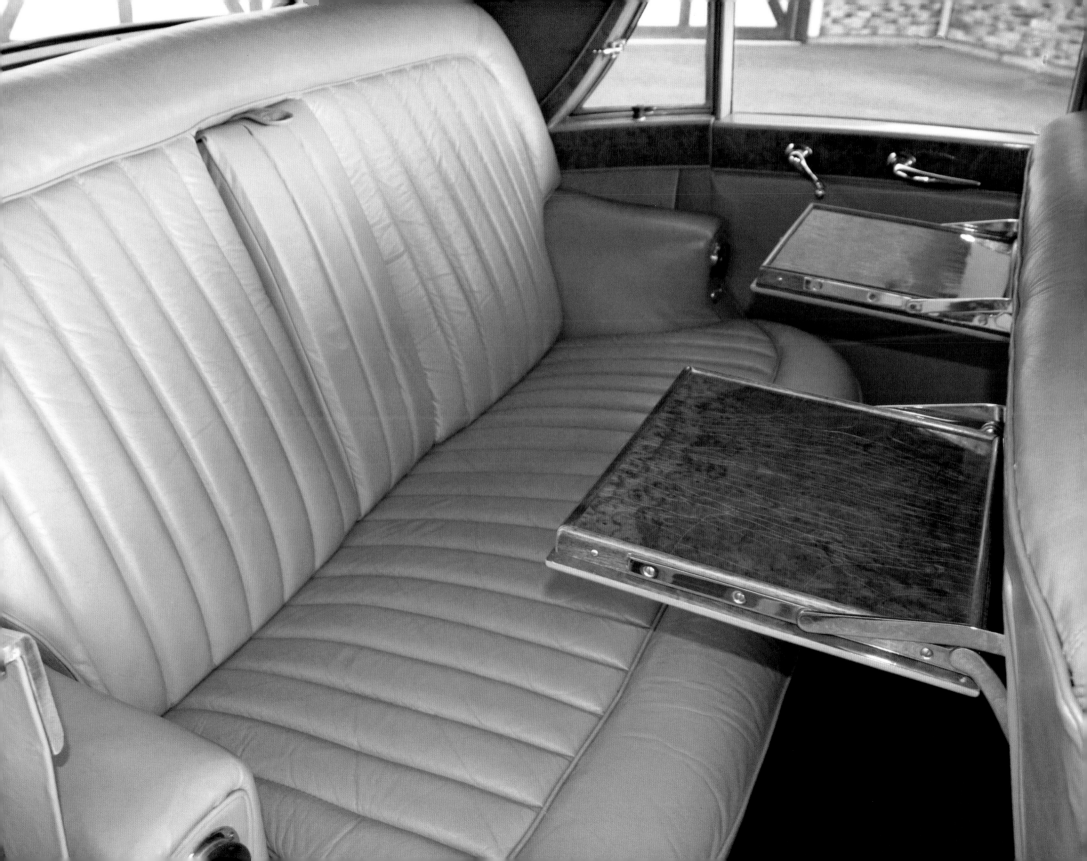

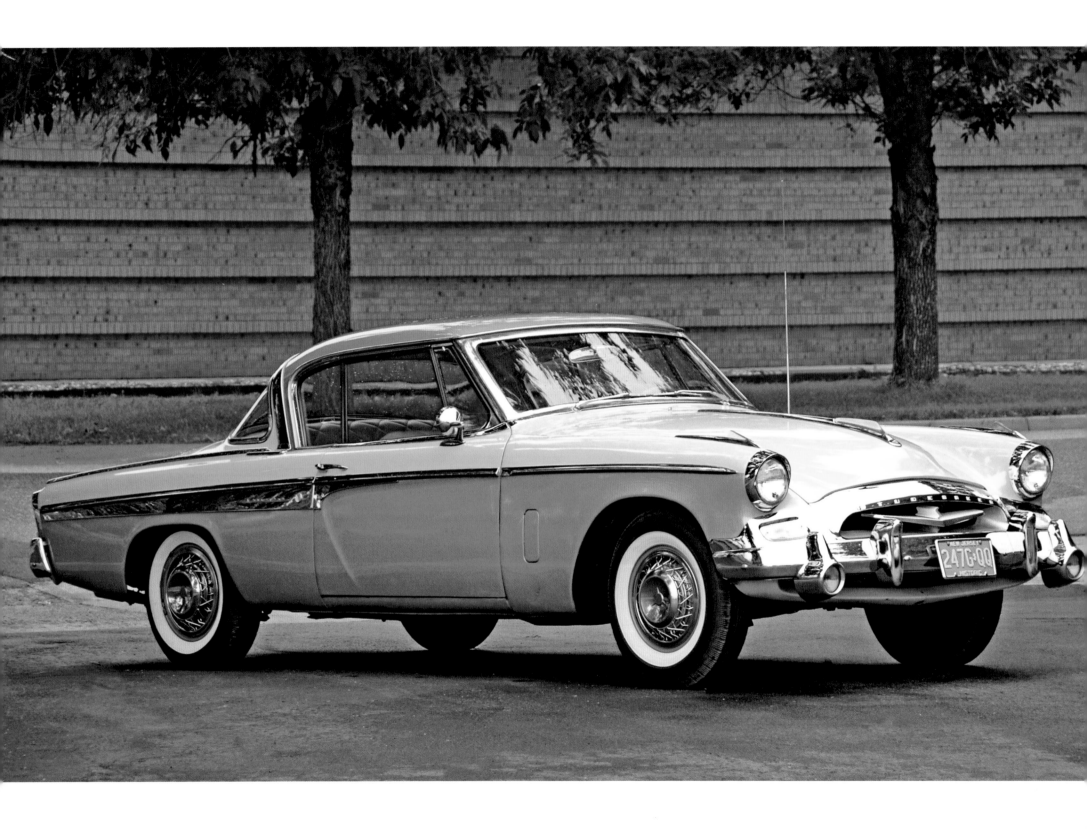

1955 STUDEBAKER PRESIDENT SPEEDSTER

After the critical acclaim and sales success of the sublime 1953 Studebaker Starliner, the company was acquired by Packard in 1954. It was decided that there should be a new "halo," or top-of-the-line model, and in '55 the President Speedster was introduced. This was a one-year-only special edition model and only 2,215 were made.

Packard equipped it so that most Studebaker options were standard for this model. Although based on the '53 Starliner, which was distinguished by a lack of chrome and low-slung design, the 1955 President Speedster had a large chrome grille

and more embellishments to accent the still-sleek appearance. This unique and luxurious new model looked like a Venus de Milo with beads, tiaras, and diamond ear studs. The company had become convinced that more chrome was the way to go, and it was lavishly applied. The factory ad agency proclaimed the new Speedster as "lightning on wheels, styled for action, powered for thrills." Not a true sports car, perhaps, but as close to it as any hardtop of the day could come.

The suspension handled well, and the new "Passmaster" V-8 had a four-barrel carburetor, dual exhaust, and 45 more horsepower

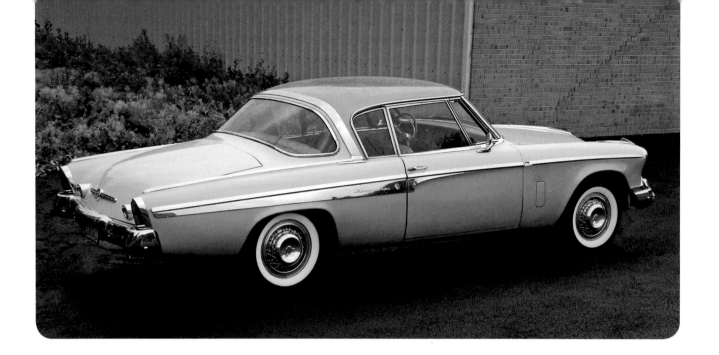

for a more high-performance standard than the earlier model Studebaker V-8.

The dash looks like it came out of a race car, with aluminum engine-turned facing and an array of easy-to-read instruments, including a tachometer. The interior is enhanced with diamond-quilted leather in color-keyed shades. This car has the seat belt option, rare for the era, with one webbed strap and buckle secured to the seat frame and the male end of the belt system attached to the door.

The President had simulated wire wheel covers, a bumper with integrated fog lamps, and either two- or three-tone color schemes with wild combinations—the most famous of which was Hialeah Green and Sun Valley Yellow—more conveniently called lemon-lime by the public.

Classic car aficionados are adding the Speedster to their collections because it was so unusual, and the prices are rising. There is one lament, though. It's a pity they never built a convertible.

My car originally came out of New Jersey, where it was photographed for two different calendars. I bought it in 1988, and except for a touch-up and a few replacement parts, it's in original condition.

A truly interesting car you don't see very often.

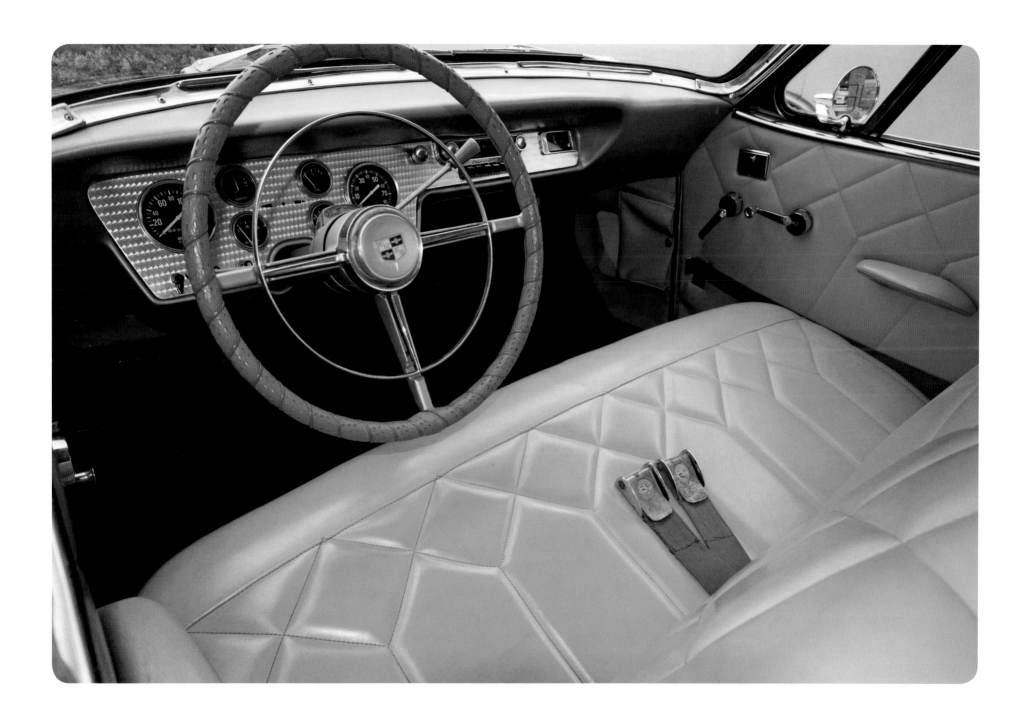

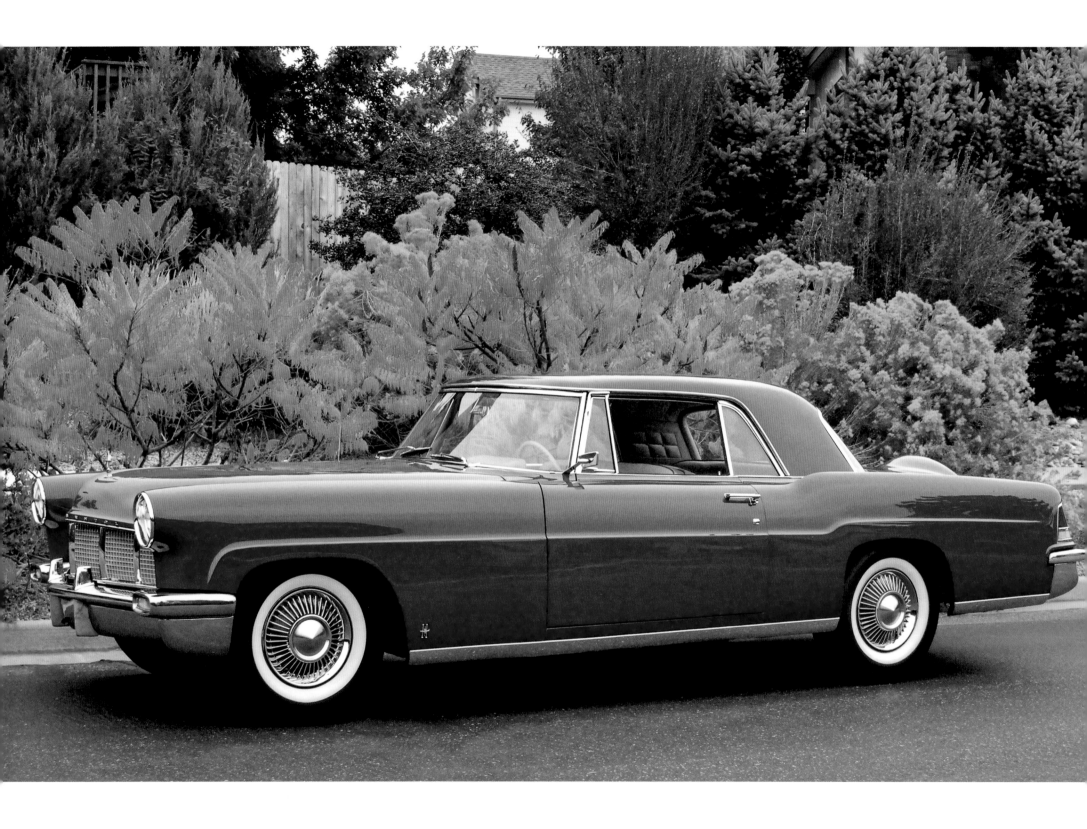

1956 CONTINENTAL MARK II

The 1956 Continental Mark II is one of the most beautiful cars ever made, regardless of cost, era, or production numbers. Back when people were known by the company they kept, a Continental Mark II was the car to drive. Many celebrities of the time owned one—Frank Sinatra, Elvis Presley, Dwight Eisenhower, and Nelson Rockefeller, to name a few. In an era of fins, scoops, two and three-tone paint schemes, side chrome accents, and the like, the Continental Mark II was specifically constructed with a tasteful sensibility for sophistication and purity of design without embellishment. There was simply no American car like this. In fact, it was meant to have a European aura of understatement. To further distinguish this car from all other American offerings and to attract an affluent and sophisticated clientele, the new Continental had its debut at the Paris Auto Show, rather than a hall in Detroit. Further distinguishing the

Mark II, Continental became a separate division, separately manufactured, yet sold and serviced at Lincoln dealerships, as it had a Lincoln drivetrain. Long, low, and elegant, some may say it's a bit conservative, but this classic makes a statement nonetheless.

The goal of Ford in 1956 was to create a top-of-the-line luxury automobile second to none. At $10,000, it was the highest-priced car in America. It was the equivalent cost of a new Rolls-Royce or two Cadillacs that year. Every inch, every bit of its construction, was of the highest order. As the corporate flagship, the Continental was virtually handmade and crafted with care of the highest standard. This resulted in fully twice the amount of man hours and expenses to complete a Mark II, as compared to the already luxurious Lincoln model built on the assembly line. Lincoln 368-cubic-inch engines selected for the Mark II were blueprinted, assembled with the closest spec parts

available, and dyno-tested. This was a wholly different procedure than that of Cadillac, Lincoln, or any other volume car producer.

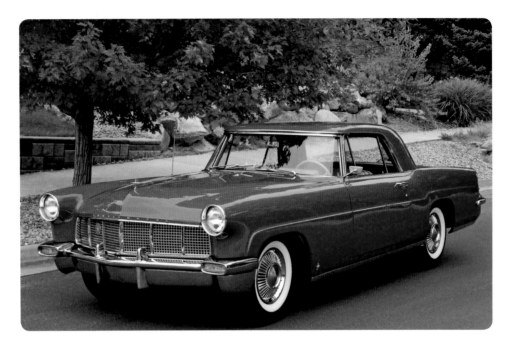

The quality of the materials and attention to detail, inside and out, was unparalleled. For the car's exterior, there were multiple coats of paint, hand sanding between each application, double lacquer coats, and then polishing the gleaming body until it was absolutely perfect. The buyer of a Mark II had nineteen standard exterior lacquer finishes from which to choose, as well as a forty-three standard upholstery trim options, including perfect, blemish-free Bridge of Weir leather from Scotland or a number of rich fabrics.

Despite its high price, the Continental Mark II was a bargain for the money. And well it should be, since Ford lost $1,000 for every one produced and sold. Three thousand were built in the two years of production of this ultimate American personal luxury car. Today, approximately half of the original cars still exist. From a contemporary vantage point, it can be argued that the Mark II was successful at being what it was intended to be: an American Rolls-Royce or Bentley.

The Continental Mark II is not a motorcar that makes its statement loudly, but it has become an avidly sought-after and prized collector car. I bought this wonderful specimen after it had gone through a very expensive and exacting restoration. Every part is correct, and no cost was spared, in making it one of the finest Mark IIs in existence.

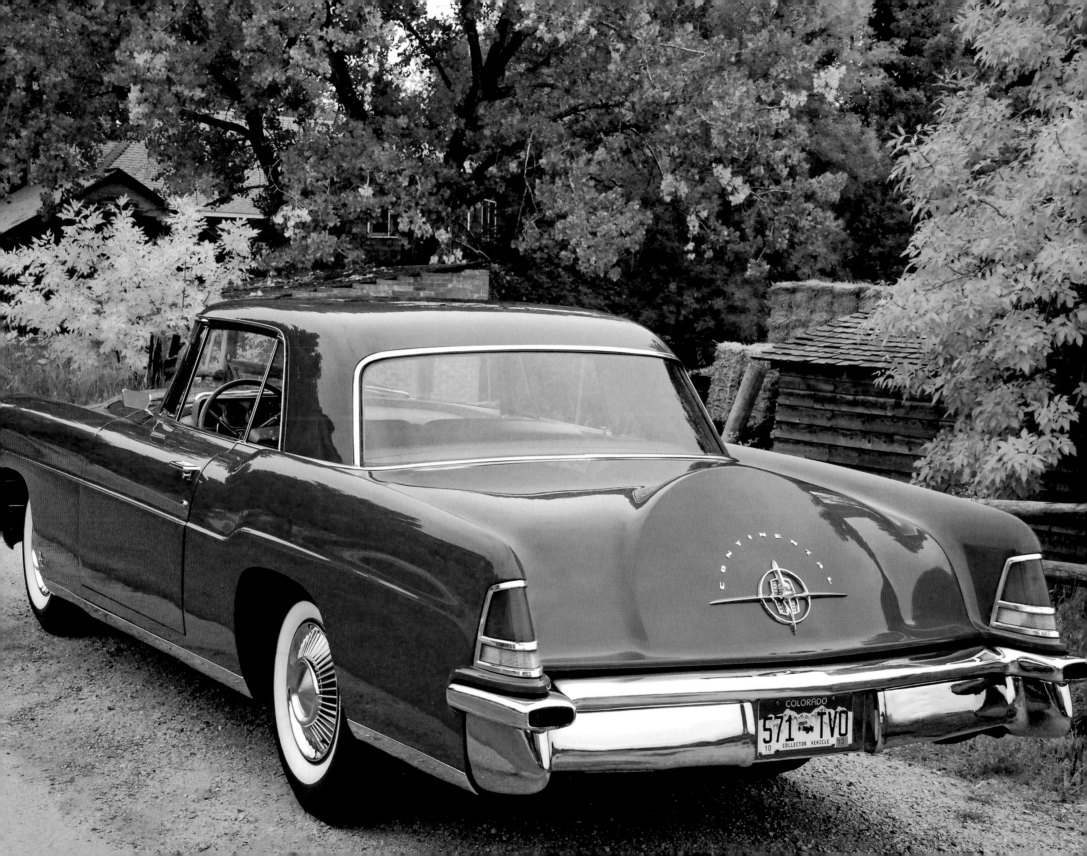

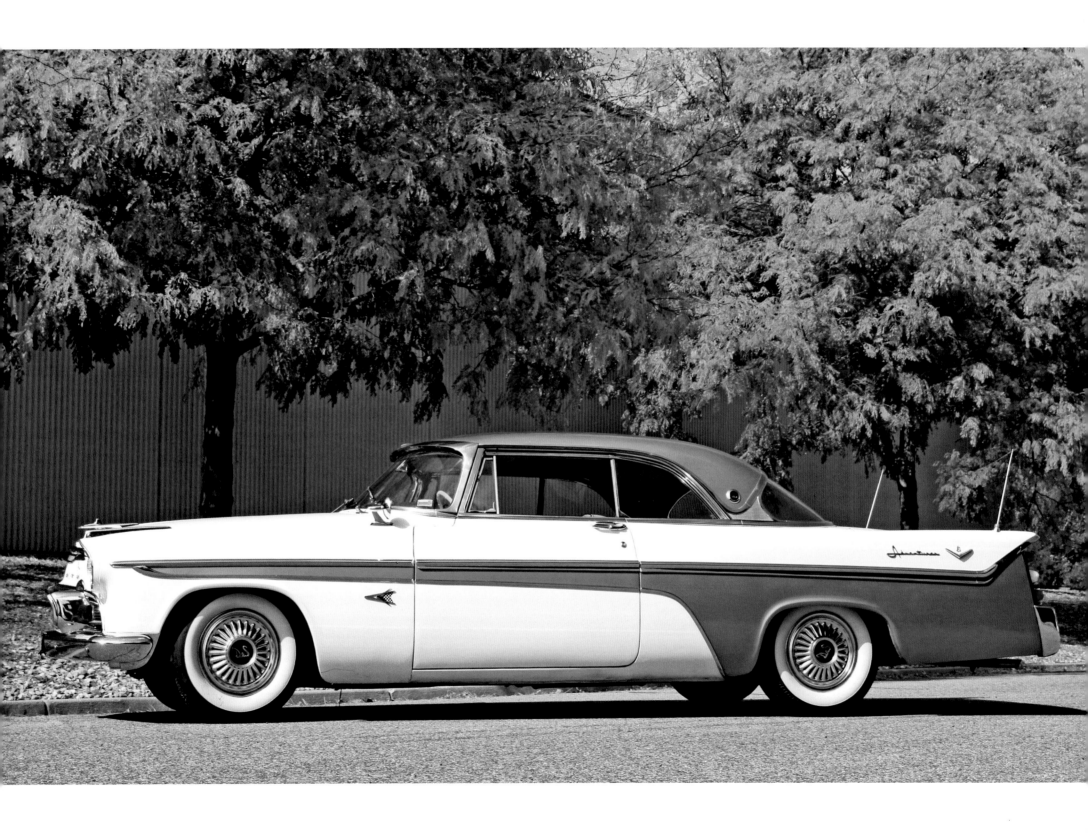

1956 DESOTO GOLDEN ADVENTURER

Because DeSoto was Chrysler's orphan child, it was often confused with the Dodge, or thought of as being a more expensive Plymouth. Then it came as a shock when, in 1956, DeSoto offered its own top-level personal luxury hot rod rival to the stunning Chrysler 300, with its FirePower Hemi engine and advanced styling. And what a hot rod the Adventurer turned out to be!

The engine was DeSoto's Firedome Hemi V-8, having a displacement of 341 cubic inches, with dual four-barrel carburetors punching out 320 horsepower, a whopping 90 horsepower increase over the previous year's engine. Dual ex-

hausts, power brakes as standard equipment, this car was a great driving experience. There was no doubt about it, the Adventurer was a goer, and it looked like one as well. One of the fastest and best overall drivers of all American cars of the fifties, an Adventurer was clocked at 137 miles per hour at Daytona and 144 at the Chrysler proving grounds. This top-of-the-line DeSoto was so admired upon its introduction that it was named as the official pace car for the Indianapolis 500 race. All Golden Adventurers sold out within two weeks.

Gold plating covered the grille and turbine-style wheels. Gold was

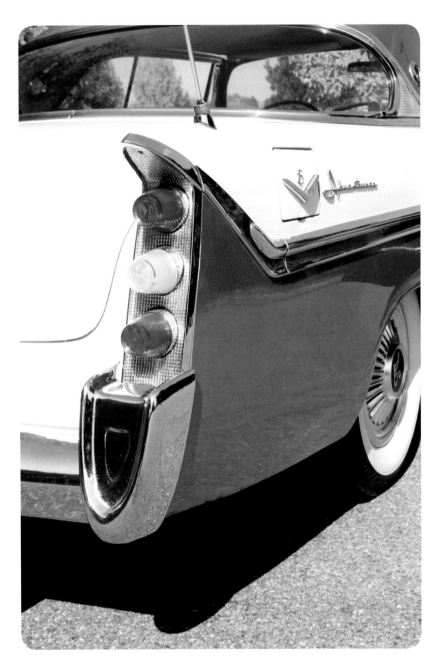

painted on the rear side panels that spearheaded to the front. The roof often matched as well. Stunning gold vinyl upholstery, accented with black and brown metallic tweed seat inserts, made the interior something to behold. There was also a gold and white steering wheel, accented dashboard, and plush black carpeting, with gold thread woven in, to complete the distinctive look. It is certainly no wonder why the car was known as the "Golden Adventurer." The Jet Age captivated the public, and the Adventurer boasted the futuristic-looking PowerFlite push-button automatic transmission. Dual radio antennas on the slightly finned rear fenders carried out the road rocket theme. Rare and interesting modern options included the so-called Highway Hi-Fi under-dash record player, and even a clock in the steering wheel hub.

This hardtop is a heavily optioned and superclean original car with only 56,000 miles. It rides and drives like new. Except for detailing, it hasn't been touched. The advertising slogan for the DeSoto and the Golden Adventurer summed the car up perfectly: "Lovely to look at and delightful to drive!"

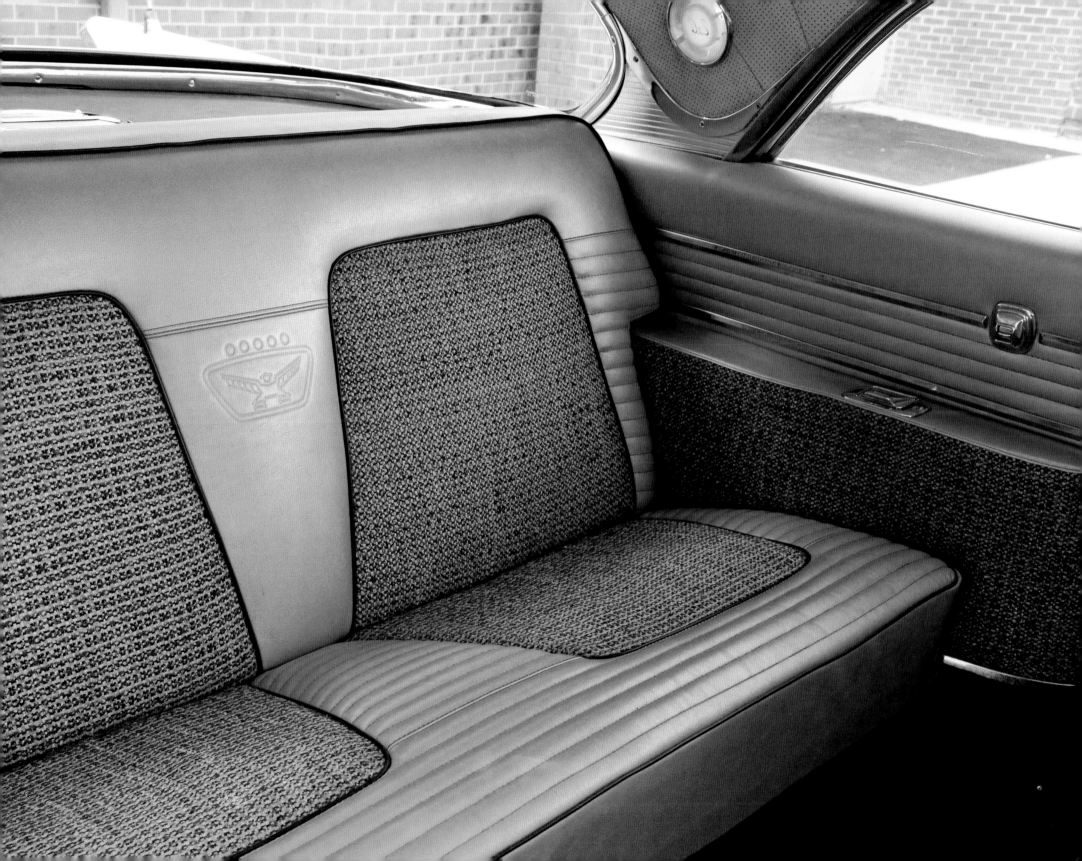

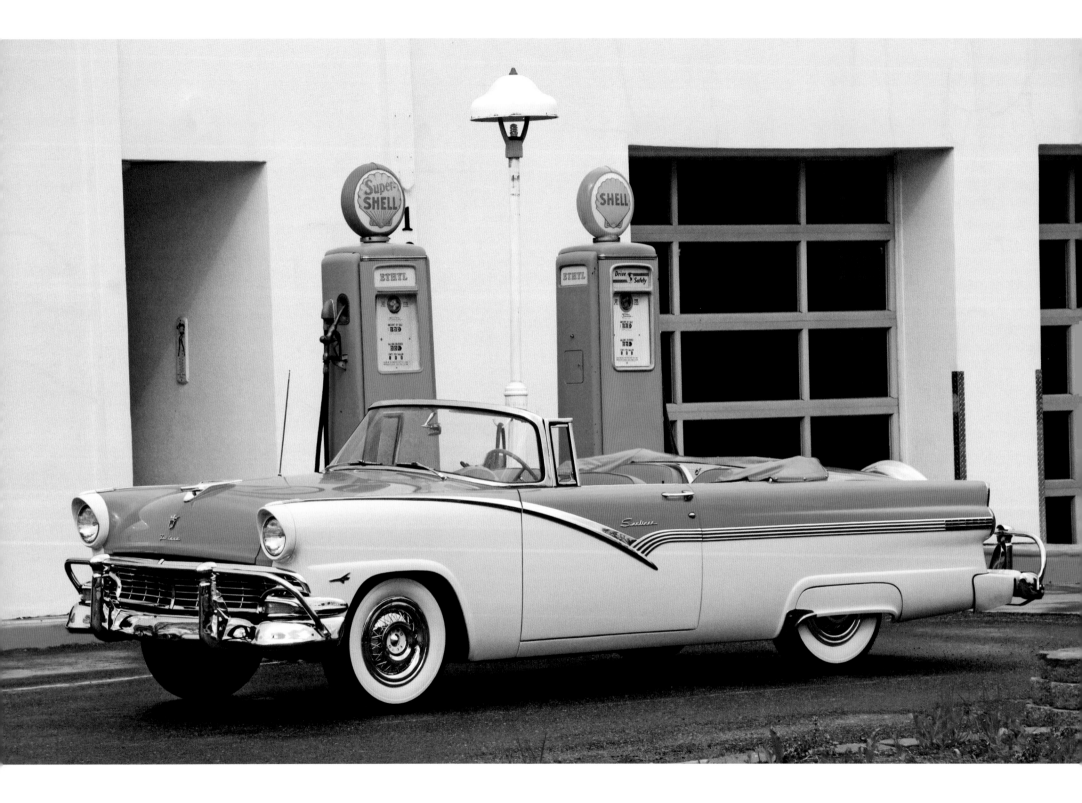

1956 FORD FAIRLANE SUNLINER CONVERTIBLE

The new '56 Fords didn't look much diffeent than the '55s; they only had a mild face-lift on the front, with an updated grille, new rear end trim, and an all-new interior. The new push at Ford was on safety features touted as "Lifeguard Design." There was the inset, concave steering wheel, breakaway rearview mirror, padded dash, sun visors, and crash-proof door locks. Factory optional seat belts (one of the first to be offered) were available as a dealer-installed option for another $9. Even though fairly evolutionary, the buying public was not convinced about seat belts, and in 1956 this option was a slow seller. It wouldn't be until 1968 that the first states began mandatory seat belt requirements. In 1956, Ford continued with their panoramic, wraparound windshields.

This afforded the driver a clearer view of the road ahead instead of letting visibility be impeded by a more forward located roof and windshield supports.

The Fairlane was Ford's top-of-the-line car. The Sunliner convertible came with several engine and transmission options, varying from a 223-cubic-inch Mileage Maker in-line six-cylinder all the way up to the Thunderbird 312-cubic-inch V-8 with its four-barrel carburetor, which gave out 225 horsepower. The Fairlane was a solid, tightly put-together car, far better than Chevrolet that year. The entire Ford model lineup was named "Car of the Year" in 1956 by influential *Motor Trend* magazine.

This car was lovingly restored by Ron Dunne of Shenandoah,

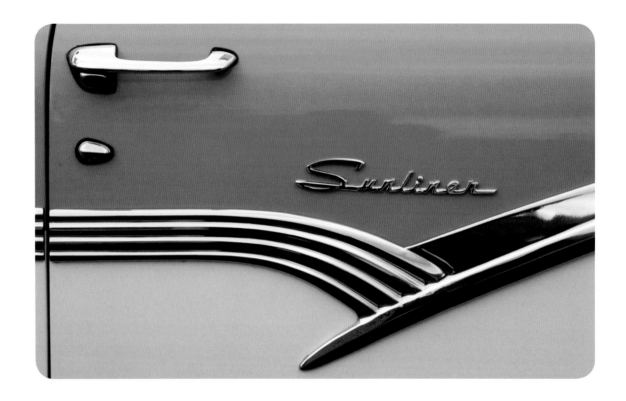

Iowa. He, his son, and a friend spared little effort. No detail was too small to tackle, no repair not made. In a letter he wrote after I bought it at auction in 1992, he said the whole family sat and cried at letting their beloved Sunliner convertible go to a new home.

This is a lovely car, with an attractive color combination, rear fender skirts, front and rear chrome overrider nerf bars over the bumpers, and that flashy Continental kit on the rear. It's a knockout.

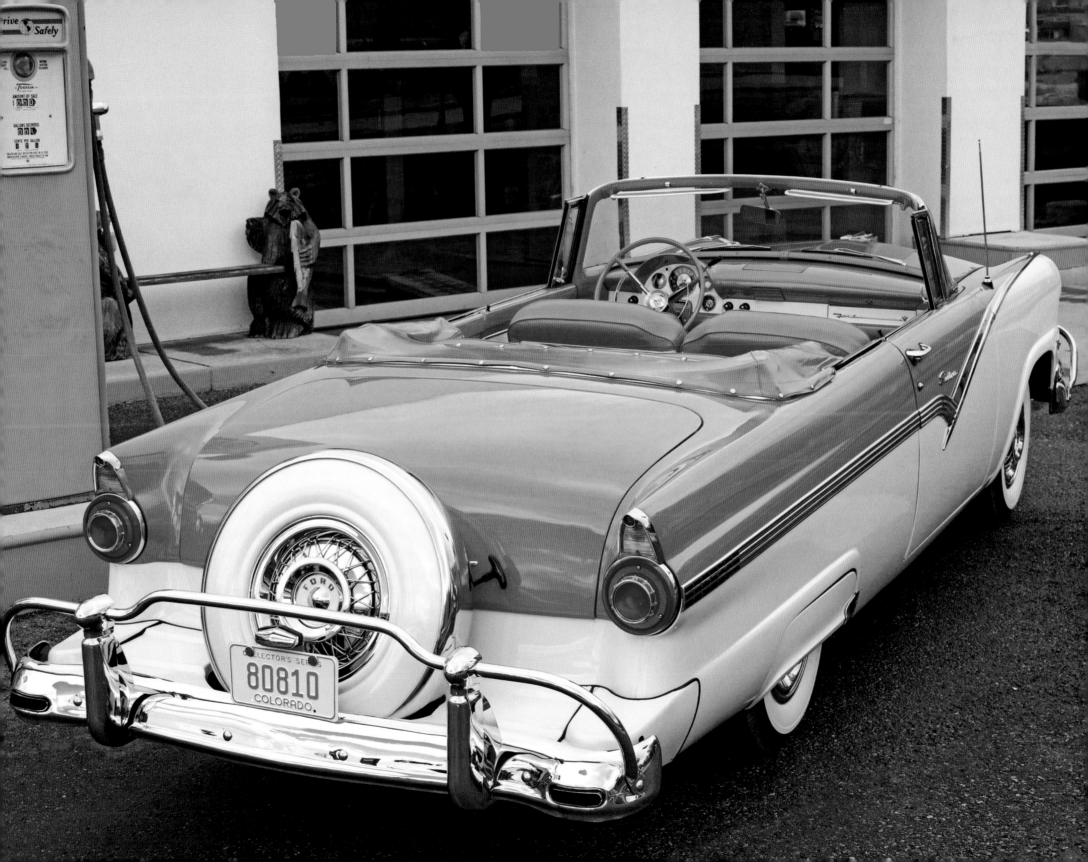

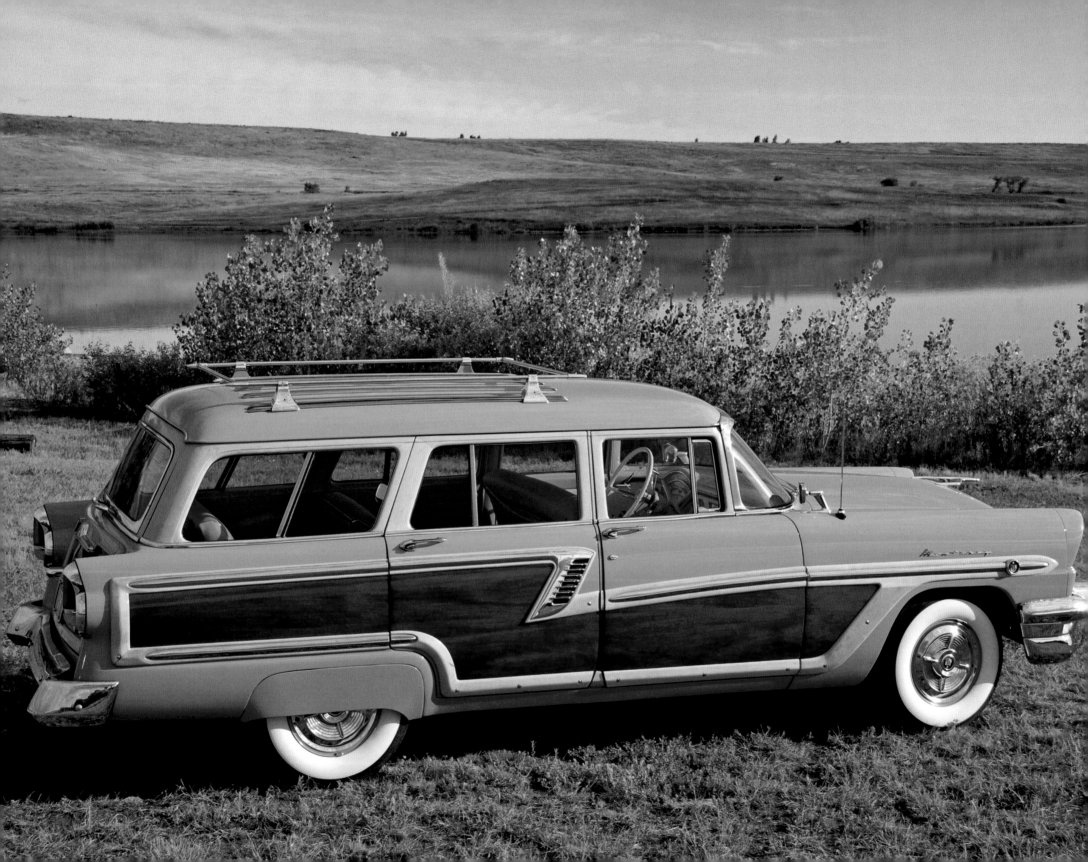

1956 MERCURY MONTEREY WOODIE STATION WAGON

The new Mercury for 1956 was basically a makeover of the '55s. The Monterey station wagon was Ford's top-of-the-line wagon. Except for a toothy grille, a set of dual bumpers on the front, and a ritzy Z-shaped side molding that separated the two-tone color combinations, there was little difference. The V-8 engines were pushed up to 312 cubic inches from 292, which also increased the horsepower to 235 on the upper-end models. The Monterey Woodie Wagon has the-new-for '56 Lifeguard Design safety package. The Mercury also had wraparound windshields, introduced the year before.

An automotive article stated, "Don't argue with a Mercury owner when it comes to roadability." There was no argument. That year, Mercury was the best car for street and highway driving.

My wife Barbara noticed this Monterey eight-passenger station wagon advertised in the *Denver Post* and insisted on seeing it. This was a tired car. The former owner, an elderly fellow, used to drive it back and forth to his gold mine in Montana. It seemed apparent his mine was no bonanza. Barbara bought the car from the man who had taken over the estate after the miner died. This particular Monterey is one

|| 89 ||

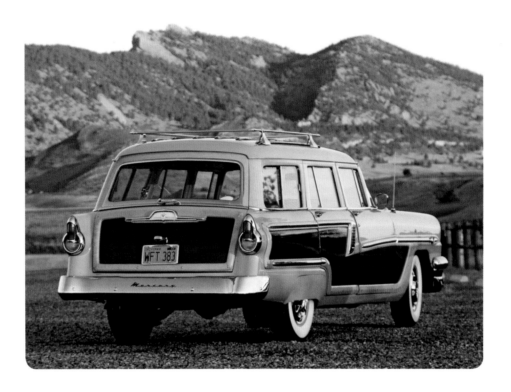

of the only ten percent made with a three-speed standard transmission.

I really got carried away on the restoration. Every screw, every nut and bolt, is new. A specialist on woodie station wagons did a masterful job on the sides, even painting the grain around the windows to look like the real thing. While it may appear to be a mild-mannered family cruiser, this wagon actually packs quite a wallop. The V-8 engine lurking under the hood has an Iskenderian three-quarter race cam and dual carburetors. It'll get you to the fishing hole pronto!

The colors on the exterior and interior are correct, and every number matches. I may be prejudiced, but I believe this is the finest 1956 Mercury Monterey station wagon in the world.

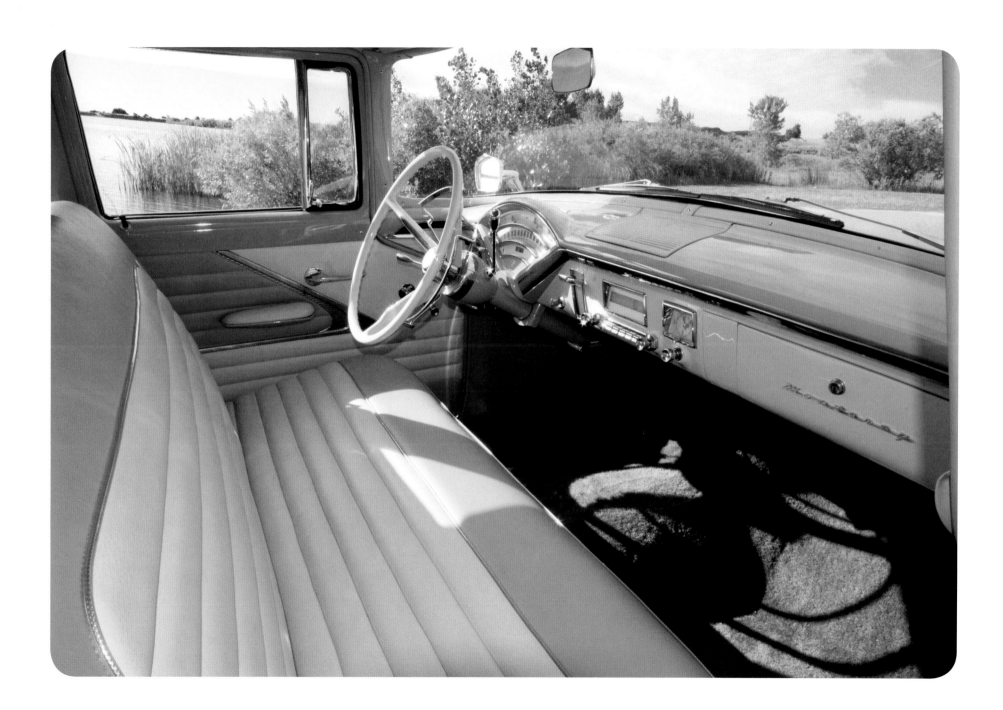

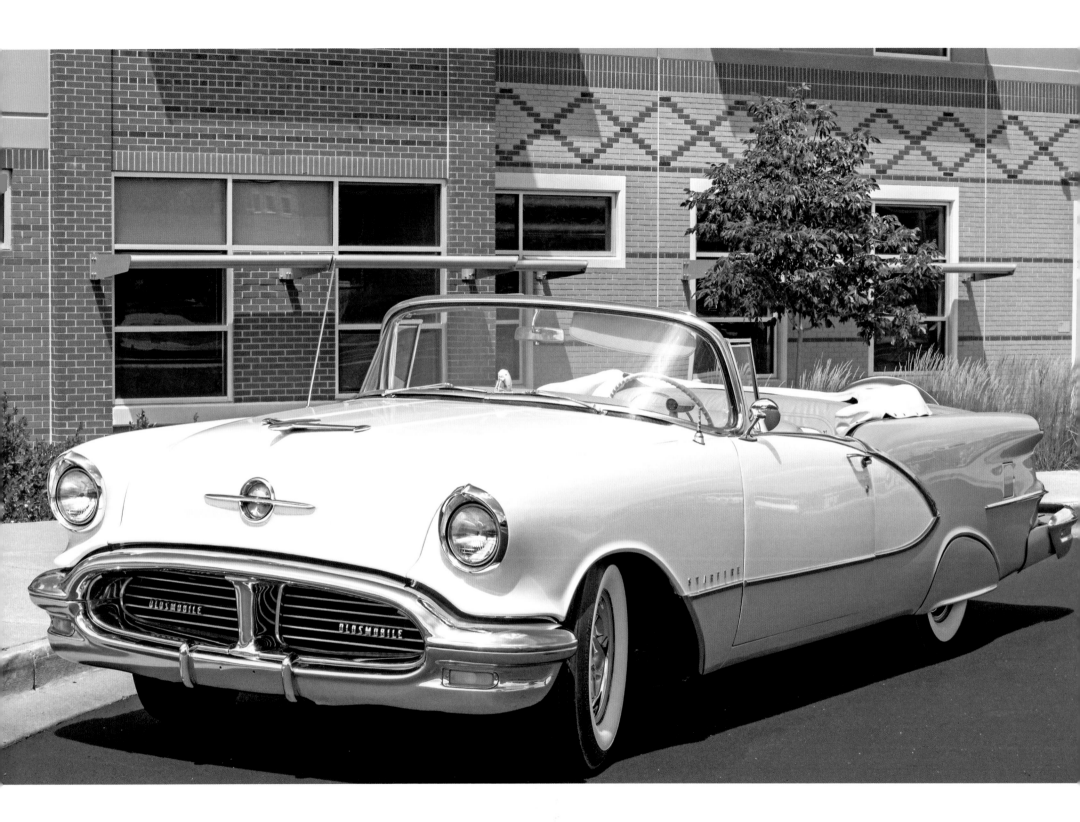

1956 OLDSMOBILE 98 STARFIRE CONVERTIBLE

The original Oldsmobile 98 Starfire show car, named after the Lockheed Starfire F-94 fighter plane, was GM's answer to the American public's fascination with the Space Age. Happily, the classy style of the 1954 Oldsmobile models would persist through '55 to '56, so there wasn't much alteration of style for the newer car. The 98 Starfire convertible added the panache of open-air motoring to the already top-of-the-line, most technically advanced car offered by Oldsmobile in 1956.

Continuing with the "Futuramic" terminology, the Starfire had

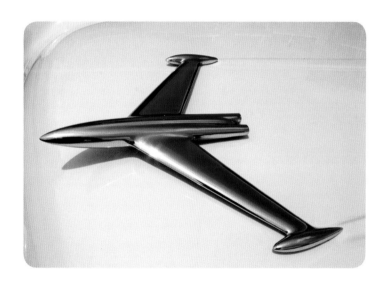

the 324-cubic-inch Rocket V-8 engine with a Quadrajet four-barrel carburetor, putting 240 horsepower to the ground through the "Jetaway" Hydra-Matic automatic transmission. The Rocket V-8 engine's performance was established when an Olds hit 144 miles per hour at Daytona Beach, setting a new Flying Mile speed record.

The 1956 98 Starfire had a huge gaping grille, reminiscent of a North American Sabrejet fighter. Jet Age dashboard controls, wraparound windshield, sleek-skirted real wheel openings, and rocket-tip brake lights must have made the driver feel they were going straight into orbit.

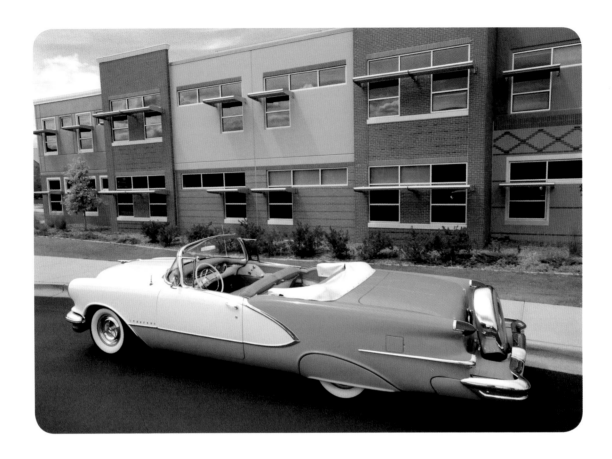

Still, it was a pretty car with a lot of class, and very striking when seen tooling down the avenue.

I purchased this 98 Starfire convertible at the Barrett-Jackson Scottsdale auction in 1989. The lady who sold it was the original owner, and when I approached her after buying the car, she was in tears. It had been a part of her life for over forty years.

It was a daily driver, so perfect and clean, with loads of factory options. I was particularly struck by the turquoise and white color combination, one of the best-looking interiors of the era, and the overall originality. The enhancement of the spare-tire Continental kit is grand. We only had to do some minor cosmetic surgery to make the car look as it had when it rolled out of the dealer's showroom in 1956.

The Starfire name was dropped after this model year. Only 261 Oldsmobile 98 Starfire convertibles remain from 1956.

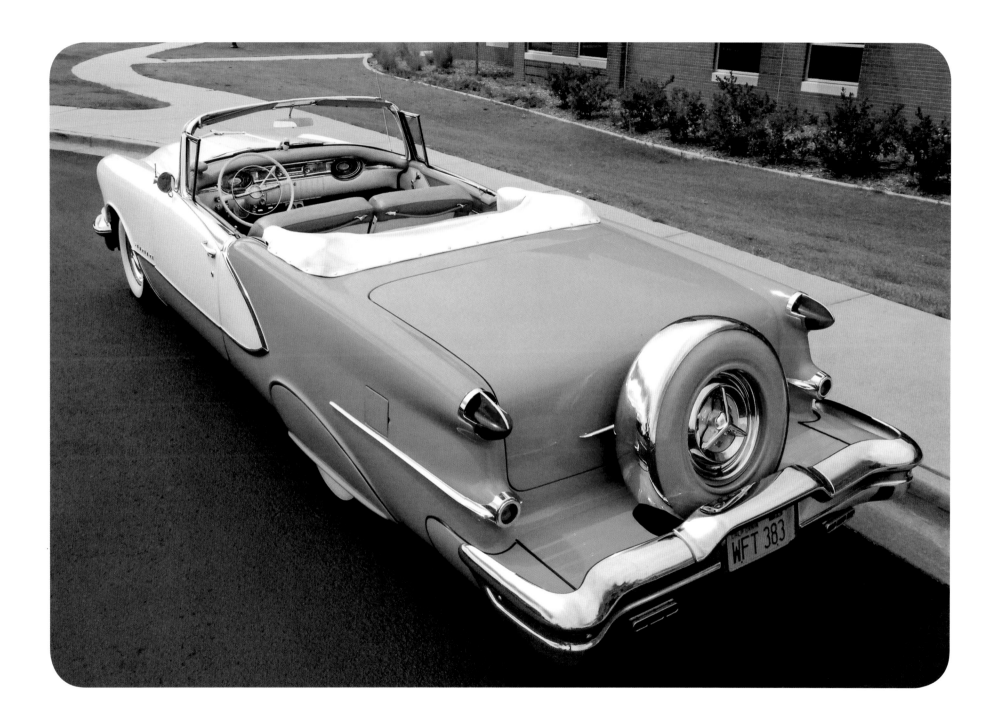

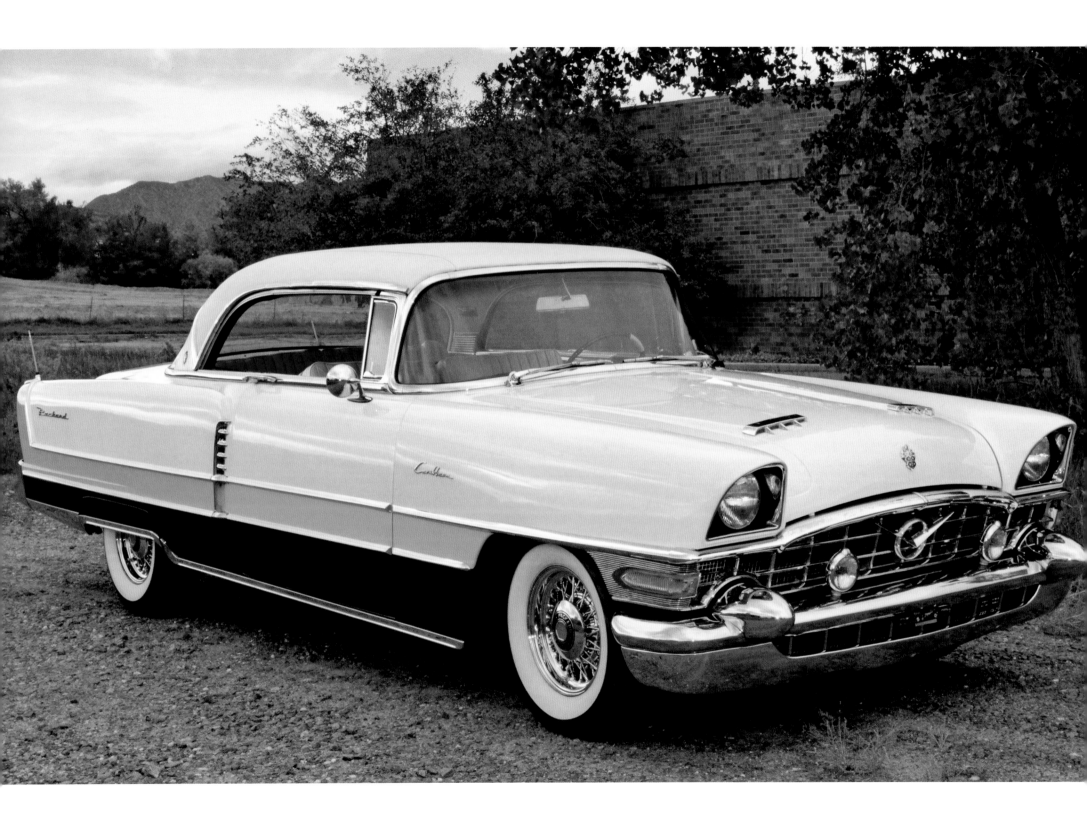

1956 PACKARD CARIBBEAN

This is truly the car, and the car company, that should have never died. Packard was a grand marque, and the Caribbean was a top-of-the-line luxury vehicle having everything going for it, except the company who built it was slowly fading into the mist. Only 263 hardtop Caribbeans came off the assembly line in this final year. To stay afloat, Packard merged with Studebaker, and, of course, neither of the once-proud American car companies survived. The last of the real, true Packards, the Caribbean is an elegant, well-engineered

beauty that elicits melancholy as the last of the breed.

The Caribbean was luxury, from bumper to bumper, and technologically advanced. No slouch on the highway, it was powered by a massive overhead-valve V-8 engine of 374 cubic inches with dual four-barrel carburetors that put out 310 horsepower. It was the most powerful production car in the industry that year.

With push-button transmission and a twin traction, the Caribbean had limited slip differential that was "designed for the fellow

who must drive in all kinds of weather." But the buyer of a Caribbean hardtop never had to worry about the weather. The car had dual heaters and defrosters, even in 1956. The interior space and attention to detail were incredible, and the posh seats were quite unique—rich leather on the doors and trim, and reversible seat cushions with leather on one side and an elegant brocade cloth on the other. These could be unzipped for cleaning. A novel idea!

And this Packard drove beautifully. It rode on an automatic load-leveling system that raised and lowered the ride height with the touch of a button, even while in motion. This made the 1956 model the most comfortable and safest ride of her time. But for all the power, all of the luxury, and all the automotive technological advances, the Packard Caribbean will be remembered for its paint. Its *pièce de résistance* was its unique three-toned exterior color schemes, the only car to have such a signature.

It's easy to call the Caribbean a product ahead of its time. Today, they are sought after as collector cars. Fully restored, they bring high prices in six-figure amounts.

I found this car in an advertisement in *Hemmings Motor News.* It belonged to a doctor in Boulder, Colorado. When I arrived at his home, the Caribbean was sitting in the driveway, under a sparkling sun, glowing like a mirrored ball over a dance floor. Three kids were sitting in the backseat, crying. The mother had tears too, while the father looked grim. After I gave him the check and made ready to load the car in a trailer, the kids really put on a show and refused to leave the back. I asked the father if he really wanted to sell the car. He pulled me aside and softly said that he had bought a Rolls-Royce Phantom I Limousine de Ville and hadn't told them yet. He meant to surprise them when it showed up the next day. I nodded and told him they didn't know how lucky they were and proceeded to drive the car into the trailer with the three kids still bawling in the

backseat. Only when a friend of mine and I began to shut the trailer's back door did they jump out and run to their father, begging him not to sell the Caribbean. Aware of the circumstances, I no longer felt as if I was abducting the family dog, knowing the kids would forget the Packard as soon as they saw the Rolls.

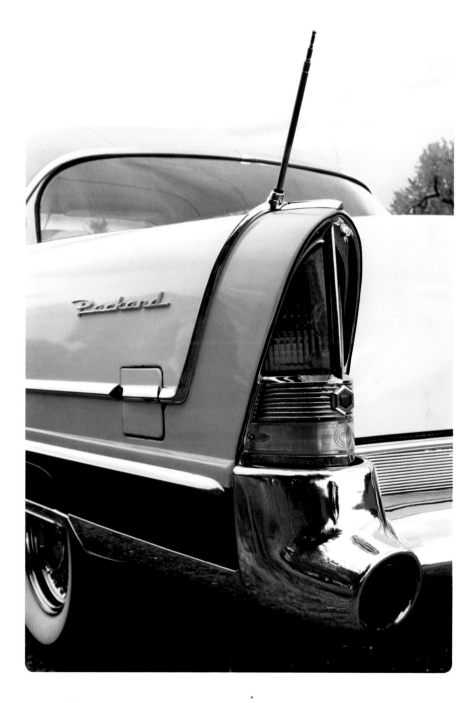

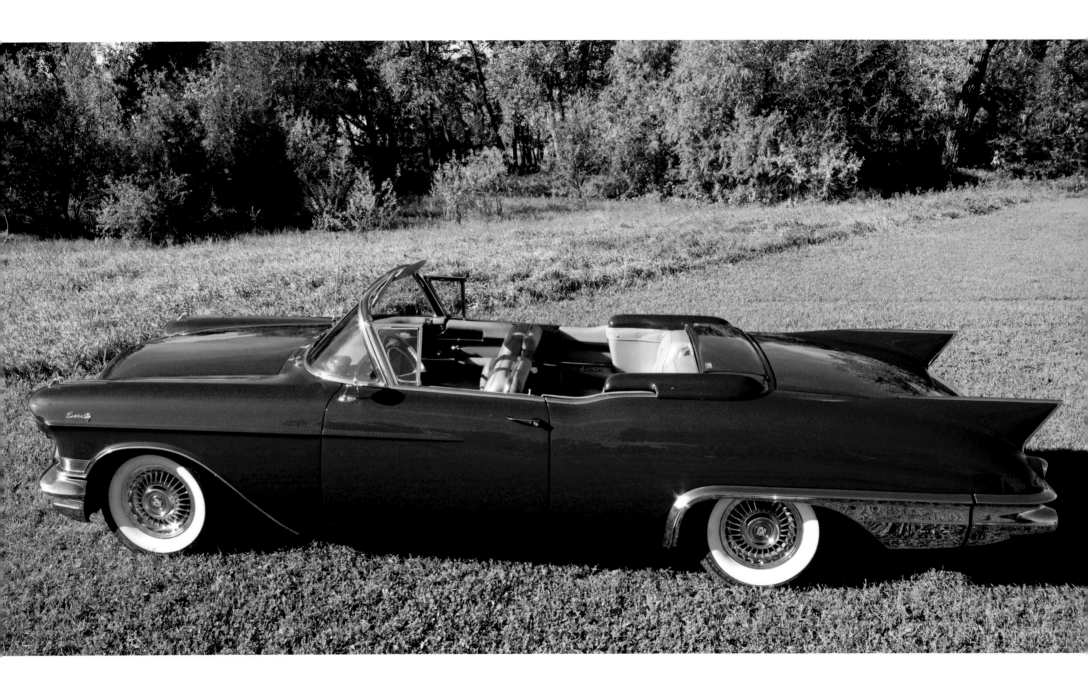

1957 CADILLAC ELDORADO BIARRITZ CONVERTIBLE

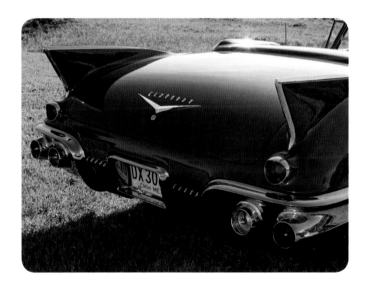

I n my opinion, the 1957 Cadillac Eldorado Biarritz convertible is the most sensuous and ravishing car General Motors ever built. The Biarritz was certainly the most opulent Cadillac to date. It was a ride befitting the King of Rock 'n' Roll—Elvis Presley owned one!

Called the ultimate example of designer Harley Earl's postwar styling, this car began with a complete redesign of the chassis, increasing the overall length and wheelbase, adding improved rigidity, and, most significantly, allowing the Biarritz a three-inch-lower ride height. Visually, the Biarritz hugged the road even when standing still. Up front, there were the

"Dagmar" missile-tip bumpers. The designers created a rear end with shark-like fins atop curvaceously rounded fenders that have a hint of a European influence. At the rear of the car, the contoured trunk sloped down to a gorgeous wraparound rear bumper with integrated dual exhaust outlets. Another elegant touch: the fiberglass parade boot, or hard tonneau cover, concealed the convertible top when retracted. Bucking the fender skirt trend, the Eldorado had outrageously large cut-out wheel openings to show off those saber-spoked wheels and wide whitewall tires.

The engine was the most powerful one that Cadillac offered,

enough to launch the 4,930-pound Biarritz. The 365-cubic-inch, 325 horsepower V-8 power plant sported dual four-barrel carburetors that propelled the long, low, luxurious car down the road at up to 118 miles per hour.

I wish I knew the history of this car, but I bought it from a dealer at the Kruse auction in Auburn, Indiana, in 1987, who knew nothing of the previous owners. After being shipped to Pastimes Restoration, it was given a complete frame-up, body-off restoration. The team beautifully recrafted the car, and it looks it. No cost was spared. The color is original, and the leather upholstery is an exact match of the original. It is correct in every way. A masterpiece of automotive engineering art, only eighteen hundred were made.

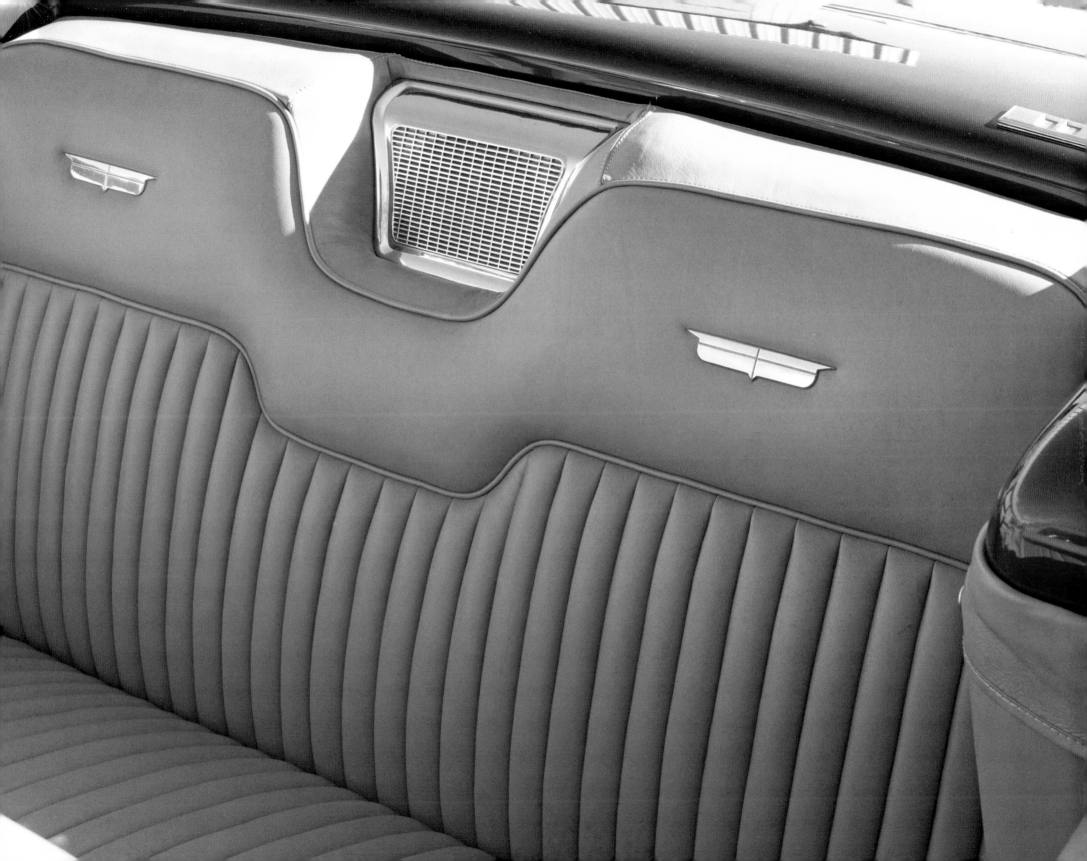

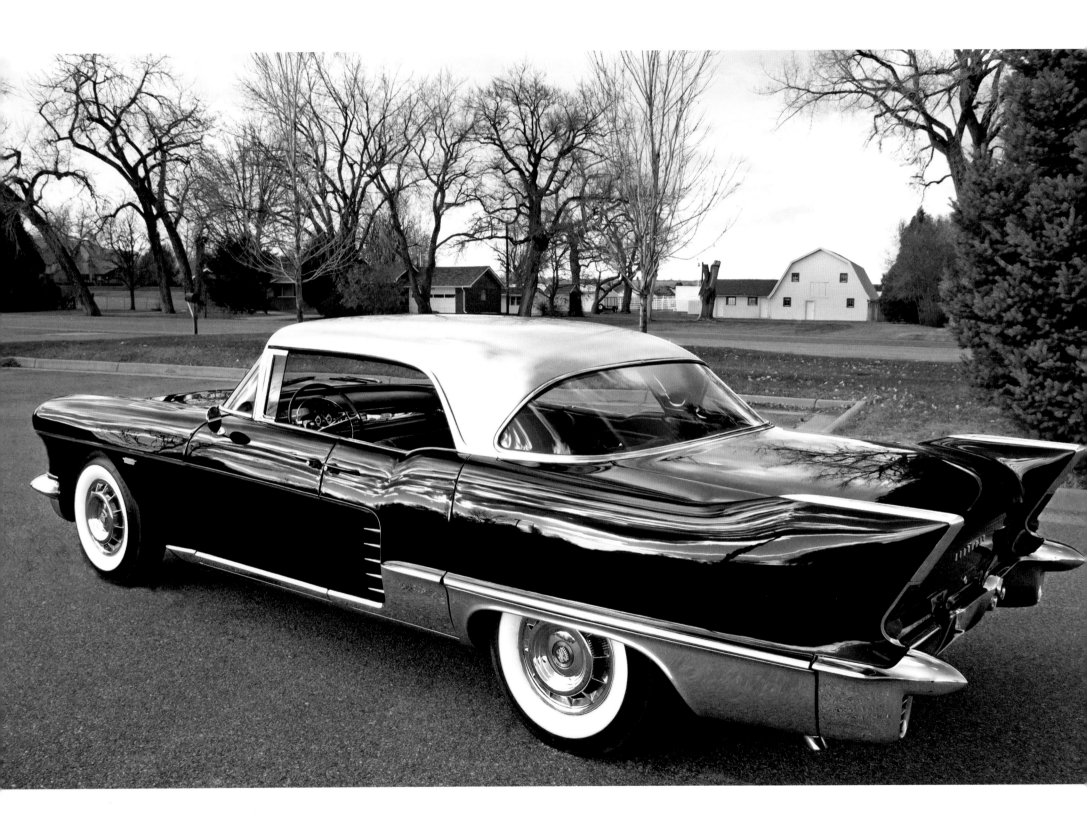

1957 CADILLAC ELDORADO BROUGHAM

Strange as it seems, there really was a car off the General Motors assembly line that cost more than a Rolls-Royce or a Ferrari, though not by much. Nonetheless, the Cadillac Brougham sold for $400 more than a new Silver Cloud. It was the most technically advanced car to ever come out of an American auto factory. The Eldorado Brougham was GM's response to the gauntlet thrown down by the elite Continental Mark II as the best luxury car in the world. To answer that claim and create such a car was costly for Cadillac. It's reported they lost $10,000 on every Brougham built, which is why the original hand-built "Eldo

Bro" was produced for only two years, with only 704 examples made. In 1957, four hundred were sold.

It was the ultimate Cadillac, costing twice as much as the Eldorado Biarritz convertible. Every conceivable complement that could be designed and created was introduced as standard equipment. The list seemed endless. There were thirty-three in all, beginning with the brushed stainless steel roof, only 54 inches high; those unique pillarless doors, opening in opposite directions; an automatic door-locking system; air-conditioning; front and rear heating outlets, with heaters under the seats; tinted glass, and polar-

ized sun visors that darkened when rotated; six front seat power positions, with memory; electric trunk opener and closer; plus, power steering, brakes, and windows; and so on. And then, to top off the luxurious items, a glove box vanity, with six stainless magnetized tumblers, fold-out shelf and mirror, tissue dispenser, cigarette case, and a ladies compact, along with an Arpège perfume sprayer.

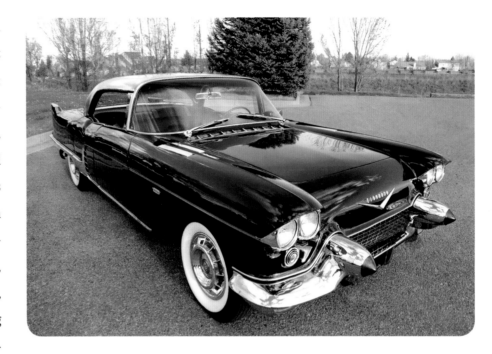

The buyer had forty-five choices of trim and color combinations, available during ordering.

A fabulous and beautifully styled car, the Eldorado Brougham's hood was lower than the fender line, and the roof was lower by four inches than the standard. A compound curved windshield graced the roof, with quad headlights on the front end over huge chrome bumpers with bullet protrusions, referred to by comedians as "dual pedestrian-impaling gear." The low-profile steel and aluminum wheels were embellished with narrow whitewall tires. The wheelbase was a short 126 inches, and the big 365-cubic-inch engine, with dual four-barrel carburetors, put out a whopping 325 horsepower. But the car had its drawbacks; with the complicated suspension, and so much power equipment, it was a nightmare to maintain.

For a long time, Broughams were virtually unknown, and unwanted, by collectors. Fortunately, all that has changed. Beautifully restored examples have long passed the $250,000 mark at auction.

I searched for an original, pristine Eldorado Brougham for over a year before I found one for sale in Iowa. It was so nice that only cosmetic restoration was undertaken. Indeed, the Brougham symbolizes General Motors' high-water mark in luxury automobiles, and I'm proud to say I own one.

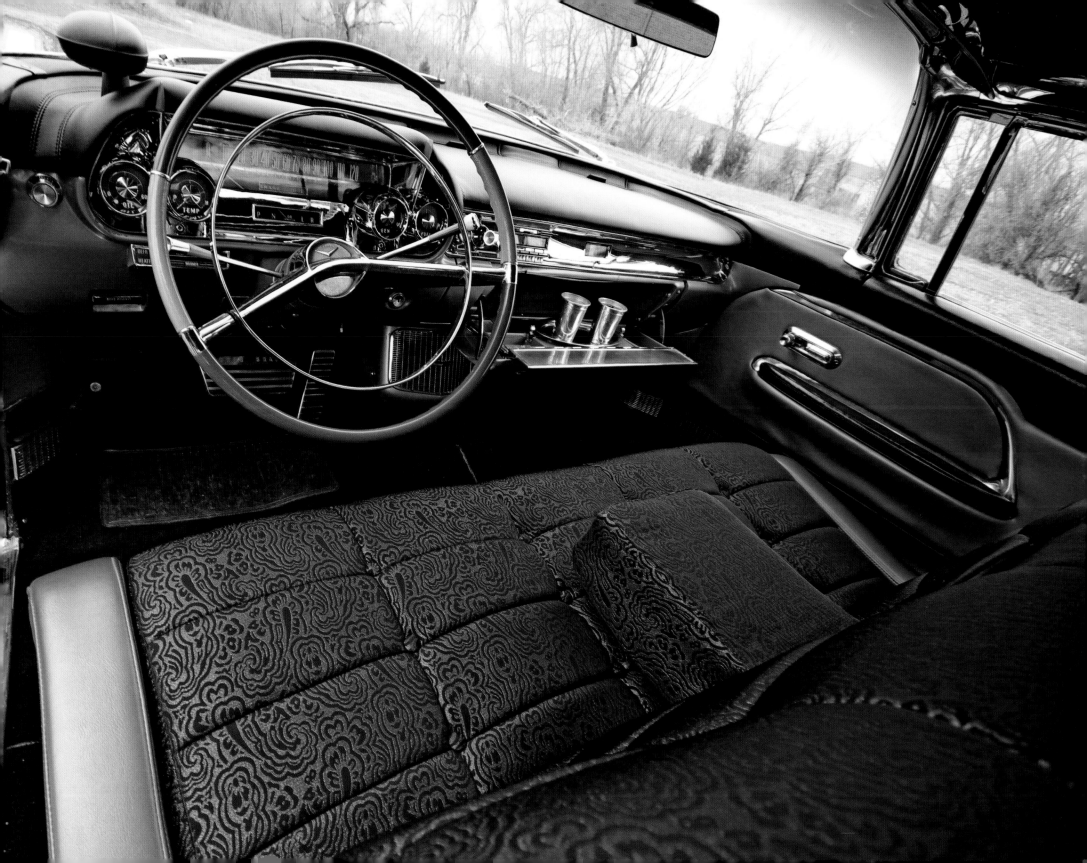

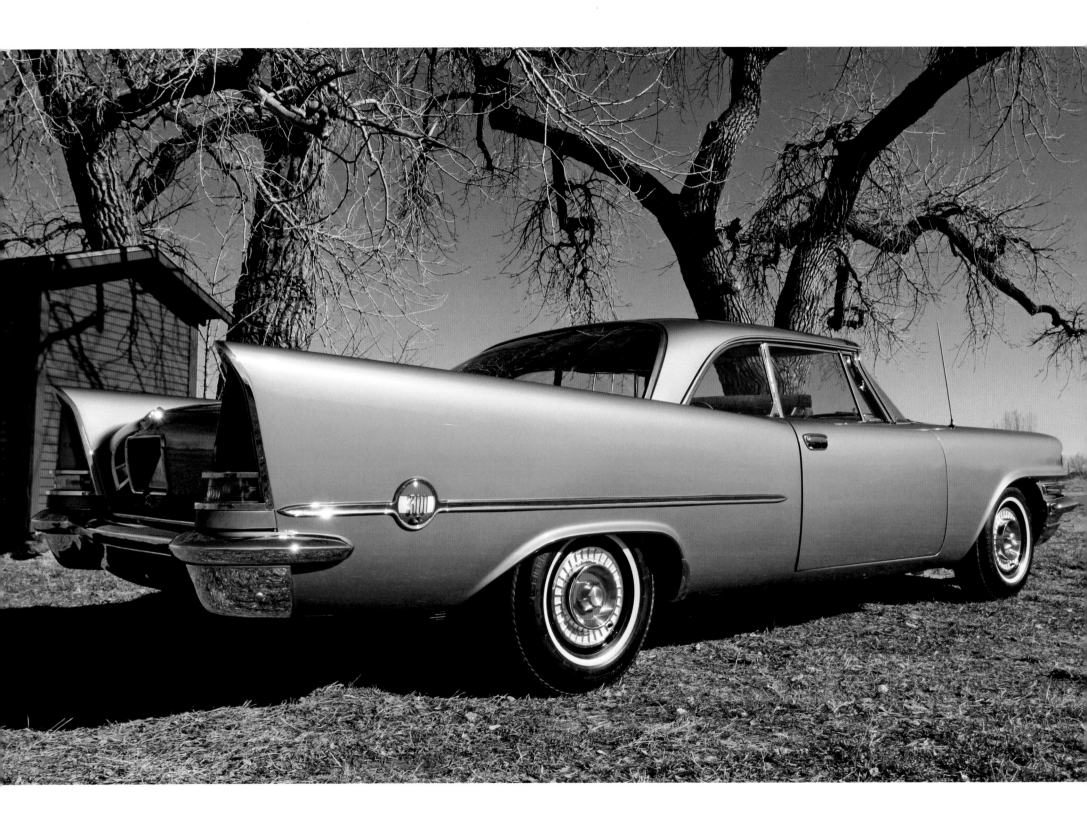

1957 CHRYSLER 300C

f the 1955 Chrysler C-300s looked good, the '57 300C looked even better. The 300C was longer and wider, with an aggressive grille, and sleek, sweeping lines that rose into high, graceful fins. The third in Chrysler's 300 letter series, the C was big, with a mean-looking low stance on the road, and it had it all: excellent handling, power, comfort, and luxury. Generally regarded as America's fastest, most powerful, and best-handling production car in 1957, the C is the absolute pinnacle of the 300 series. This was the ultimate Chrysler produced at

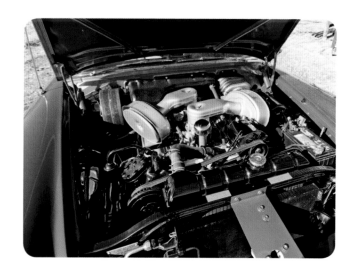

the time, designed and built to outrun the best in the world. Not mass-produced, only 1,918 of these coupes were made.

The Hemi engine went up to 392 cubic inches, and the horsepower for the 300C reached as high as 390. The car just about flew. Torsion bars came along for the first time, softening the effects of road shock and increasing handling characteristics. Push-button controls shifted the transmission. Those distinctive tail fins—or, in Chrysler adspeak, "rear stabilizers"—claimed to reduce crosswind buffeting. It was a real rocket

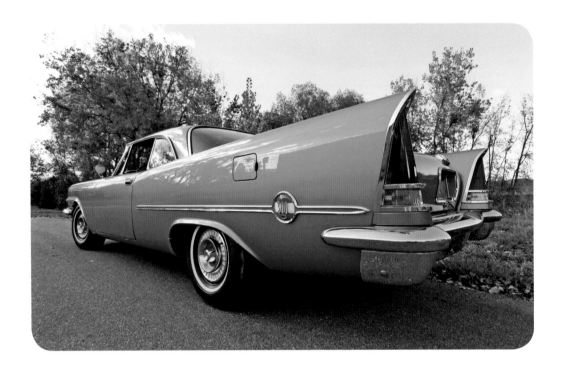

sled. Chrysler's debut of the 300C was at Daytona Beach, where the new car won the Flying Mile with a top speed of 134 miles per hour. I bought this car, in 1990, from an elderly fellow in Colorado Springs who had owned it since new. He had just had the engine totally rebuilt, and it runs like the wind. Pastimes restored the car from the frame up; everything is new. It has the original, and fairly rare, metallic green color. Regardless of the exterior, all interiors were standard rich tan leather. The car proudly wore red, white, and blue "300C" medallions on the sides, hood, trunk, and interior.

This Chrysler is still one of the best of the 300 hardtops I've seen at shows.

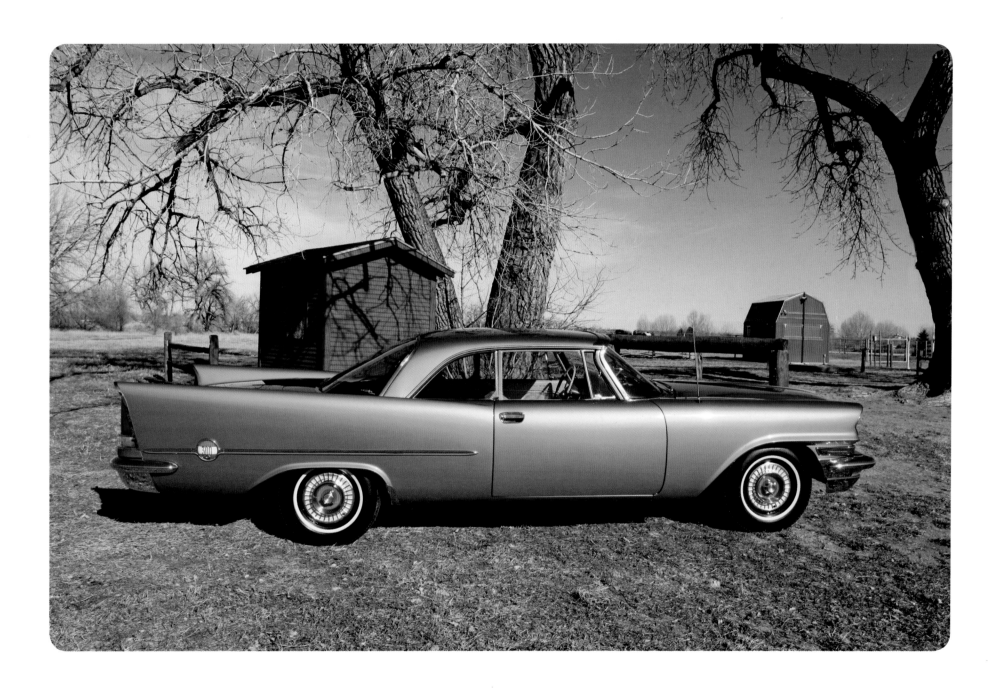

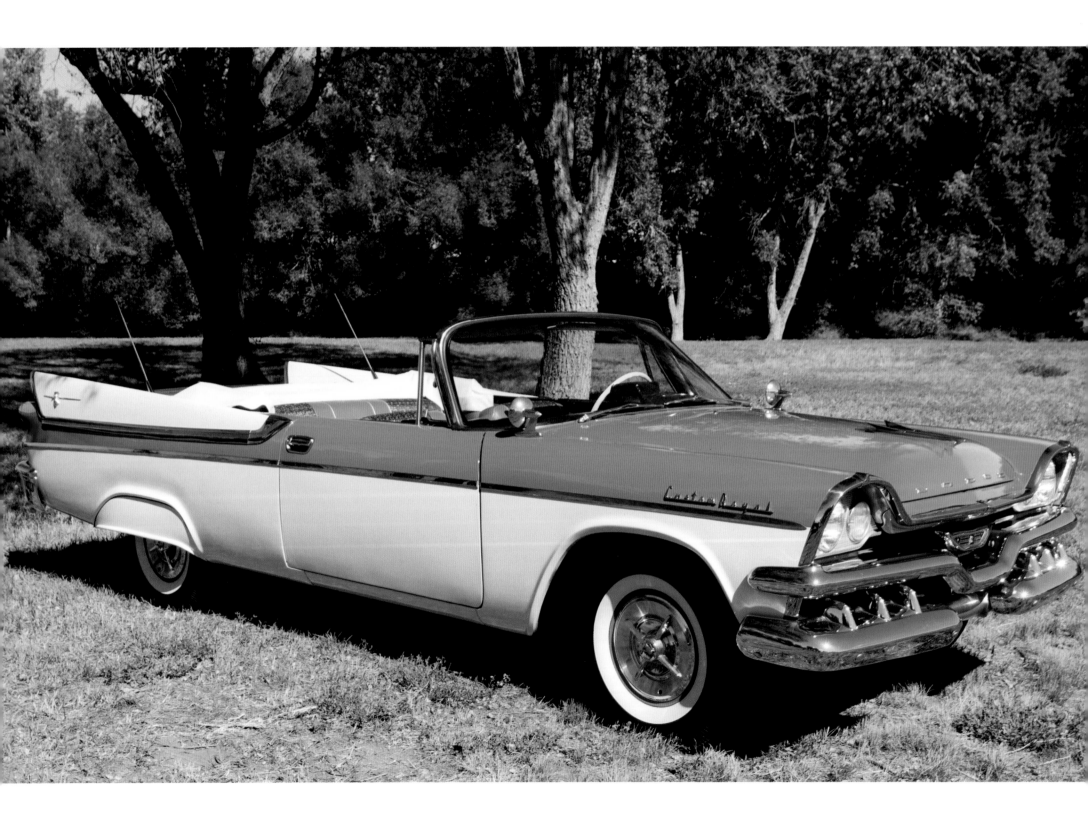

1957 DODGE SUPER D-500 CUSTOM ROYAL LANCER CONVERTIBLE

"Keep your eye on the D-500 . . . It's a real bomb." Not my words, but those of the Dodge advertising agency during 1957. Obviously, "bomb" had a different connotation in those days. The ad copywriters were kept busy dreaming up so many slogans to capture the imagination of the American car buying public. People were fascinated with jet flight and space travel. They wanted to "Step into the wonderful world of autodynamics"—and the new Dodge sure delivered.

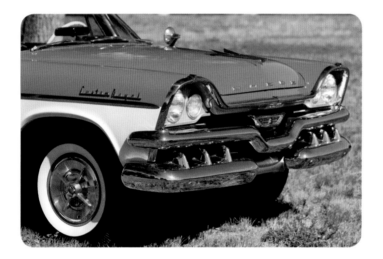

Virgil Exner's design edict for Chrysler, the "Forward Look," encompassed vertical rear fins inspired by the designer's "swept wing" styling. These mimicked the new generation of delta wing jet fighters then breaking the sound barrier. Commercial jet travel was still a dream for most Americans at this time, so effortless, powerful highway travel in a sleek new Dodge convertible was more attainable. Dodge's top-of-the-line model was a step above Plymouth in luxury and performance. The flamboyant Custom Royal Lancer

was, in Dodgespeak, "completely new from road to roof"—and that, of course, meant longer, lower, and wider. The car had a hungry look, with the expansive bumpers, an immense Mono-Grille, Twin-Jet tail lamps, and a modern interior, featuring the push-button Torque-Flite automatic transmission and Scope-Sight horizontal red ribbon speedometer.

This car was equipped with the very rare Super D-500 option, with a 340 horsepower Super Red Ram Hemi V-8 engine with dual four-barrel carburetors and dual exhaust. The D-500 was fast, beating all the competition at the acceleration trials at Daytona Beach.

It is a very rare car; I've only seen two other Super D-500 convertibles. You would have to look far and wide to find one as nice and correct, with the exact match of the original colors and upholstery and other important, correct parts, including dual four-barrel carburetors, with their proper air cleaners. In 1992, I took delivery from a fellow known as "MoPar Mel," who specialized in restoring Dodges.

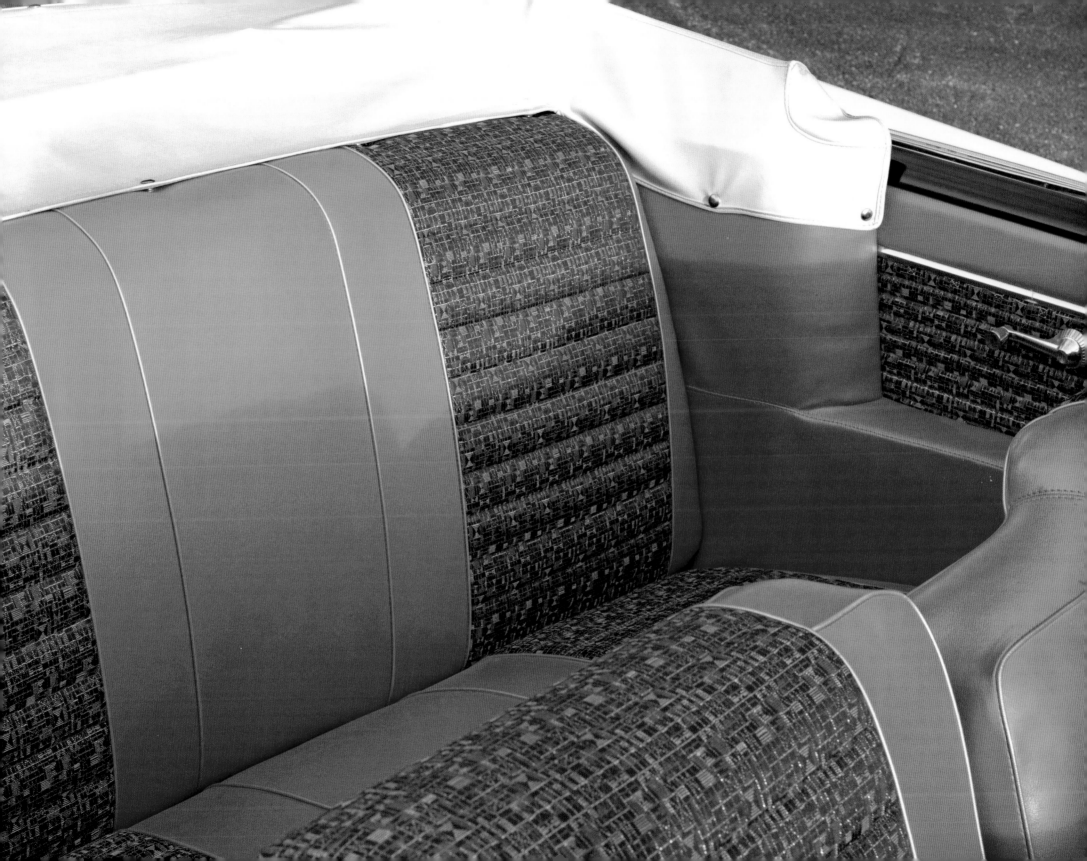

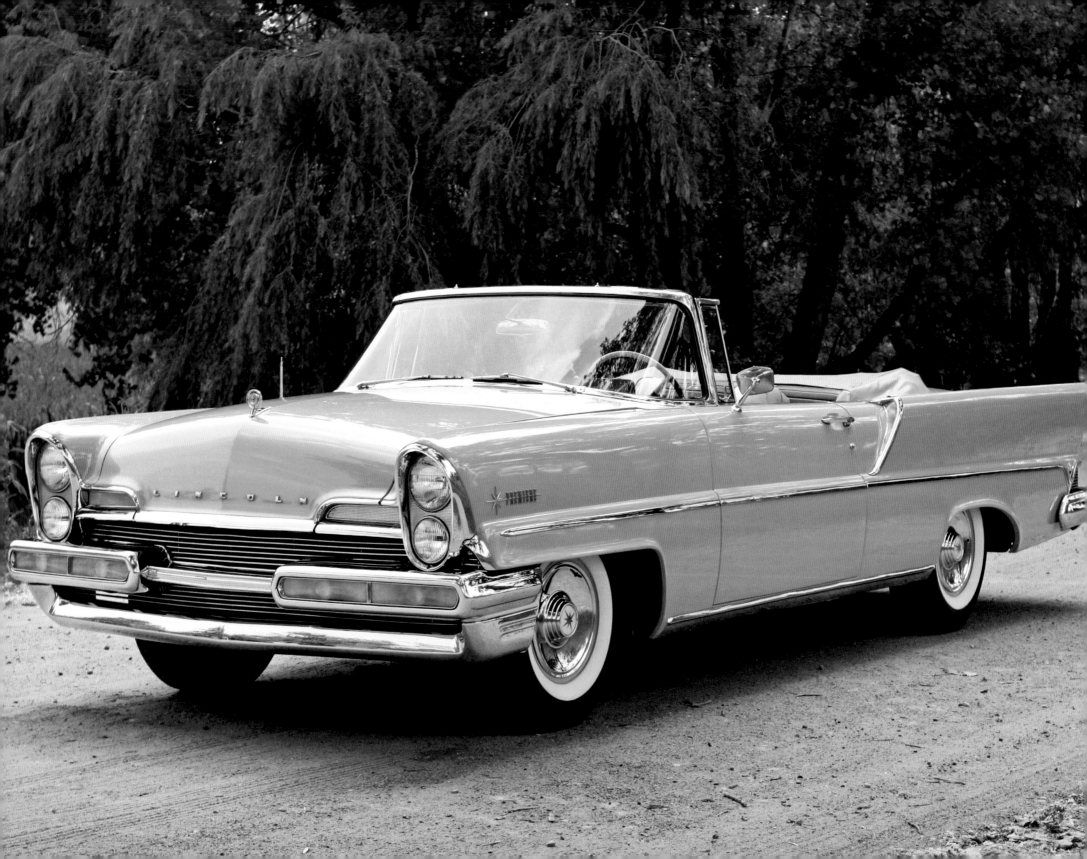

1957 LINCOLN PREMIERE CONVERTIBLE

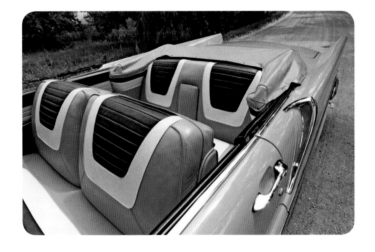

Any way you look at it, the 1957 Lincoln Premiere convertible is a fabulous automobile. It held the distinction of being the longest car produced by an automaker in the industry that year. From its Quadra vertical headlights, with two different-sized lights separately switched, to the massive cantilevered cathedral tail fins that literally cast a long shadow, the Premiere achieved a height of quality that Lincoln would not see again for ten years. The big car had a garnished dignity about

it, though one auto critic said, "The big taillights remind you of a fire in a Gothic cathedral." And, for better for worse, accurate or not, tail fins seemed to define American car design in the fifties.

The 1957 Premiere boasted several luxury improvements, like power vent windows, electric door locks, a six-way power seat, and, a new innovation, the Autronic Eye automatic headlight dimmer, as well as a padded dashboard. There was even the so-called Multi-Luber option, allowing the driver to lubricate the front suspen-

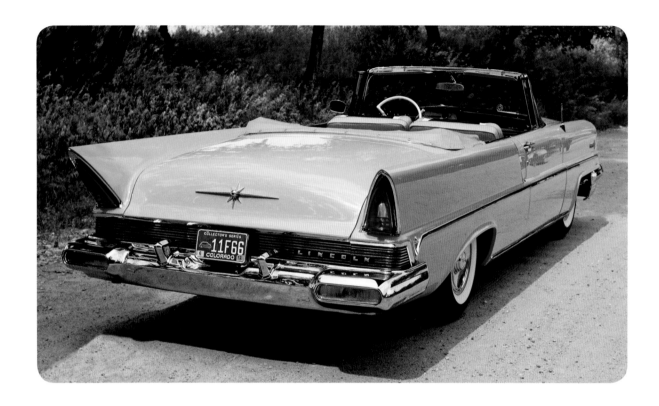

sion at the touch of a button on the dash. The convertibles featured a fully automatic top. All the driver had to do was put the transmission into neutral and push the top up-and-down button. It actually attached or detached itself from the header screws.

A big overhead-valve 368-cubic-inch engine developed a hot 300 horsepower. Strong enough to pump the Premiere to 60 miles an hour in 11.5 seconds. Not bad for a big family car.

I bought this Lincoln Premiere convertible in 1999; it is one of 3,675 built, and very few remain in a condition such as you see here. It was beautifully restored, and I've presented it in several shows where it took first-place awards. With its coral paint motif and elaborate interior, the car is a real stunner.

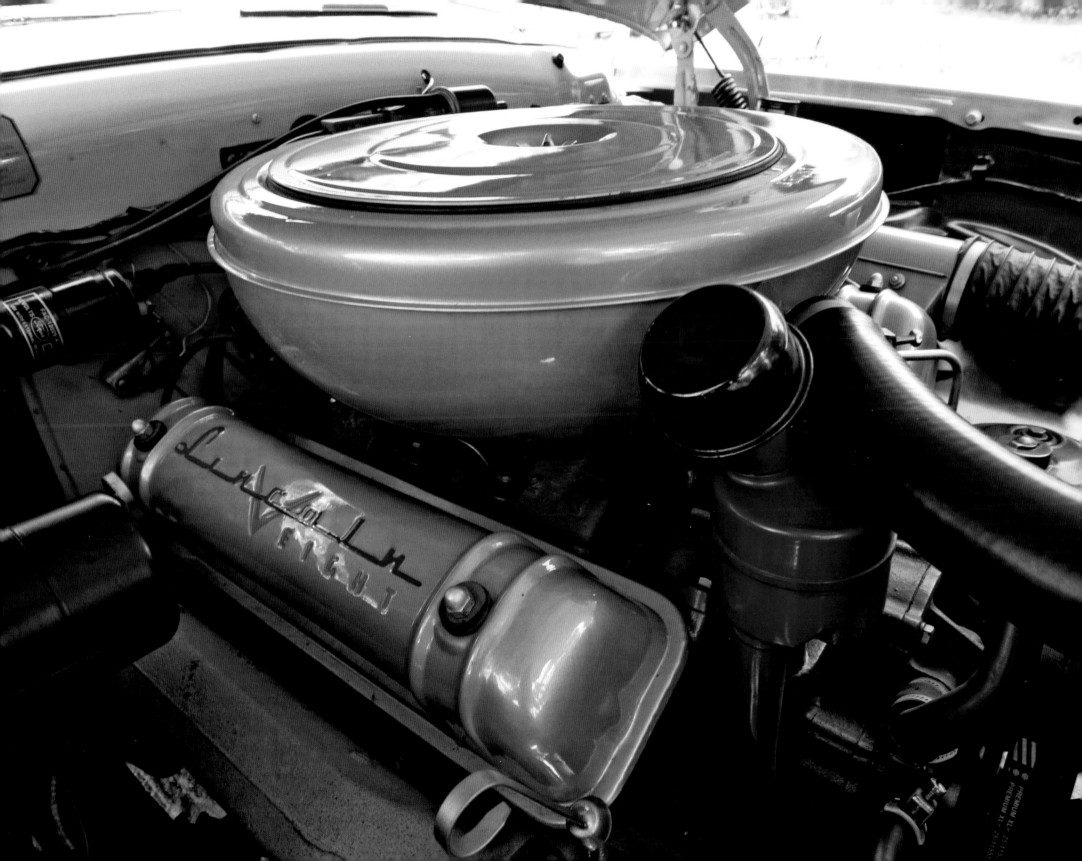

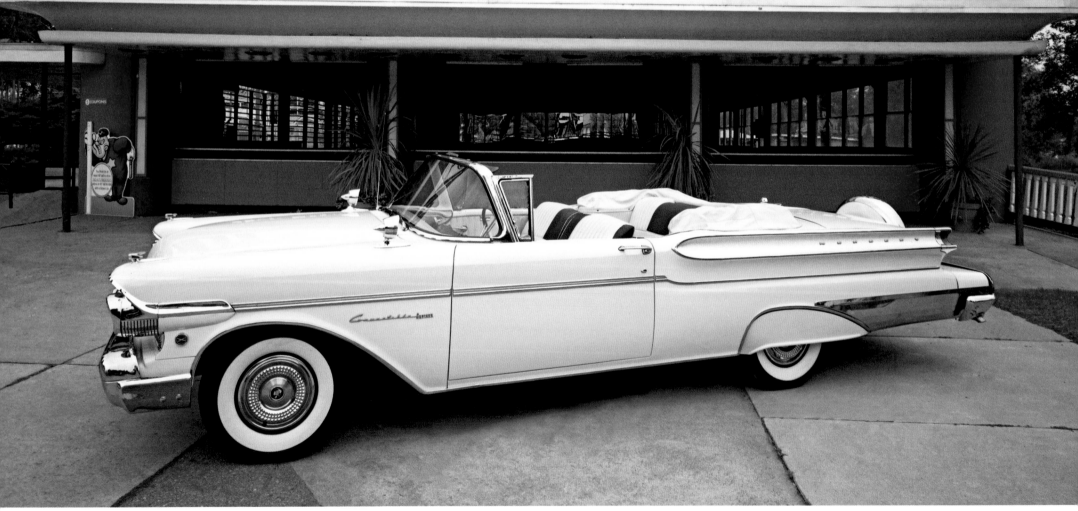

1957 MERCURY TURNPIKE CRUISER CONVERTIBLE

Mercury was always known as the big brother to Ford. It was larger, more lavish, and faster. Mercury's flagship model in 1957 was the Turnpike Cruiser, and the convertible version was honored as the pace car for the Indianapolis 500 race that year. All Turnpike Cruiser convertibles were painted yellow (Sun Glitter), similar to the original Indy pacer, and factory-fitted with a Continental spare-tire kit, or, in Mercury adspeak, the "Dream Car Spare Tire Carrier."

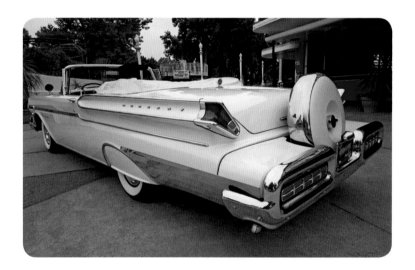

If ever a car was gaudy, it was the Mercury Turnpike Cruiser. The design was totally new, far grander in every way than the 1956 Mercury. It put all Fords to shame in the gadgets and amenities department. A host of mechanical advances were installed, along with the first twelve-volt electrical system and dual exhaust. Other features included the "Seat-O-Matic" automatically adjusting seat, and an average-speed "computer" for short jaunts or long cruises. Several ornaments were positioned

around the body: crossed checkered flags; the god Mercury, with his winged helmet; and gunsight fender adornments that flashed along with the turn indicators. The plush vinyl interior matched the pale yellow exterior, but was complemented with black trim. The massive grille and bumpers would have done an earthmover proud, and

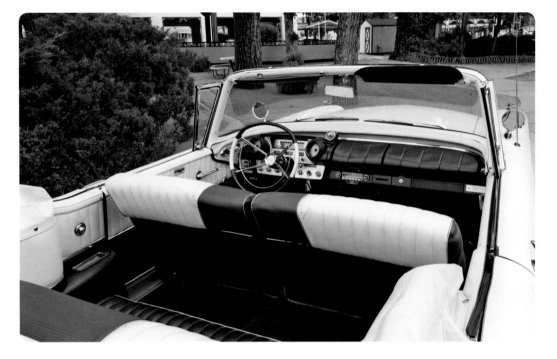

the factory Continental kit extended the rear bumper another ten inches to put an exclamation point to the scale of the car.

The 368-cubic-inch engine muscled out at 290 horsepower, less than competing models from Chrysler and General Motors. However, the Mercury Turnpike Cruiser received high marks from *Motor Trend* magazine for fuel economy (14.6 miles per gallon at 60 miles per hour) and comfort, but, unsurprisingly, low scores for handling.

Mercifully, the Turnpike was soon discontinued, and more stylish models graced the dealers' showroom floors. The car turned out to be fairly scarce with Mercury producing only one for approximately every two and a half dealers. Still, you've got to give it credit, its glitz was unparalleled.

There are few Mercury Turnpike Cruisers around anymore; collectors generally migrate toward the Chevy Bel Airs. I looked for a clean one for almost three years before my friend Dr. Steve Miller of Muncie, Indiana, found one and bought it for me at the Kruse auction in Auburn. It was restored by a former owner and needed very little after it was shipped from Indiana.

She's fun, and it's a pleasure to drive surrounded by so many bells and whistles.

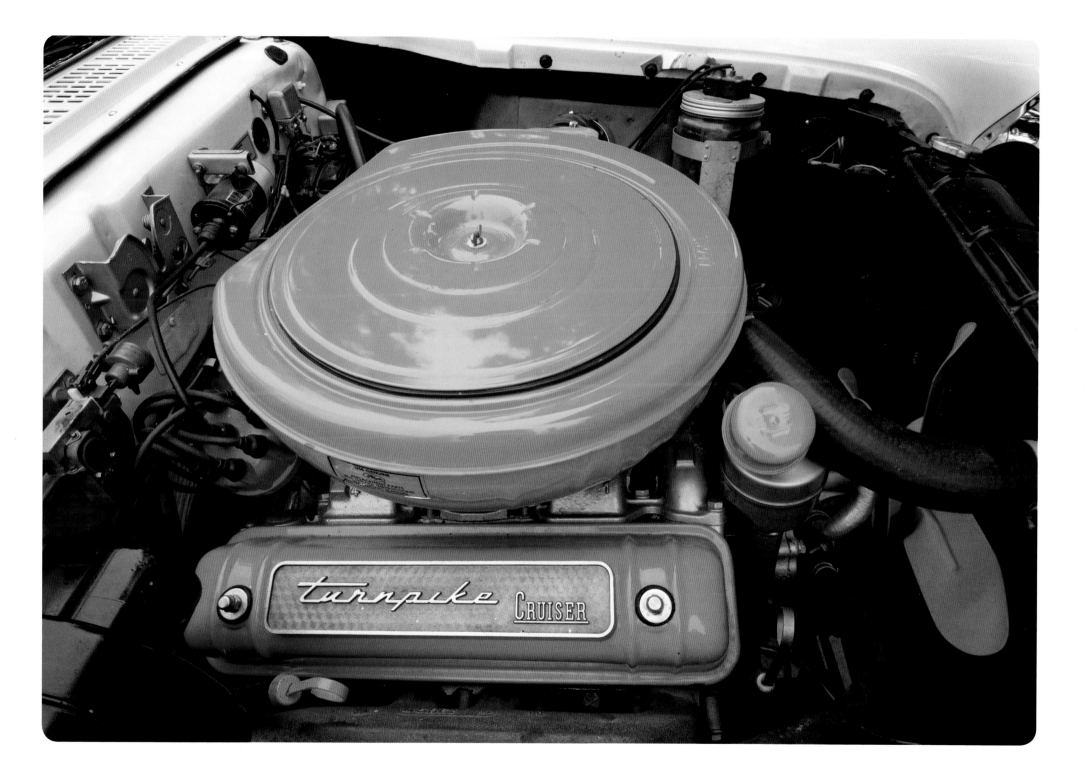

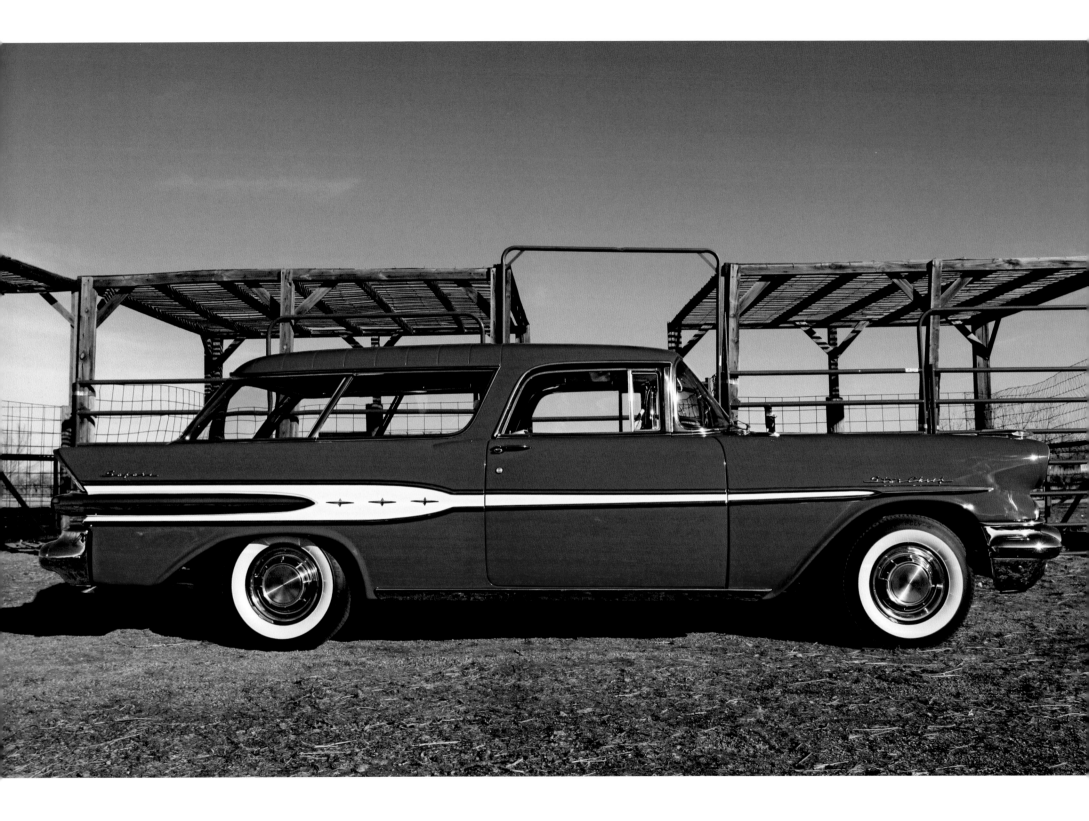

1957 PONTIAC STAR CHIEF SAFARI STATION WAGON

A sought-after fifties collector car that is little known is the Pontiac Star Chief Safari wagon. It was Pontiac's more sophisticated answer to the basic but popular Chevrolet Nomad wagon. The six-passenger Star Chief was the most upmarket version of General Motors' unique two-door sport wagon concept. At a cost of twenty percent more than the Nomad, the Safari was chockful of luxury features, with an exotic interior, and a bigger engine than the Nomad.

Unknown to most, the Pontiac Safari's similarity in design to

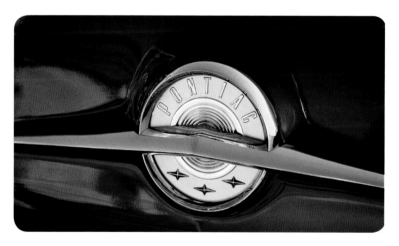

the Chevrolet Nomad was really only skin-deep. They were very different vehicles. Though the Nomad and Safari shared a similar body, the Safari sat atop a longer chassis and had a wider wheelbase.

Propelled by a V-8, 347-cubic-inch engine, spawning a substantial 270 horsepower, it was no slouch at leaving the stoplight. Yet there was a touch of elegance about the Safari. The Nomad may now be in higher demand among collectors, but there is no denying the fact that the Safari is a better-looking automobile. Much rarer than the Nomad, only 1,291 of the specially bodied two-

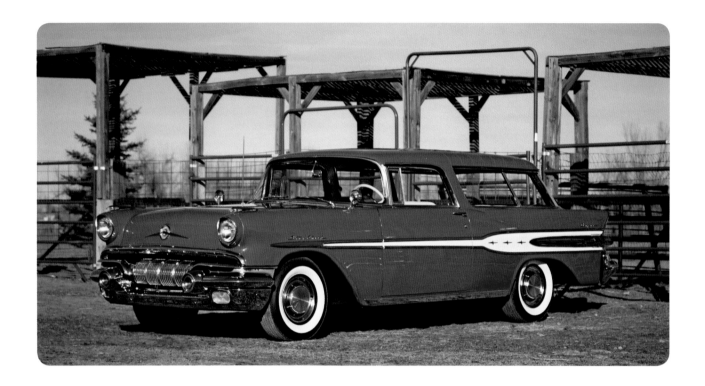

door Pontiac Star Chief Safari wagons were made in '57 compared to the 6,534 Chevrolet Nomads. Only in production three years, the Safari was considered the cleanest and best-looking design of the entire model run.

I bought this sport wagon at auction after examining it closely and being amazed at the quality of workmanship in the restoration. Every screw is new, and those embedded in carpeting of the luggage compartment are all set in the same direction. That's attention to detail. I've yet to see a Nomad of this caliber workmanship.

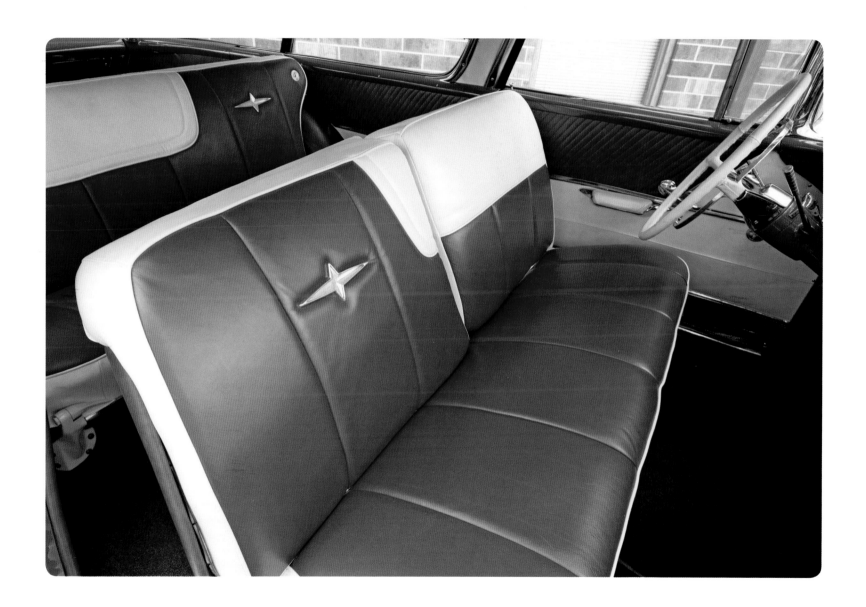

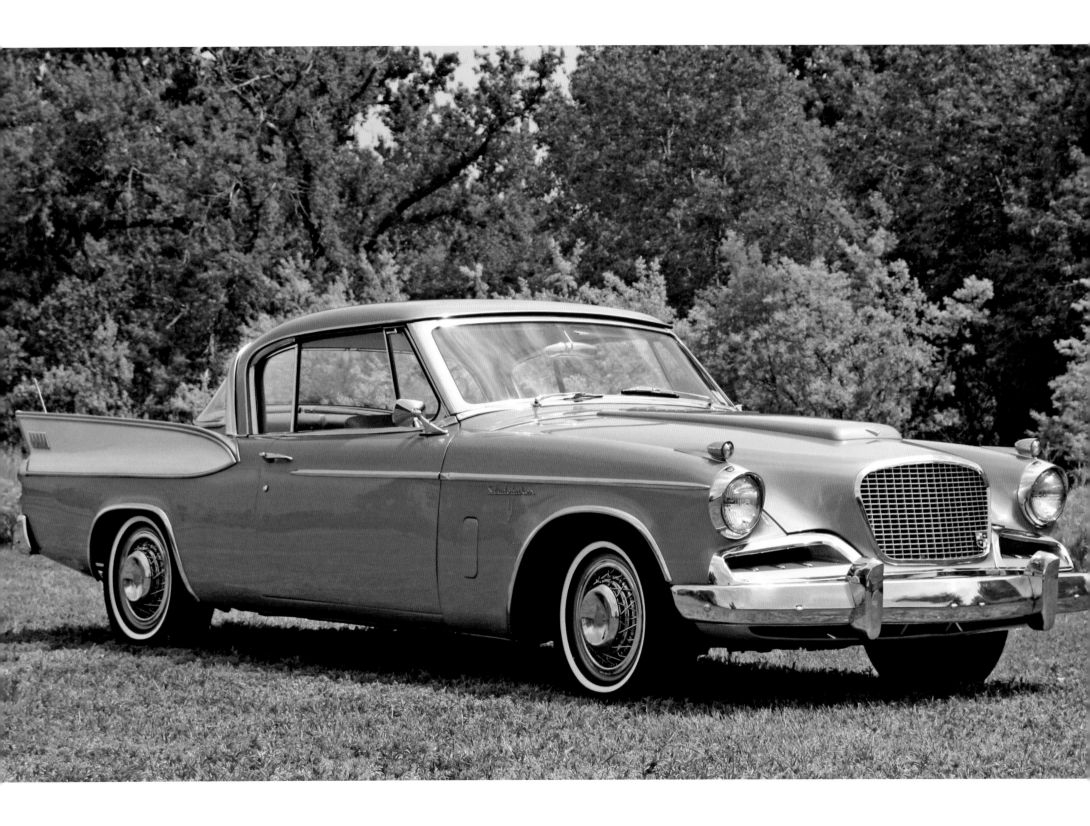

1957 STUDEBAKER GOLDEN HAWK

Retaining the basic body configuration of the handsome and aerodynamic 1953 Studebaker Regal Starliner Commander, the '57 Golden Hawk was the last Studebaker until the Avanti to have styling influenced by industrial designer Raymond Loewy's studio.

The five-passenger Golden Hawk was Studebaker's top-of-the-line, only available with a blindingly fast supercharged V-8 engine to compete with the era's top muscle cars. In a *Speed Age* magazine test, the supercharged V-8 Hawk beat the Corvette, Thunderbird, and the Chrysler 300B in both 0 to 60 acceleration runs and in quarter-mile times. The Golden Hawk was a going machine!

The 1957 Golden Hawk was given a vertical egg crate grille, with a raised hump on the hood to clear the new supercharger mounted high on the engine. This was a necessary change from the original long, swooping hood line. To add insult to injury, where the sleek '53 Starliner had a gracefully sloped rear end, the '57 had raised concave tail fins tacked on to the rear fenders to adhere to the era's ubiquitous design theme. These fins were outlined in chrome trim, normally painted a contrasting color between the chrome strips, and swept out from the sides of the car. Still, the Golden Hawk is not a bad-looking car.

What made the Hawk more beautiful was its performance. The 289-cubic-inch small-block V-8 engine was souped up with a McCulloch supercharger, providing 275 horsepower. It was a potent com-

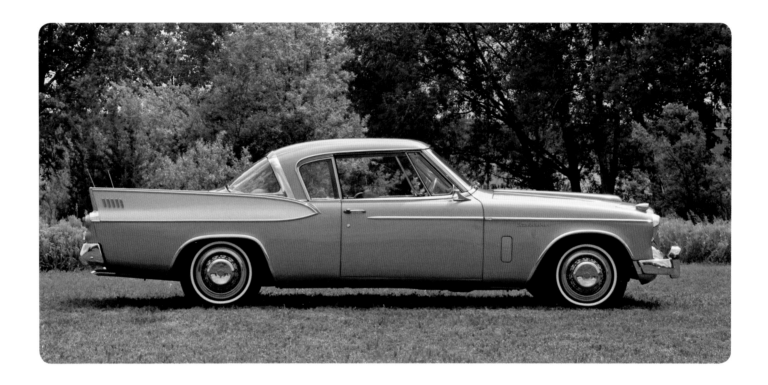

bination that enabled the Studie to smoke all comers. It turned in a blistering 0 to 60 miles per hour in only 7.8 seconds, better than many hot cars on the market today.

This car came off a farm in Ohio—it's true. I had it completely restored, painting it with a festive copper-gold tone and Arctic White. It is plush yet sporty on the inside, with its impressive aluminum engine-turned dashboard. Is it ever fun to drive, blasting away from a light, stunning drivers of newer cars who watch it roar into the distance. Now, that's beautiful!

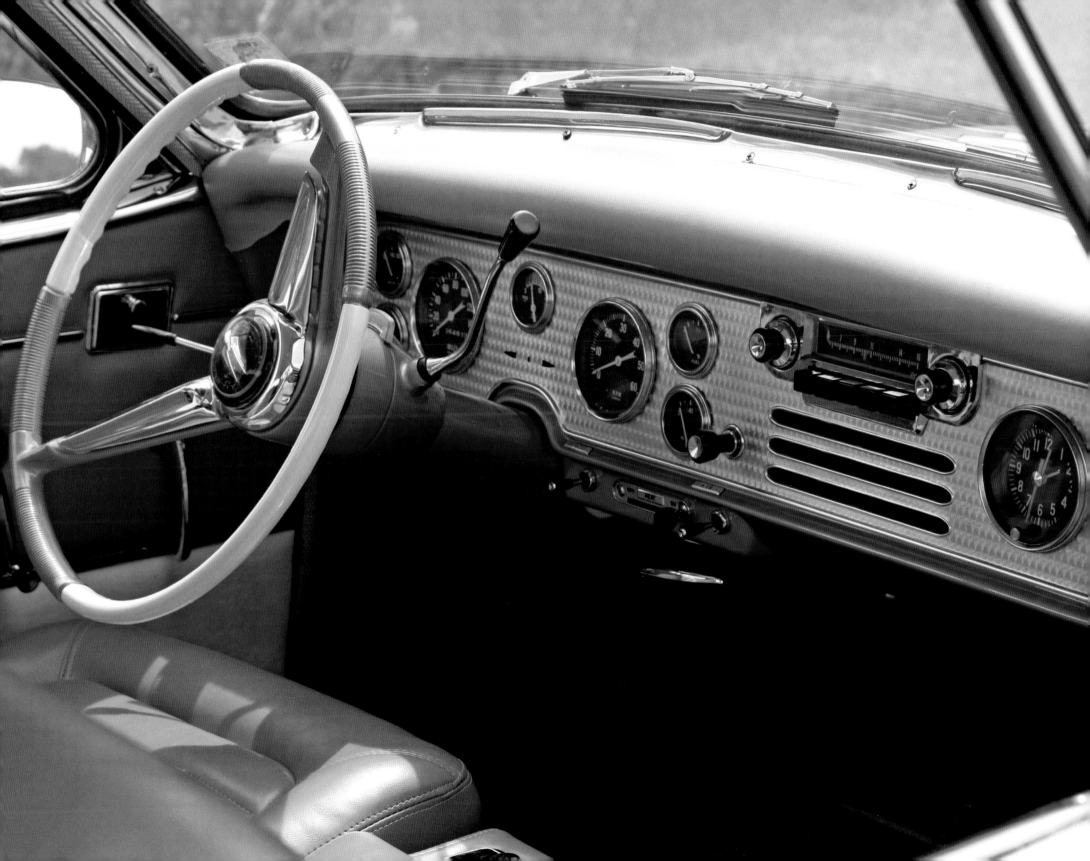

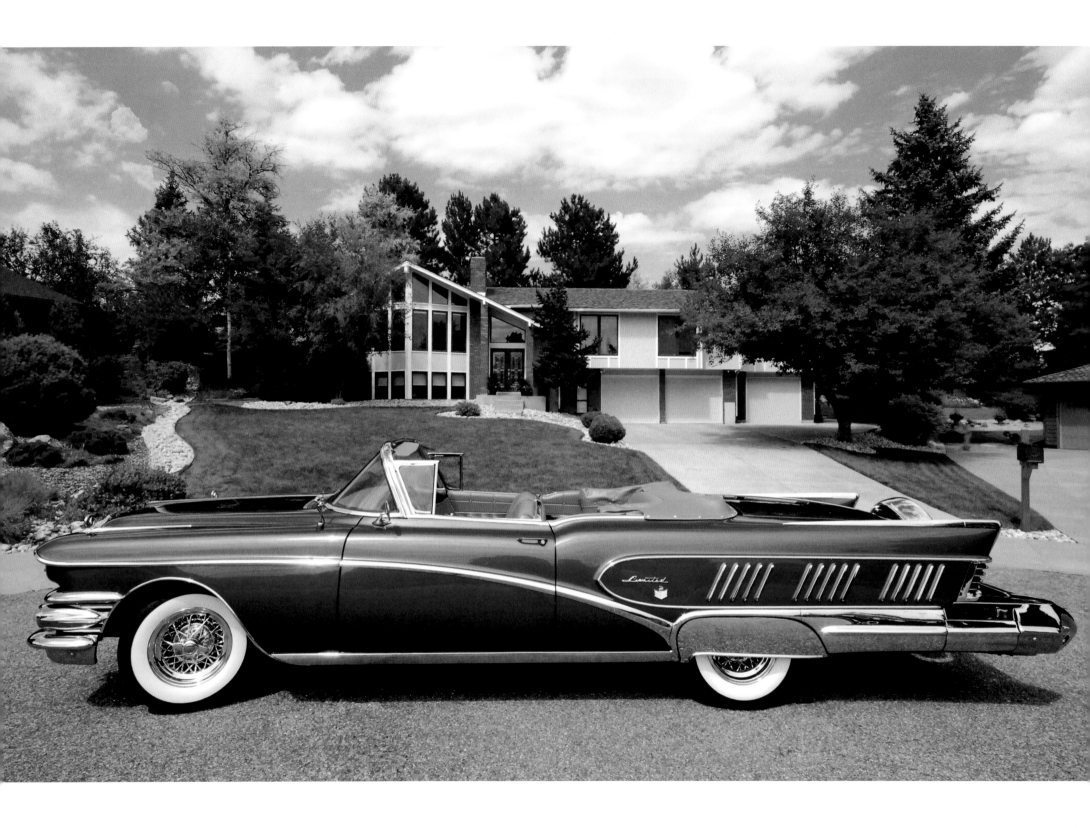

1958 BUICK SERIES 700 LIMITED CONVERTIBLE

If ever a car was created by designers with dreams of grandeur, it had to be the 1958 Buick Limited. The Limited was born in the "Age of Excess," which it exemplified. There was so much chrome, it looked as if it was laid on with a trowel. No more massive bumpers were ever built. The grille looked like the ceiling of a restaurant whose architect never left the bar. Called the Fashion-Aire Dynastar Grille by the admen, it was composed of hundreds of little chrome boxes, which ran from fender to fender. They were

"shaped in a design to maximize the amount of reflective light." That was a priority in 1958. But there is more chrome than that, of course, as you can see.

The Limited was the heftiest, highest-priced, and most opulent monster ever to hit the street in the fifties. This example, with a Continental kit, stretches 22 feet. It is ostentatious magnificence in the first degree.

The production run of the Limited was only one year. Eight hundred and thirty-nine were built and only

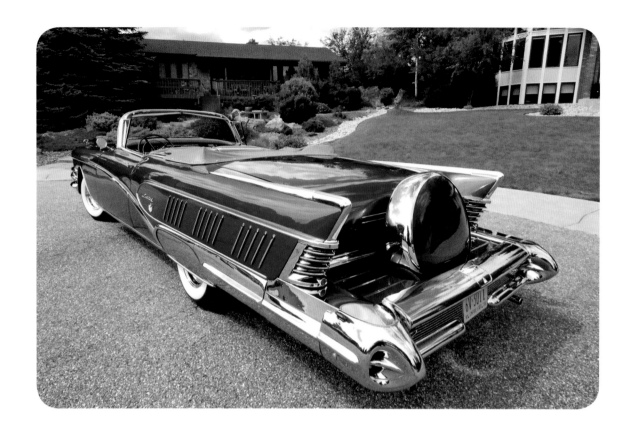

about twenty are known to exist today. I bought this car from Gordon Apker, the owner of Shakey's Pizza. Pastimes Restoration worked their magic and turned out a car that draws raves at every show it has entered.

I can honestly say that I have never seen a nicer example of designers who got carried away. Despite all that being said, she drives very well, and few cars are as comfortable riding at 100 miles an hour.

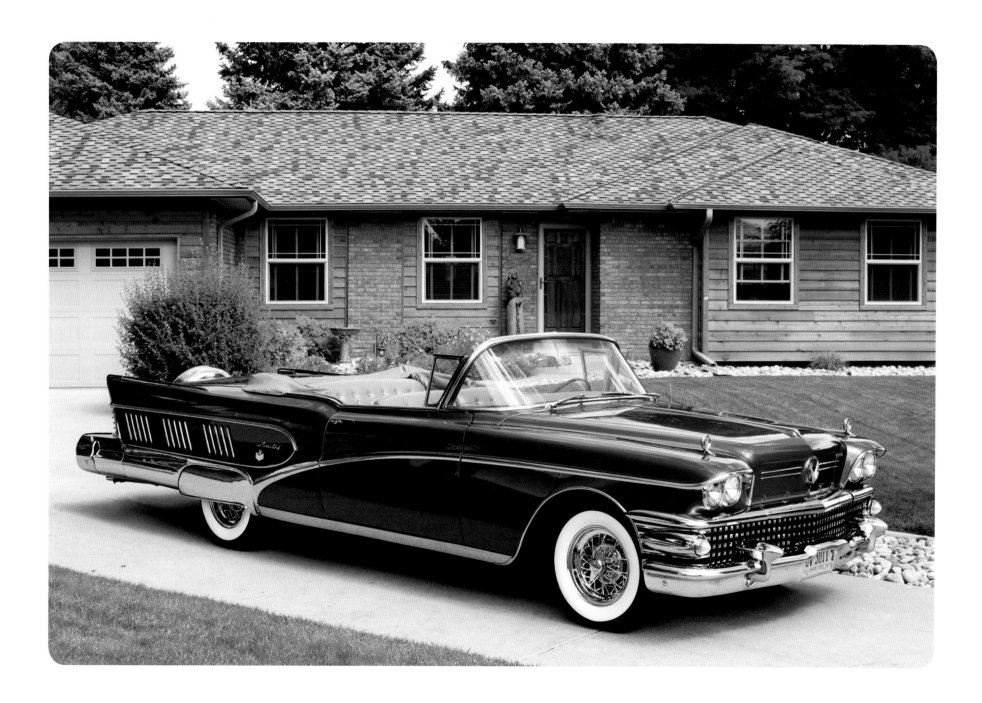

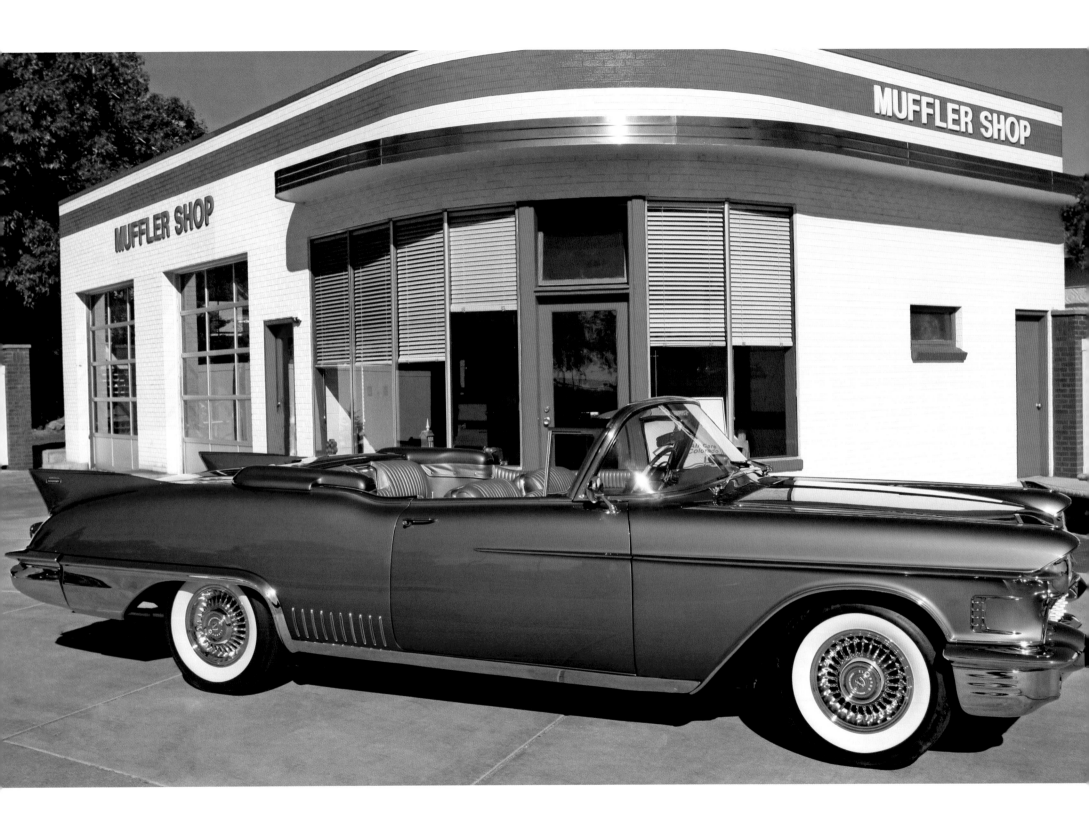

1958 CADILLAC ELDORADO BIARRITZ CONVERTIBLE

Cadillac played it close to the vest in 1958. Styling changes were minor with a few differences in the chrome and a more massive but not as attractive grille as the '57. The most notable difference in appearance was the new quad headlight system, as seen on the earlier Brougham. But this was just the lull before the storm. GM design chief, Harley Earl, went over the top with Cadillac. It was the ultimate expression of tail fins, which reached its apex—or, some might say, its nadir—in 1959.

The '58 Eldorado Biarritz convertible price went up to $7,500 from $6,800, which, during that year's recession, meant sales were cut to only 815 from the previous year's production of 1,800. It was the second-lowest production Eldorado ever built, and they were gobbled up by Elvis Presley, the Shah of Iran, and the most affluent buyers.

The wheelbase stayed the same as the previous year's, and the 365-cubic-inch V-8 engine, producing 335 horsepower, was topped with a most impressive array of triple two-barrel carburetors. The Cadillac Eldorado Biarritz interior was on par with any luxury car of the era—or for years to come, for that matter. It used the finest materials, and the lengthy list of options included every comfort and convenience feature Cadillac could conceive. Driver and passengers enjoyed a top-of-the-line motoring experience, full luxurious leather interiors, and numerous comfort and driving amenities. The color of our Eldorado Biarritz convertible is from the 1958 paint chart, and the leather

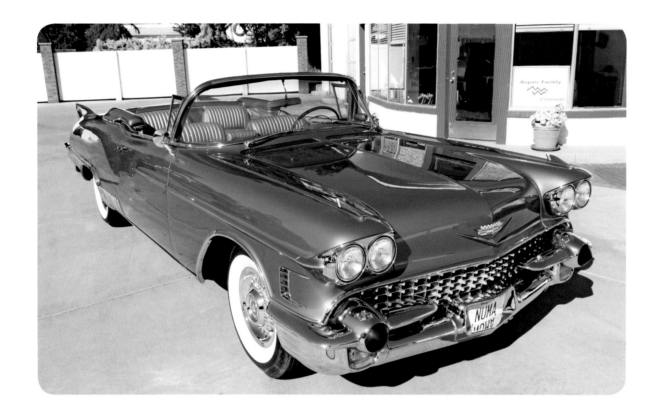

upholstery is identical to the original. A solid three-piece parade boot covers the convertible top when it's fully retracted for a clean, tailored look. This rocket sled rides on chrome saber wheels.

I bought the car in Colorado from a fellow collector in 1985. It was one step above a basket case. Pastimes restored this '58 Eldorado Biarritz at the same time as our 1957 Biarritz, so they were kept busy for quite some time. In the end, the products of four and five men's labor look better than when these two cars left the factory. This particular one's an elegant and fine-driving machine, correct and perfect in every detail.

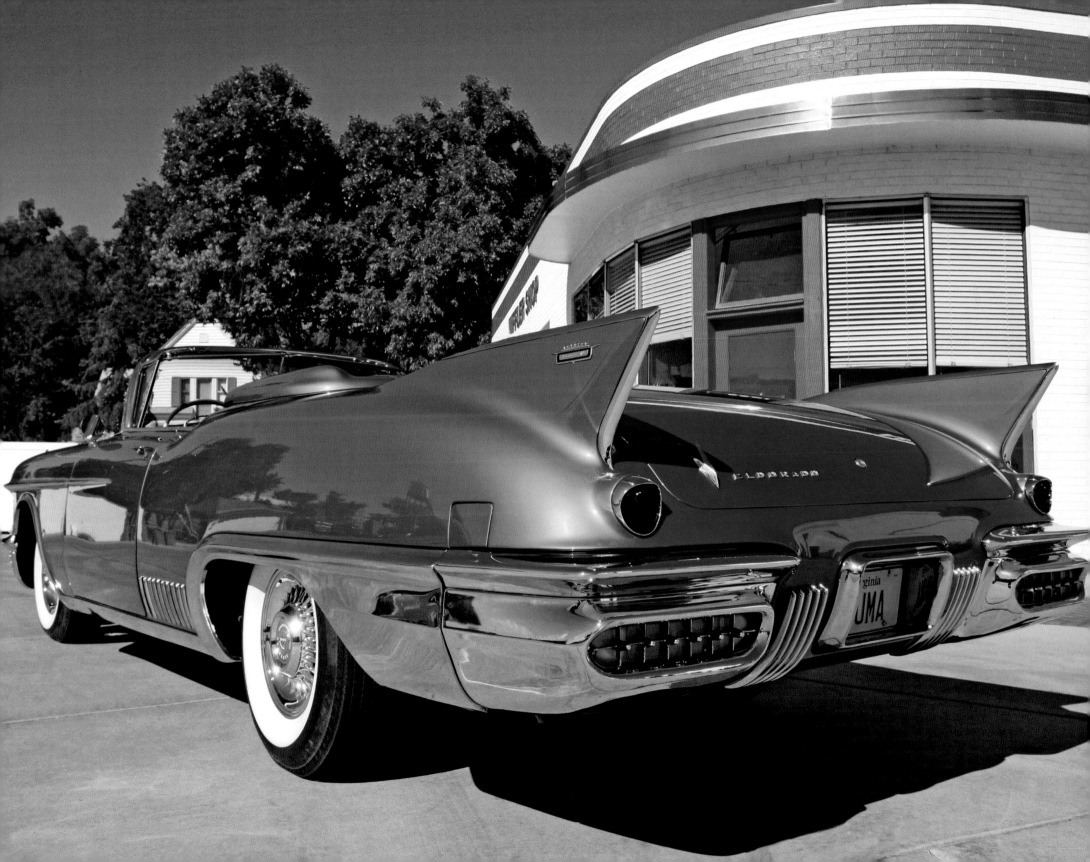

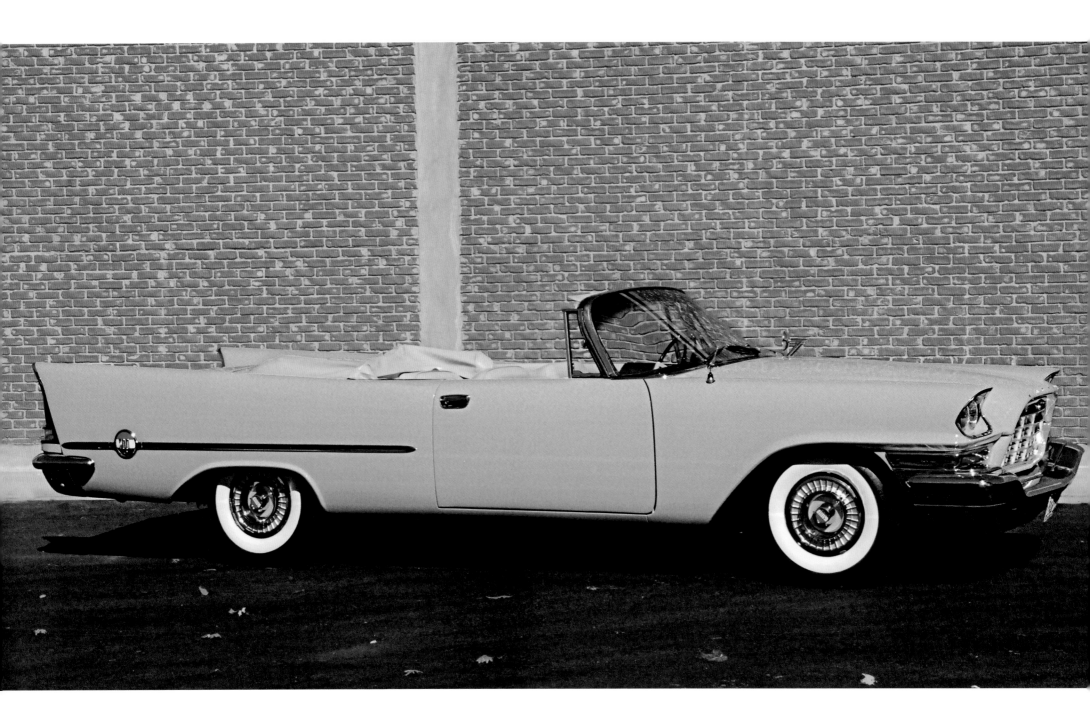

1958 CHRYSLER 300D CONVERTIBLE

The 1958 Chrysler 300D marked the end of Hemi engines for the early letter series. It was the ultimate muscle car engine for the new hot-rodding era. Usually mated to a factory performance-modified automatic gearbox, this iconic engine had dual four-barrel carburetors, a race-profile camshaft, solid valve lifters, special manifolds, and a special enlarged dual exhaust system. Chrysler had always kept the production of the iconic Fire-Power Hemi muscle car engine limited, as it was costly to produce. Finally, by 1959, Chrysler abandoned the Hemi-head concept in favor

of their new Wedge-head design, which endured and prospered into the sixties.

This year's styling was quite similar to the '57's except for a bigger open shark's mouth grille. Hardly a compact, the 300D stretched over 18 feet, from the opulent chrome front end to the tips of its towering tail fins. Long and wide, it had four feet of fender, and bumpers hanging beyond the tires.

Still fast, the big 392-cubic-inch V-8, with dual four-barrel carburetors, was upped to 380 horsepower and could run 0 to 60 in 8.4 seconds, as good as many cars today. As if a parting shot, a Hemi-

powered 300D won the Flying Mile trophy at Daytona by scorching the sands at 156 miles an hour. Impressive.

The car shown here is quite rare. Only 191 300D convertibles were produced in 1958. Mine is one of only fifty-five known to exist. I bought it from Steve Hook of Corpus Christi, Texas, who makes a business of restoring Chryslers. It came in a beautiful original turquoise color with a white top. A very striking combination. Pastimes checked it out very carefully and replaced a few items with NOS (new old stock) parts, so every detail is correct. The car has less than 100 miles on the engine since Hook rebuilt it. An exceptional and uncommon automobile.

In the book *Black Wind,* Dirk Pitt prevailed in a bidding battle at auction to acquire this classic car: "'Sold to the man in the NUMA hat!' the auctioneer barked . . ." Not long afterward, Dirk Pitt prevailed again by narrowly escaping certain demise in a hail of machine-gun bullets due, in equal parts, to his evasive driving prowess and the Hemi power of his Aztec Turquoise 300D.

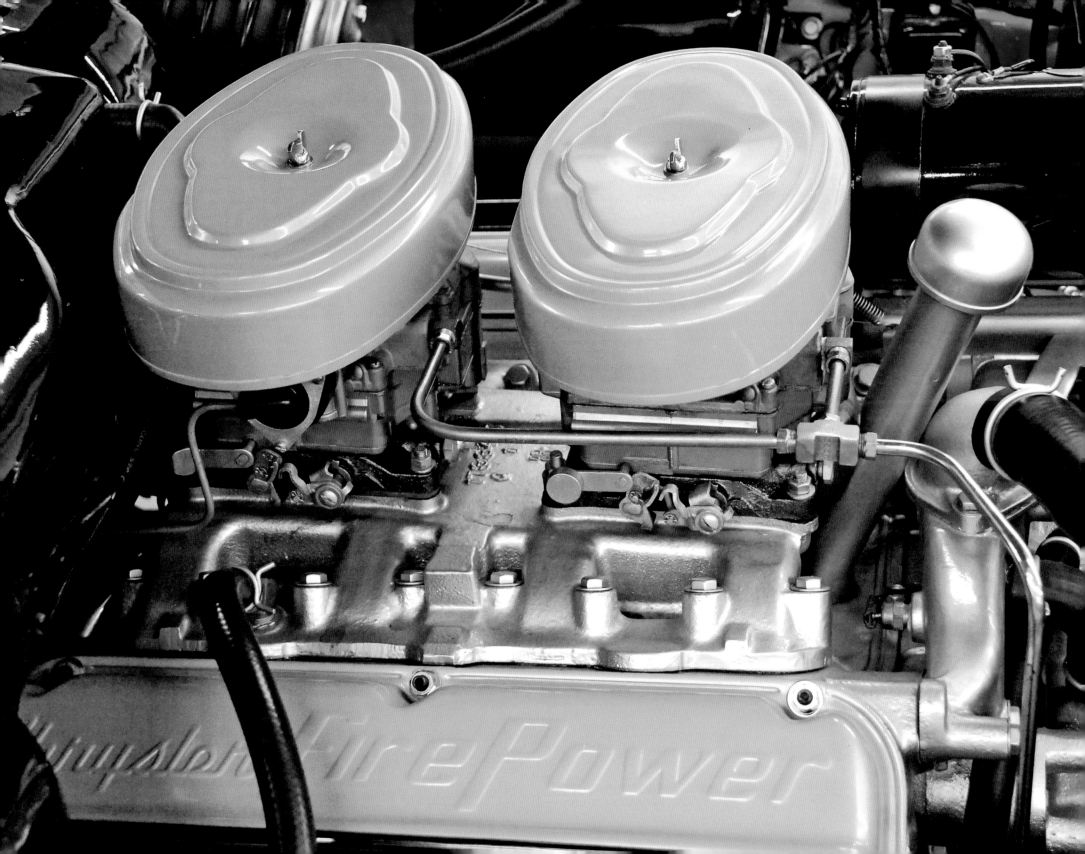

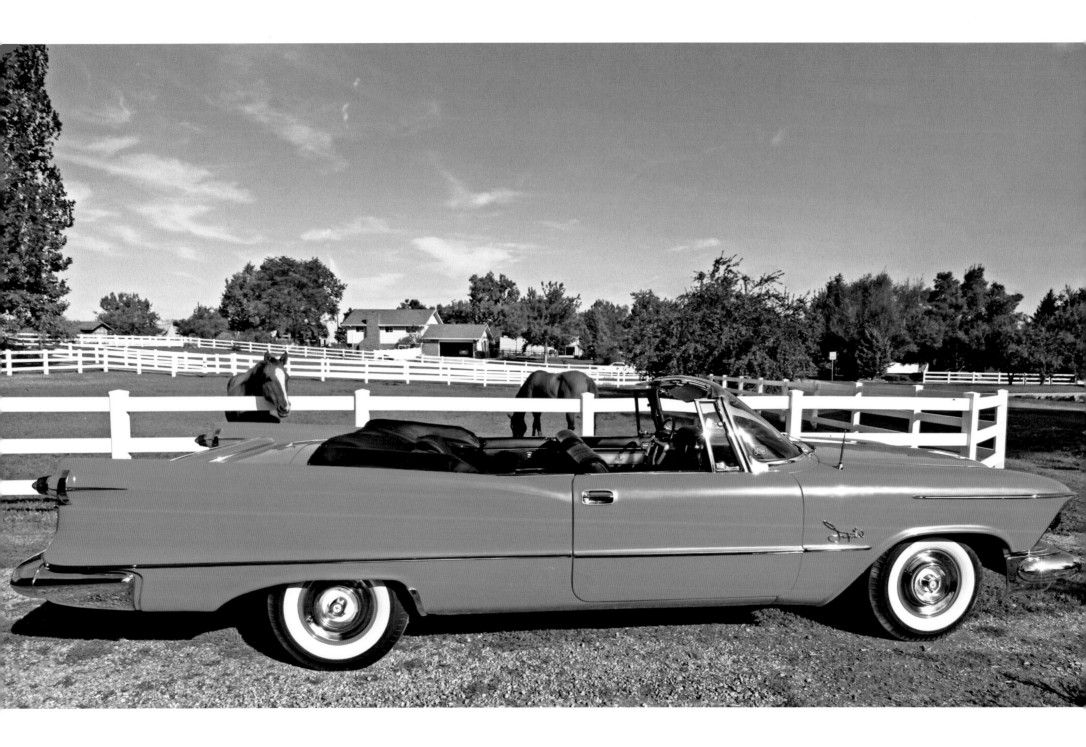

1958 IMPERIAL CROWN CONVERTIBLE

mperial had everything in 1958. The car touted "The finest expression of the Forward Look," outstanding styling, sound engineering, and enough luxury to satisfy the most demanding owner. Handling and comfortable riding were fundamental. The big Imperial Crown rode like a feather, turned with fingertip ease, and moved out when the accelerator was eased toward the floor.

Providing the punch to move that big luxury convertible down the high-

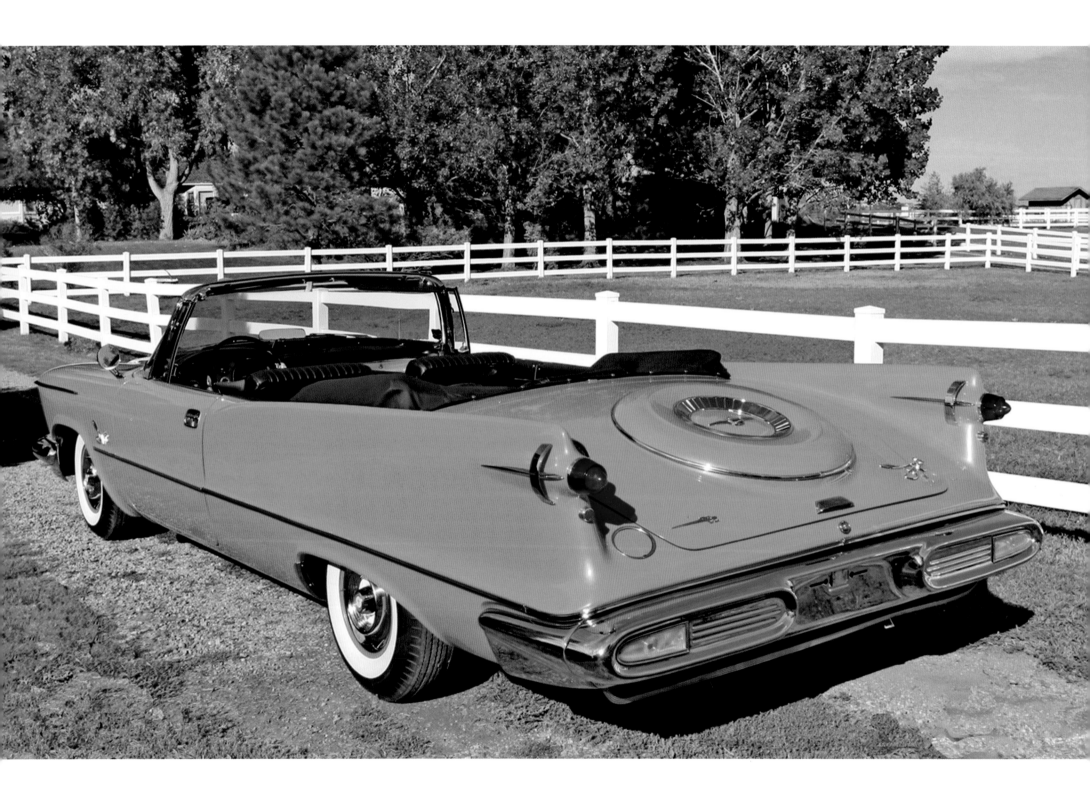

way was the standard 392-cubic-inch Hemi engine, boasting 345 horsepower. Nineteen fifty-eight was the last year of the Hemi-powered Imperial convertibles and the independent division packed an extra 25 horsepower into that final year's motor to punctuate the dominance of that muscular V-8.

Imperials were substantially wider than other MoPars of the same period. The chromed grille was simpler and far nicer-looking than before. The round protrusion in the middle of the trunk, dubbed the Flight Sweep deck lid, wasa design element that suggested a spare-tire cover. The luxurious Crown Imperial had beauty a connoisseur could love, a car that offered drivers the ability to cruise in the style the designers intended.

Of all the fifties Imperials, the '58 was the best-looking and most sought-after. They are as scarce as hen's teeth, as 675 Imperial Crown convertibles were built in '58 and only a few dozen survivors are known to exist. I looked for several years for a '58 Crown Imperial convertible. I finally found this one in Amarillo, Texas. The owner never got around to restoring the car, but it came with solid parts. Pastimes Restoration worked their skilled magic and did a complete rejuvenation. Everything was rebuilt, from the engine to the transmission to the convertible-top motors. I doubt if there are more than three fully restored 1958 Chryslers left in the country, and this one could very well be the nicest.

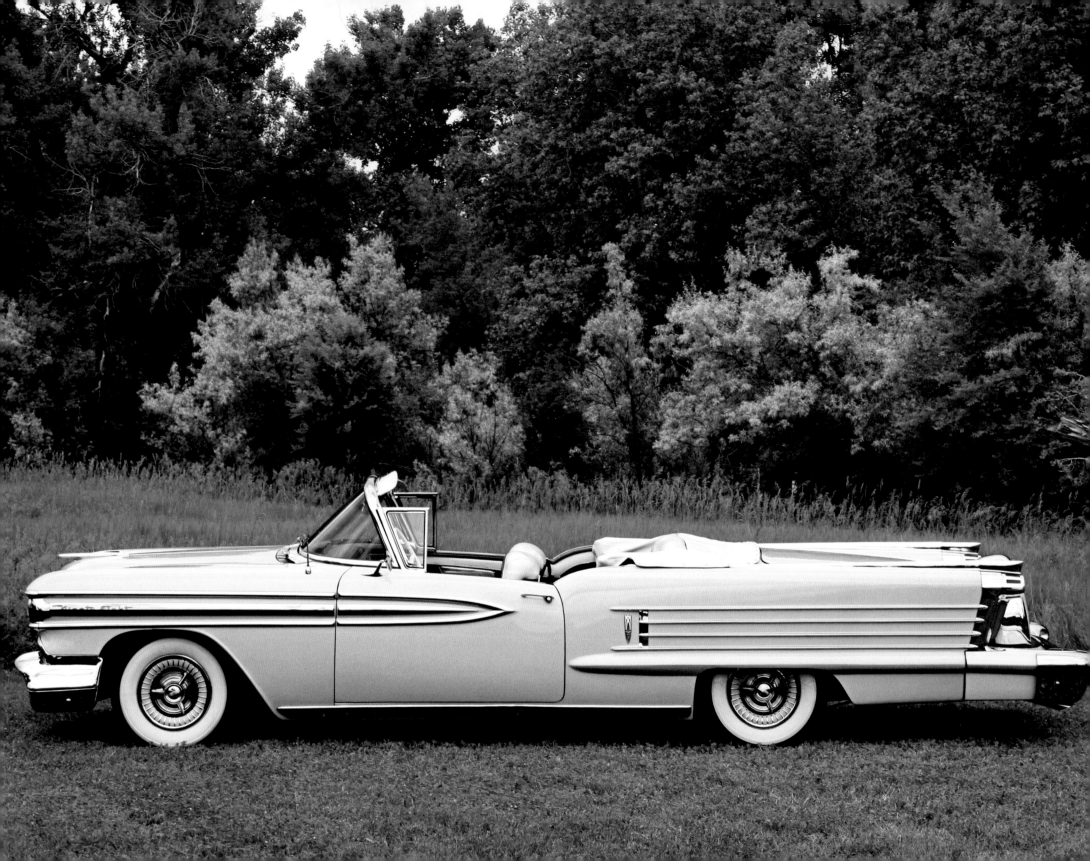

1958 OLDSMOBILE 98 CONVERTIBLE

If 1955 was the year Detroit turned out cars with smooth, flowing lines, then 1958 was the year they produced huge chrome-laden barges. Oldsmobile was no exception. Large and boxy, the Olds was gaudy, with enough side trim to build a bridge. The '58 Olds 98s kept their basic inner structure from the '57 model while adding a mile of sheet metal to the outside.

That trim had a purpose, as the quadruple chrome horizontal accent lines on the sides worked in concert with a new inch-lower roof-

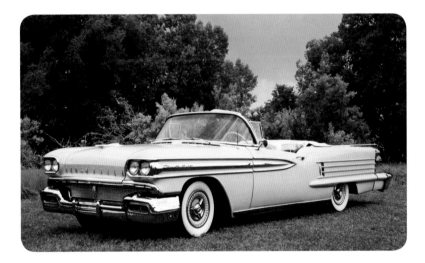

line to make the car seem much longer and lower than the previous year's model. Harley Earl, chief designer for years at General Motors, had a credo: "Go all the way, then back off." I can't see where the designers backed off on the chrome, or pomposity, on the '58 Olds.

Exotic options abounded. There was the Trans-Portable radio that could be removed from the dashboard and operate on batteries. There was also the Autronic Eye, an automatic headlight-dimming system, as well as the Twilight Sentinel, which turned the head-

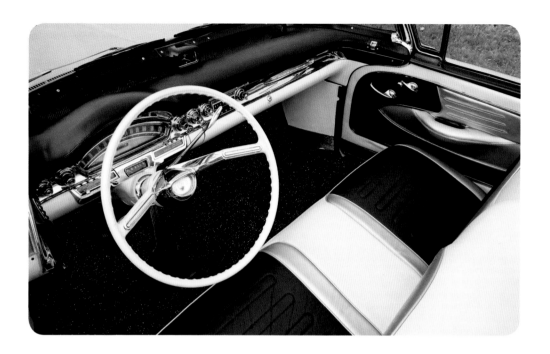

lights on and off through a timer set by the driver. The Safety Sentinel speedometer, a new speed-warning device, was interesting, if not practical.

A novel air suspension, New-Matic Ride, was an option that barely survived the test of time—and maintenance. It seldom worked, and most cars with this option were converted to conventional springs.

The bright spot was the new J-2 engine option, with triple two-barrel carburetors on a special intake manifold. With the J-2, 312 horsepower could be squeezed from the 371-cubic-inch V-8 engine, running through a smooth-shifting four-speed Hydra-Matic automatic transmission.

I searched for three years for a nicely restored '58 Olds 98 with the J-2 Tri-Power option and finally found one at the Kruse auction in Scottsdale, Arizona. It had been ninety-five percent restored. I wasn't satisfied with the work, so I had the engine pulled and body removed. All chassis components were rebuilt. The entire underneath was then painted and sealed. The top was redone, including pumps and struts. Then a Continental kit was added. She is a beautiful car, with Heather Mist Lavender paint and white leather interior, which is correct. I spared little in making this an award-winning car.

Nineteen fifty-eight Olds 98 convertibles must be being hidden away by their owners because you rarely see one.

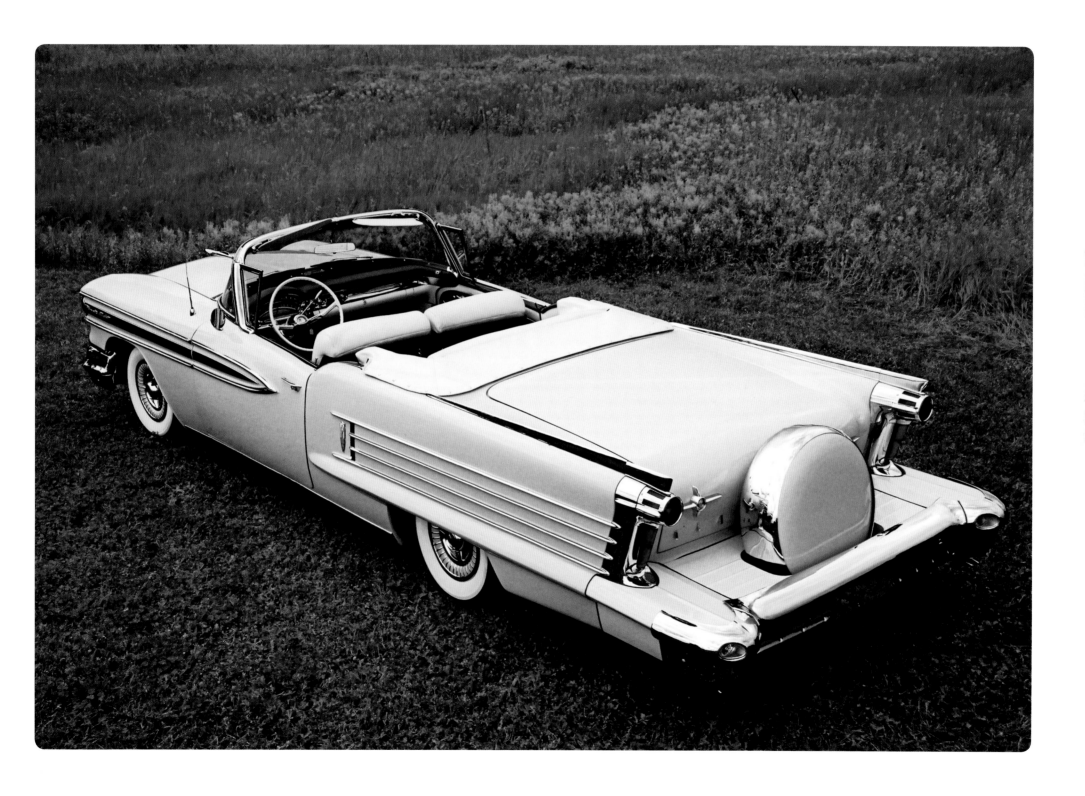

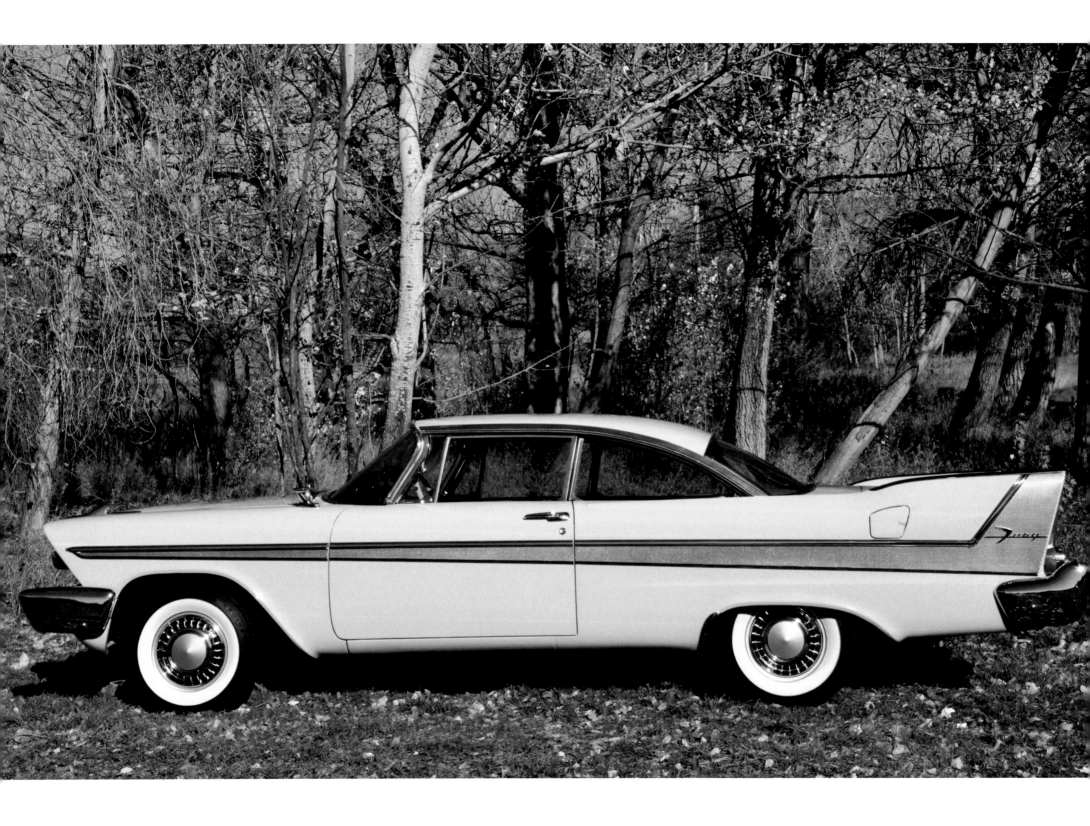

1958 PLYMOUTH FURY
GOLDEN COMMANDO

The 1958 Fury models were big departures from the sedate family sedans that Plymouth had produced in the past. It was three inches longer and over five inches lower than the previous design. The new car had long, sweeping lines flowing into graceful raised shark fins. A low window line and a seemingly floating roof heightened the sleek effect. With this clean new look, Chrysler led the way in smoother, less chrome-adorned land yachts. "Suddenly it's 1960!" the boys at the ad agency declared in '58.

This rare Golden Commando has the optional high-displacement 350-cubic-inch engine with dual four-barrel carburetion, special camshaft, high-compression heads, and dual exhaust, churning out 305 horsepower. Only forty-one 1958 Golden Commandos still exist today; all were finished in Sand Dune White on beige, with white and brown interior. The gold-anodized grille, side trim, and wheel covers with gold centers certainly punctuate the namesake statement.

At Daytona Beach Speedweek, the Fury consistently blew the doors off the competition. It broke the timing lights at a phenomenal 147 miles an hour, the fastest Plymouth in the company's history, and three miles an hour faster than the vaunted Chrysler 300B. The car could handle too; it had a special sport suspension. A three-speed manual or a three-speed, dash-mounted push-button automatic transmission was available. This Torque-Flite automatic was the bulletproof industry standard for many years.

Yet despite the beautiful design and speed accomplishments, the

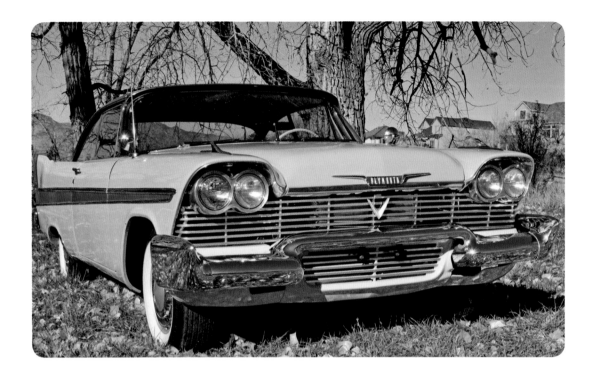

1958 Plymouth Fury will always be best known as "Christine," from the Stephen King book and movie of the same name. The '58 Fury was, and is, one dangerous-looking car.

I bought this Fury from the original owner, in 1990, and had the crew at Pastimes restore it from the tires up. Engine, drivetrain, body, upholstery—everything was completely rebuilt or refurbished as new.

Nothing was spared in making this an outstanding car. The original owner's manual and service receipts are in the glove compartment. Very few of the '58s are left, and, with this engine and color combination, the Golden Commando seen here is quite rare. It was the last and most powerful of the classic Fury models.

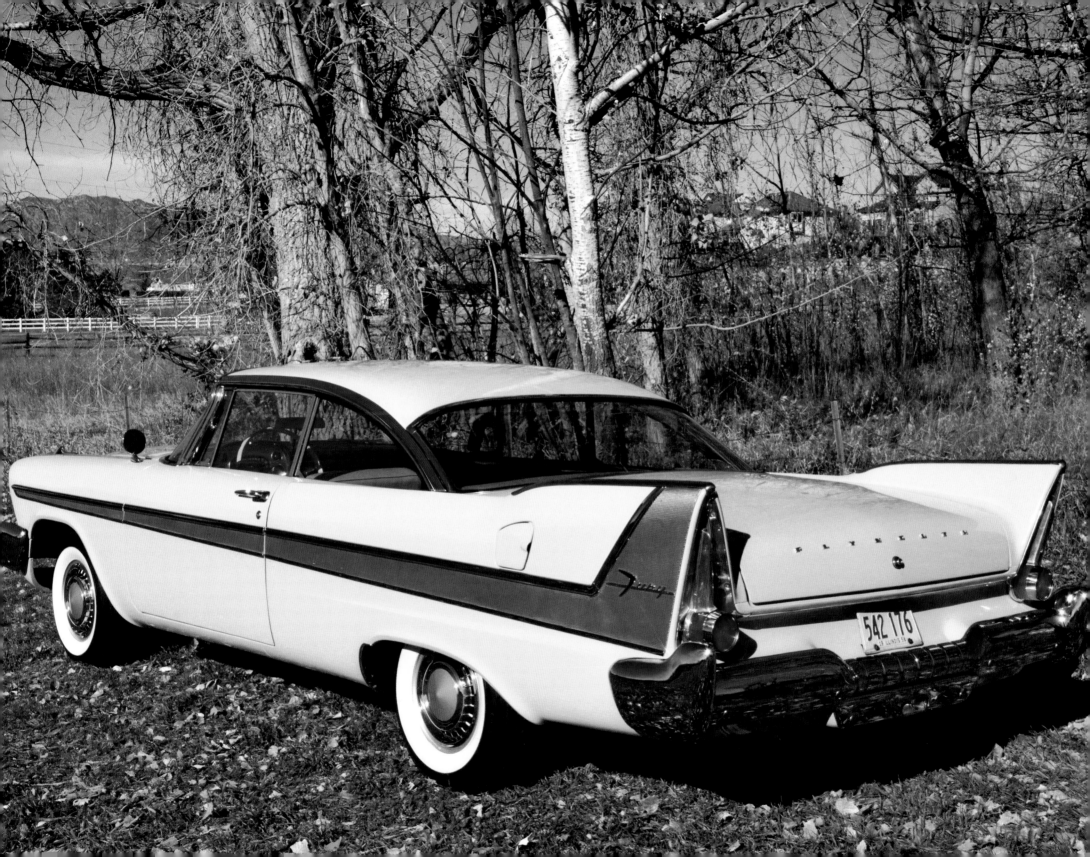

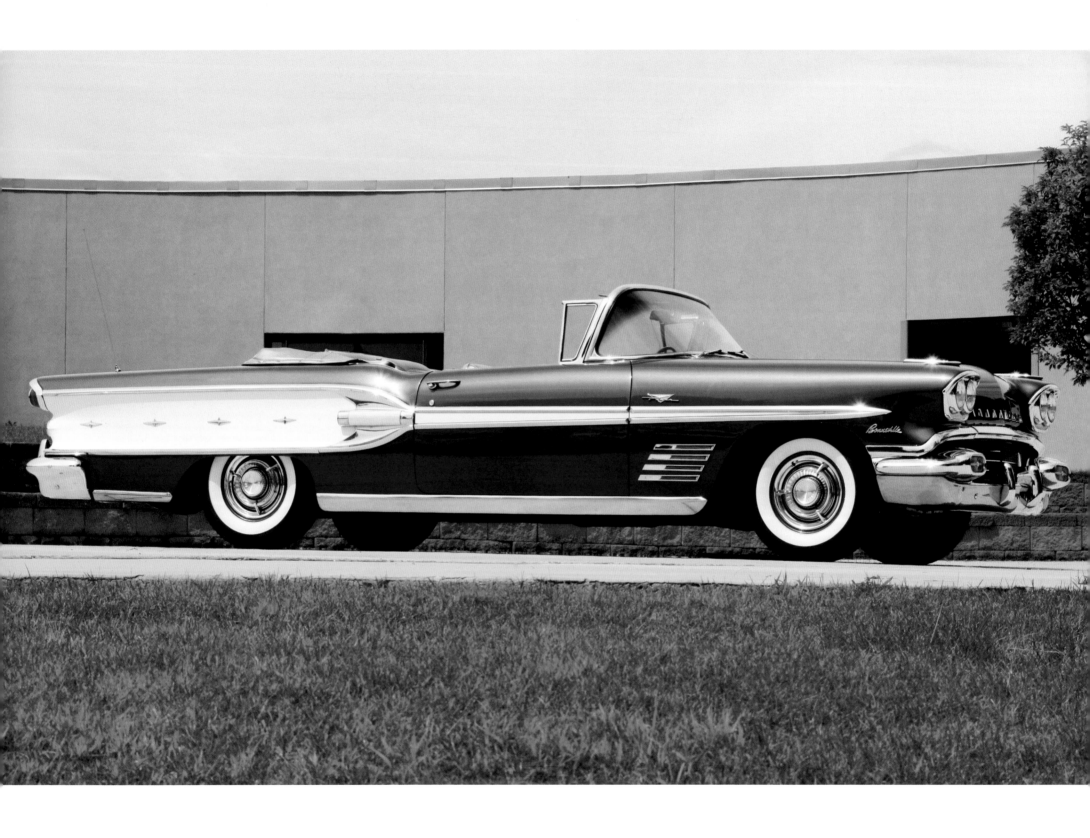

1958 PONTIAC BONNEVILLE CUSTOM CONVERTIBLE

"Give 'em the old razzle-dazzle" must have been on the minds of Pontiac's engineers when they dreamed up the 1958 Bonneville. It was almost as if they were in competition with Oldsmobile for the most chrome-laden road ship of the year. This is one of the flashiest of all American cars of the fifties. A fully optioned Pontiac Bonneville could cost more than a Cadillac at the time.

The Bonnie was all new for '58 with a complete redesign—"New Direction" styling—one of the last by Harley Earl. In fact, this new direction was a seriously important change, as General Motors planned to share bodies from 1959 onward and reap huge design and production savings. And so 1958 was a very costly "one year only" body style for the Bonneville, based on a Cadillac frame, while Pontiac prepared to officially roll out their "Wide-Track" designs in 1959.

At the top of the lineup, the sporty Bonneville stood supreme. Copious chrome accent details and eye-catching two-tone color combinations on the exterior were dazzling. There is gold script and a sporty vent trim on the front fenders, a side spear running from the front of the car to the concave rear fenders, along with a row of chrome stars. This entire rocket sled was a tribute to the Jet Age. A "Tri-Power" insignia on each side of the Bonneville emphatically assured the admirer that this car had the go power to match its futuristic styling. The interior got the modern treatment too, with textured stainless steel surfaces on the dashboard binnacle, a color-matched steering wheel, and carpets with sparkling metallic accents.

Power ratings came from a new 370-cubic-inch engine, and this car has the rare Tri-Power option of three two-barrel carburetion, of-

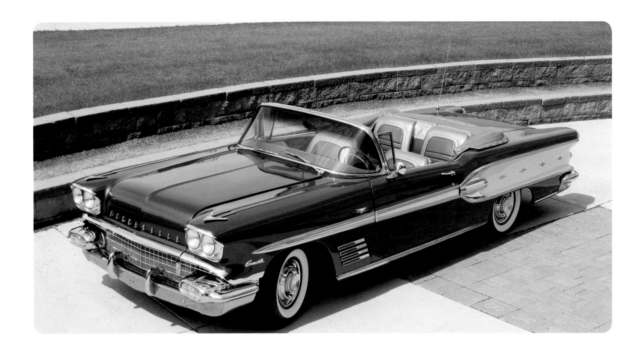

ficially rated at 330 gross horsepower. Dual exhausts, with two mufflers and two resonators, were an option for only $30. This big monster could turn 0 to 60 in just 8.2 seconds. All this power was transmitted through a Strato-Flight four-speed Hydra-Matic automatic. Pontiac engines were overbuilt for strength and were known by racers to be powerful and dependable. Hot-rodders of the era considered these the best-carbureted V-8s General Motors ever made.

"The 1958 Pontiacs are hotter than a blowtorch," said *Mechanix Illustrated*. A Tri-Power Bonneville convertible was the official pace car of the 1958 Indianapolis 500, a high honor for a new model in those days.

I bought this car from a fellow in North Carolina who had restored it ninety percent. Pastimes finished the job. It has all the accessories, including the bucket seats.

She's a real head-turner when driven through town.

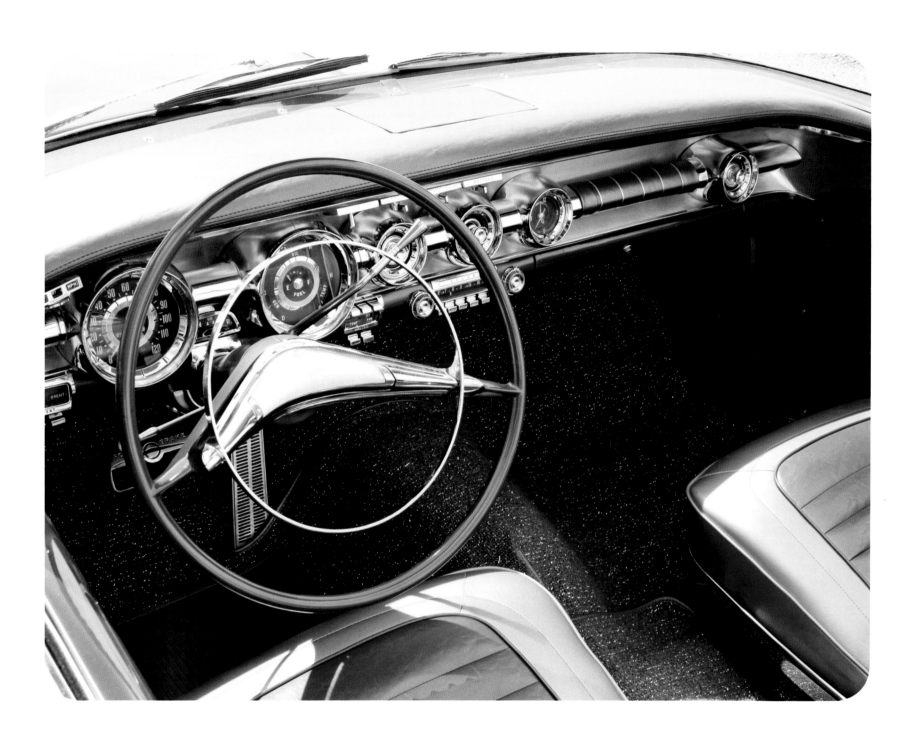

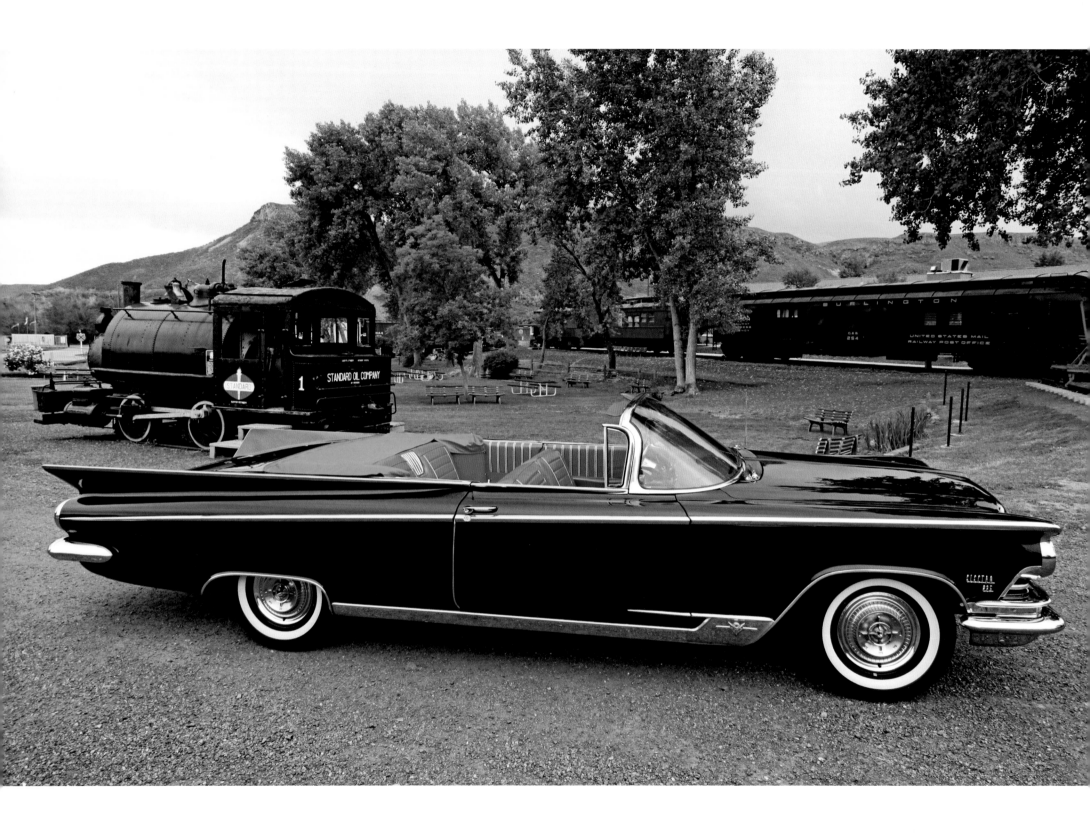

1959 BUICK ELECTRA 225 CONVERTIBLE

Buick's Delta-Fins styling was unlike anything company designers had attempted before. It looked fast at a standstill, ready to blast off down the runway to supersonic velocity. More graceful in appearance than the ugly '58s, it was the difference between night and day. However, the overall appearance of the car came as a mild shock to more conservative Buick buyers.

Such an impressive and bold design departure from anything else, it was honored to be named as the official pace car of the 1959 Indianapolis 500 race. The body featured swooping fins with chrome, knife-like edges at the rear like a sweptwing jet and matching chrome-edged, fin-like projections over the canted dual headlights at the front. It was one of the smoothest and lowest bodies Buick had

yet produced. The "225" model designation related to the 225-inch overall length, longest of all cars produced by General Motors during that time. The only feature retained from the previous model were the little squares in the grille.

A brawny 401-cubic-inch Wildcat V-8 with a four-barrel carburetor and 325 horsepower was standard and the only available engine for the big Electra 225. The engine, known as the "Nailhead," was mated to a Dynaflow automatic transmission, and the car sported power steering, power brakes, dual exhaust, and a Red-Line horizontal speedometer. Power windows, power seats, and leather interiors were standard Buick luxury items on the Electra 225 convertible and optional on all other models.

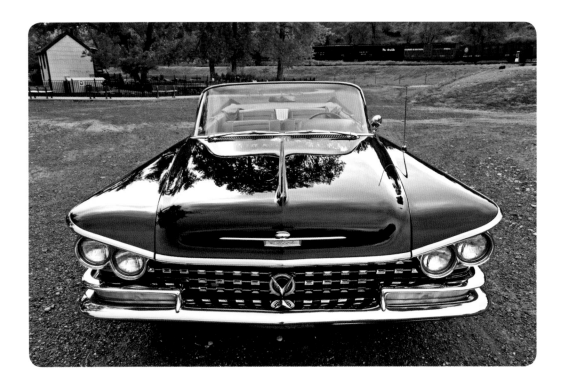

Buick expected great sales from its audacious new 1959 Electra 225; it was a beautiful car but didn't sell as well as it should. The big-finned cars, sadly, were out of tune with their potential customers. Buick buyers were not ready for audacious.

I bought this one in Los Angeles from Palmer Carson, who had the car pictured in just about every publication on Buicks. It was featured in the *Illustrated Buick Buyer's Guide* and in *Great American Automobiles of the 50s*.

A wonderful automobile that deserves to be remembered as such.

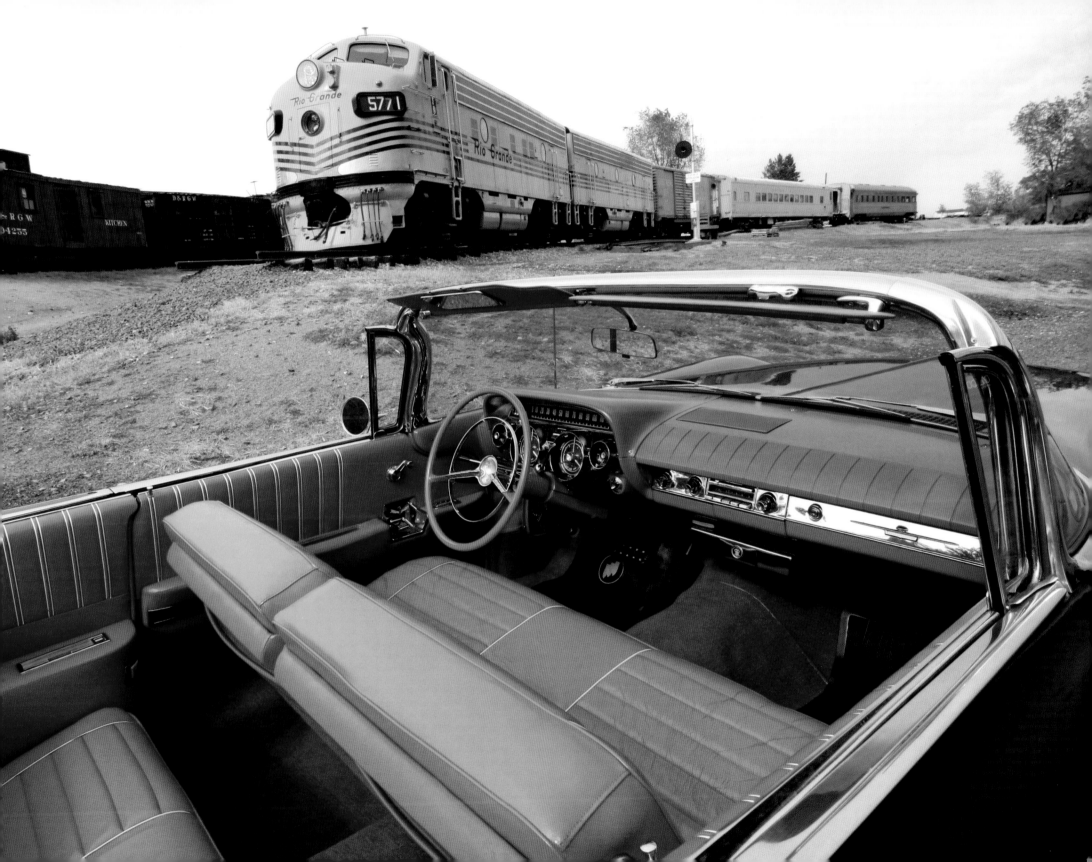

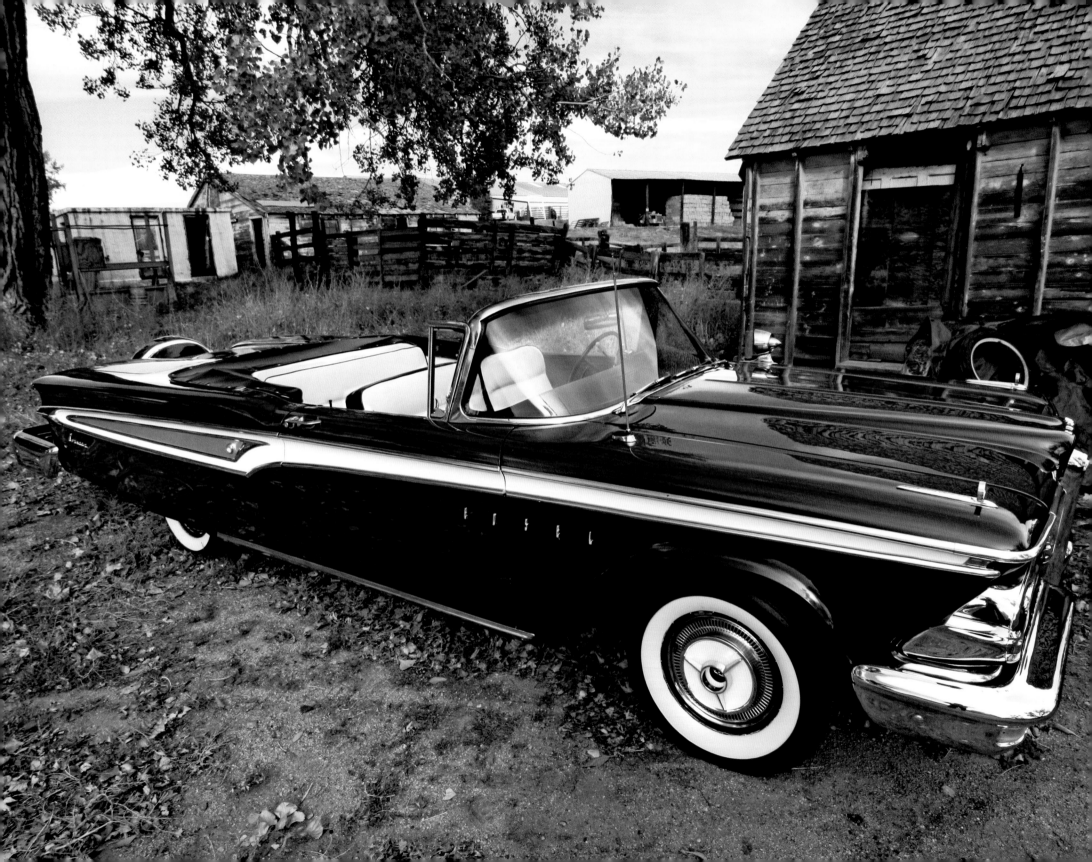

1959 EDSEL CORSAIR CONVERTIBLE

The Edsel has become a classic example of the wrong car at the wrong time. Was it the "horsecollar" grille or was it bad timing for the car coming out on the crest of a recession and spiking prices of gasoline? Like many things, the story is complicated but based on the best of intentions. The midpriced Edsel was created as a stepping-stone for buyers growing out of a basic Ford product to a more upscale one, eventually moving up over the years to a Continental, as buyers became more affluent.

Ford wanted a buyer for life, much like for the vaster spectrum of models that General Motors already had in place.

But the Edsel confused buyers. There was no actual Edsel factory, the cars instead being built at either Mercury or Ford plants; early cars were built on a long and wide Mercury platform, late cars on a shorter and narrower Ford chassis. And they were sold through Lincoln-Mercury dealers, yet the Edsel was definitely not a Lincoln and not quite a Mercury. Sold for only three years, 1958 through

1960, it was Ford's $250-million-dollar gamble. And loss.

It was all downhill until 1960, when production stopped from lack of sales. Now the name Edsel stands for "loser." And yet it really was a damned fine car. Whatever its faults—and they were actually very few—the Edsel was not a bad car. It was fairly luxurious for a midrange vehicle. The

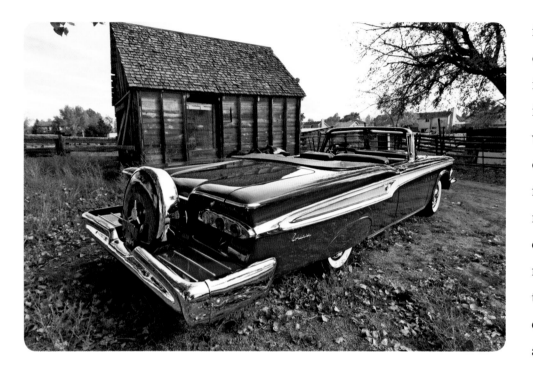

body styling was most appealing when viewed from the side, showing off its attractive stainless steel trim. When it hit the dealer showrooms, the Corsair models sported a 410-cubic-inch engine that rocketed the car with 345 horsepower.

This model is the top-of-the-line convertible loaded with options, including the factory Continental kit. I bought it from a father and son

from Greeley, Colorado, who did a beautiful job restoring it. They did such a fine job, in fact, that it wins trophies whenever it's shown. This car is one of 1,343 built and fewer than one hundred remain, so the Edsel Corsair convertible model is one rare bird indeed. That said, the Edsel Owners Club is one of the largest such clubs and most zealous when touting the merits of the car. I hear that many members have more than one Edsel. That's dedication.

Much time has passed, and now when I drive the car people are always asking, "What is it?"

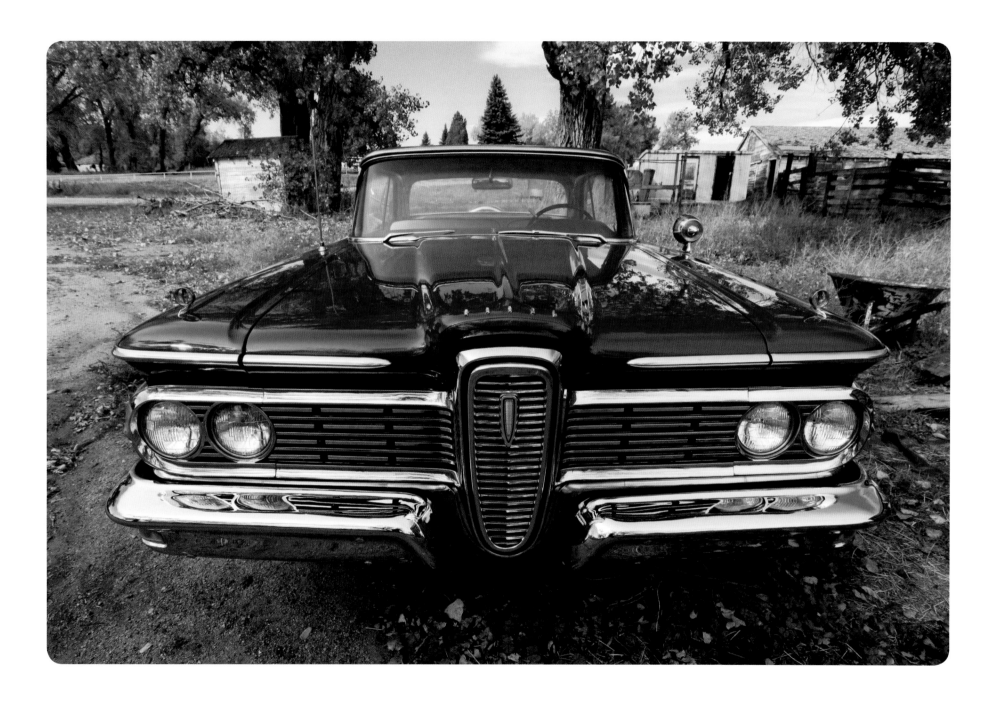

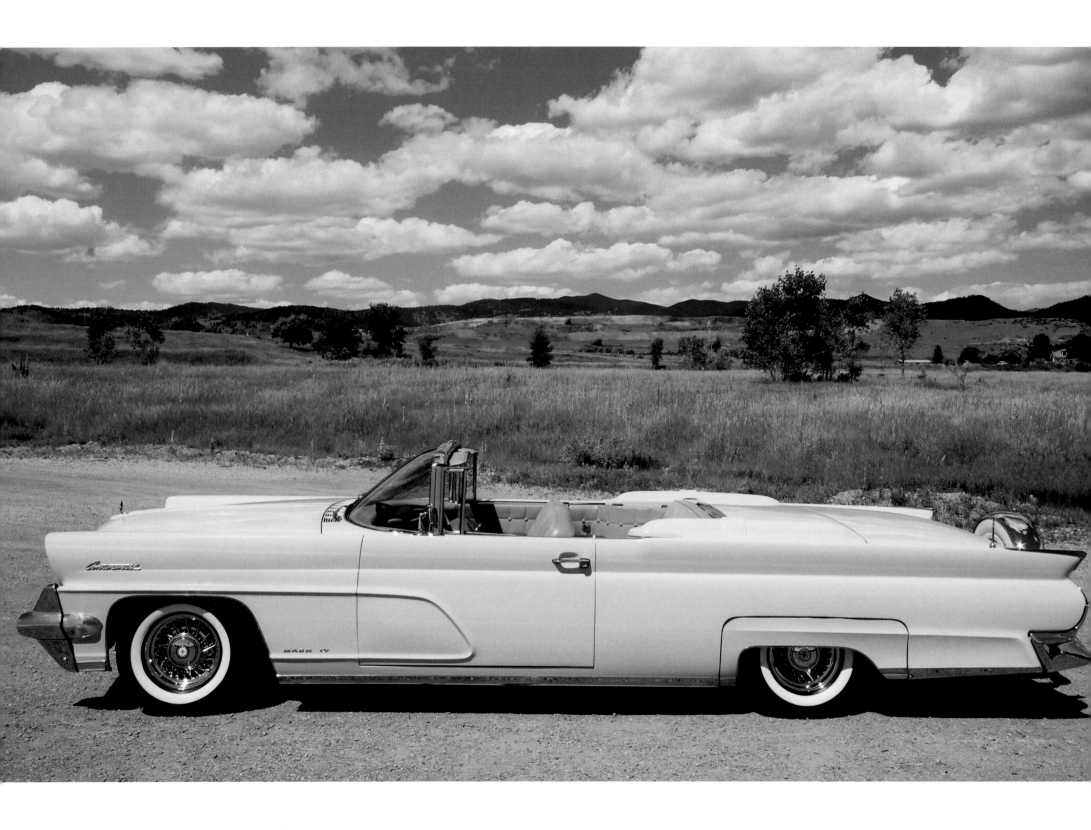

1959 LINCOLN CONTINENTAL MARK IV CONVERTIBLE

The new model, known as the "Mark IV," radically restyled and reengineered from 1958, was now a Lincoln Continental. Costly hand assembly was out. Continental as a separate division was out. Lower manufacturing costs, higher sales and profits was the goal. Less expensive to produce and lower-priced, the new car outsold its elite, limited-production predecessor in its first year, despite recession conditions and higher

gas prices. The Mark IV was a very different car in every way.

The body was "unitized," a form of construction where the separate frame, suspension, and running gear are all mounted as one unit. And Mark IVs were the biggest unibody cars ever built. While in '59 the styling was toned down from the wild '58 model, it still retained the canted quad headlights, sculpted fenders, and reverse-angle retracting rear window glass. Large and boxy, it

|| 169 ||

was like driving a cruise ship down the street without the dining room. Lincoln Continentals for 1958 through 1960 were so huge that it was rumored that when you bought one, you received your own zip code.

Some thought the angled headlights and scalloped fenders were over-the-top, but Lincoln needed to compete with other luxury '59s that made big styling statements such as the Cadillac Eldorado, Buick Electra 225, and even Ford's own Mercury Monterey. As unique as the Lincoln Continental was, it almost looks understated when compared to the wildest fins of them all, those on the '59 Cadillac Eldorado.

It took a lot of power to move such a behemoth, so it had a brawny yet smooth 430-cubic-inch V-8 engine with 350 horsepower. This Mark IV convertible is loaded with all the luxury features. The large convertible top retracts with just the push of a button, and a panel cover hides it to retain a sleek appearance. Interestingly, the convertible Mark IV retains the model's highly unique reverse-angle "breezeway" rear window, which retracts behind the backseat. This grand luxury car even lubricates itself, with the new Auto-Lube feature. The price tag for all of this was just over $7,000.

The engine and running gear were fully restored, the car rewired, and all the parts were either rebuilt or new. The turquoise paint is the original color, and the upholstery was stitched in the correct manner. The wire wheels were a factory option, as was the Continental kit that we installed—making the car even longer.

It's an awesome automobile that gathers great interest as it sweeps down the road. Very few were made. Precious few remain.

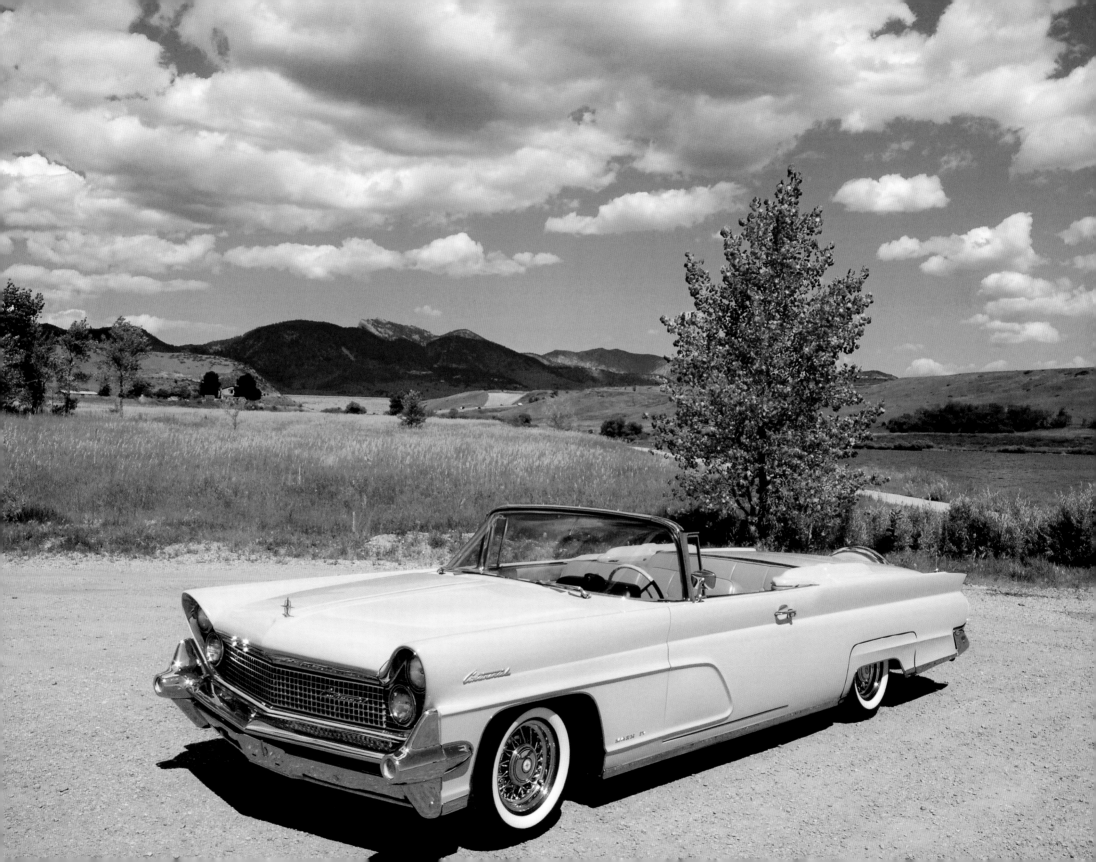

1959 PONTIAC BONNEVILLE CONVERTIBLE

The 1959 Pontiacs were no makeover of last year's model. The new Bonneville was reengineered, redesigned, and startling. It was voted "Car of the Year" by *Motor Trend* magazine. It was also the first year of the "Wide-Track" wheelbase body and frame geometry. More than good ad copy, it was literally a design and engineering philosophy embraced by Pontiac for the rest of its days. Pushing the wheels out toward the fenders and widening the track by five inches was initially a design decision to enhance the visual proportions of the big Bonneville. Increasing the width of the wheel track and frame geometry afforded the

Bonnie not only an aggressive stance on the road but also gave the big car enhanced handling capabilities.

Wide-Track gave birth to a performance and styling standard that would thrust Pontiac into undreamed splendor well into the sixties. Sharp new styling in '59 introduced the split-grille design theme that became integral to Pontiac brand identity for all of their cars, until the discontinuation of the marque in 2009. In 1959, the Bonneville broke with the general flamboyant styling trend of the day by scaling down rear fender fins and reducing side trim. The car bucked the year's gaudy trend, and it was appreciably simpler and

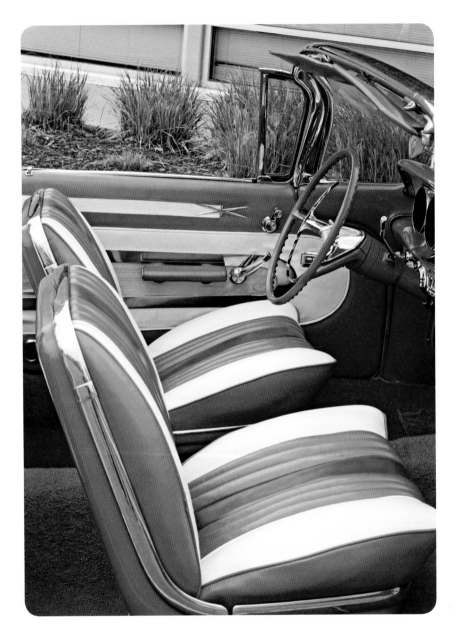

tighter in design than other big cars that year. The beltline was very nearly horizontal from front to rear; the roofline was thinner and flatter, and seemed lower due to the new, wider proportions of the car.

In 1959, Pontiac also introduced their 389-cubic-inch V-8 engine. It was a larger and more powerful engine than the '58 motor. Known by racers to be powerful and dependable, these Pontiac engines were overengineered for strength. With the optional Tri-Power triple two-barrel carburetion, the new engine was rated at 348 horsepower and used the four-speed Strato-Flight Hydra-Matic automatic transmission.

This beautiful Bonneville convertible came to me at auction in 1988. It was just too handsome to pass by; it's a very special car. In addition to the highly desirable Tri-Power option, this car also sports very rare factory bucket seats. It is a car that is more than admired; it is respected for its creative engineering and body style.

The '59 Bonneville set the standard for many Pontiacs to come.

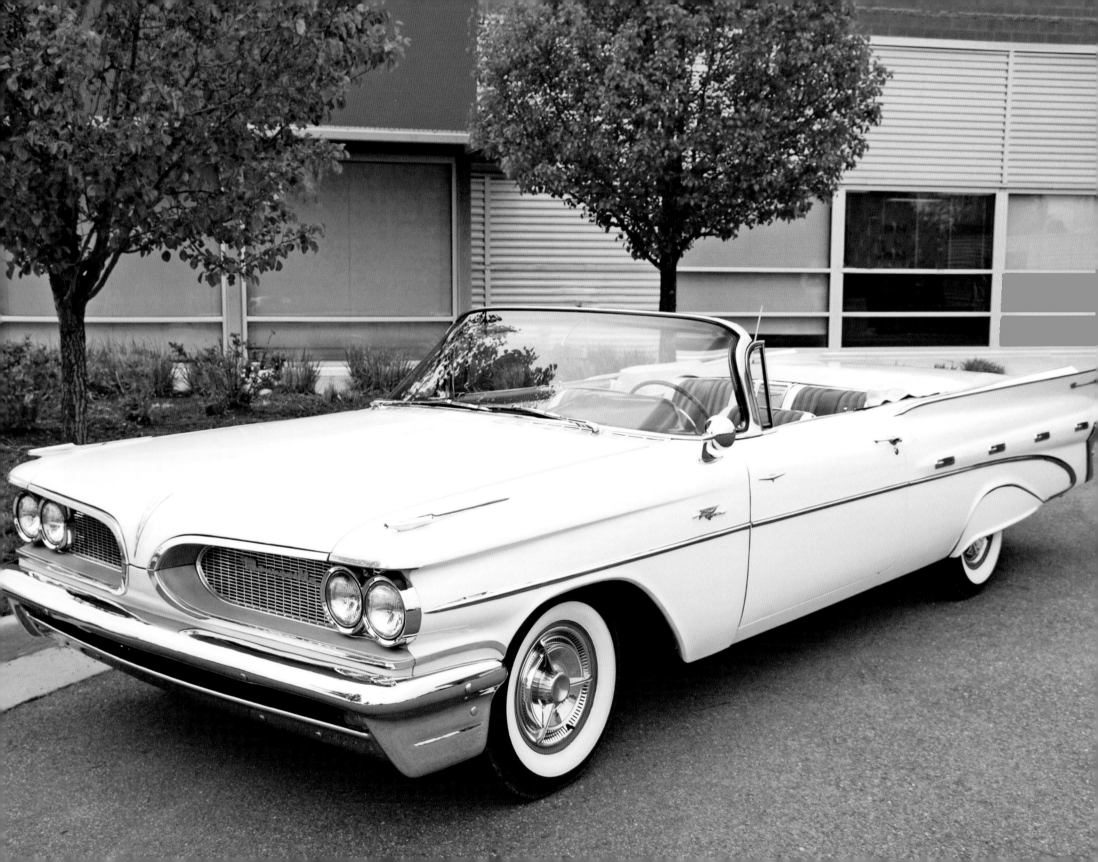

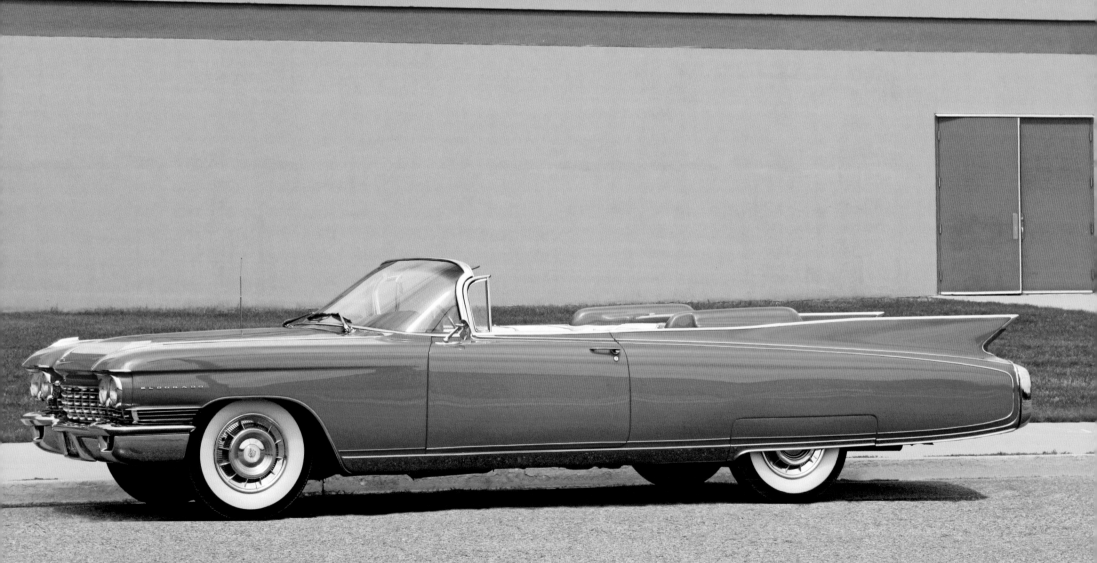

1960 CADILLAC ELDORADO BIARRITZ CONVERTIBLE

The 1960 model year marked a turning point for Cadillac. Gone were the excesses of the fifties. The new styling was more graceful and refined. Though the shark fins that ran over the trunk and rear fenders that housed the taillights remained pretty much the same, the overall design of the body was conservative in relation to other luxury cars on the market. The clean horizontal lines are still considered a masterwork of automotive sculpture.

With the Biarritz's convertible top down, the car was given a sleek profile because the top was hidden by a metal cover in the

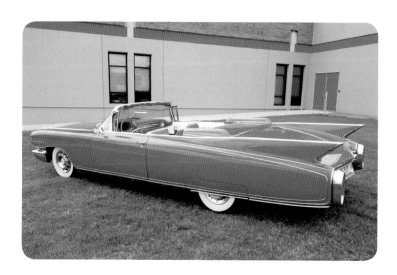

same color as the body. Cruise control—a new innovation—as well as the automatic headlight dimmer and air-conditioning, were standard equipment. That year, the factory price was $7,401.

The wheelbase moved up slightly, to 130 inches, but the big Eldorado V-8 was hyped as 390 inches, with an output of 345 horses, the highest on the market that year. Still the "Standard of the World," Cadillac was universally known as the "Best Buy in the Luxury Field."

As with the earlier Eldorado Biarritz convertible, I bought this car from collector Tony Fico, but this time after he had it restored.

Except for a little touch-up here and there, it looks pretty much as I bought it.

The car is quite large, and driving it down the street literally feels like steering the *Queen Mary*. The only difference is that this big car is fast. It can do 0 to 60 miles an hour in just 10.3 seconds. Not bad for a monster weighing in at 5,000 pounds.

And if anyone is wondering why neither Dirk Pitt nor I own a behemoth 1959 Eldorado Biarritz, it's because I have yet to find one I like that isn't vastly overpriced.

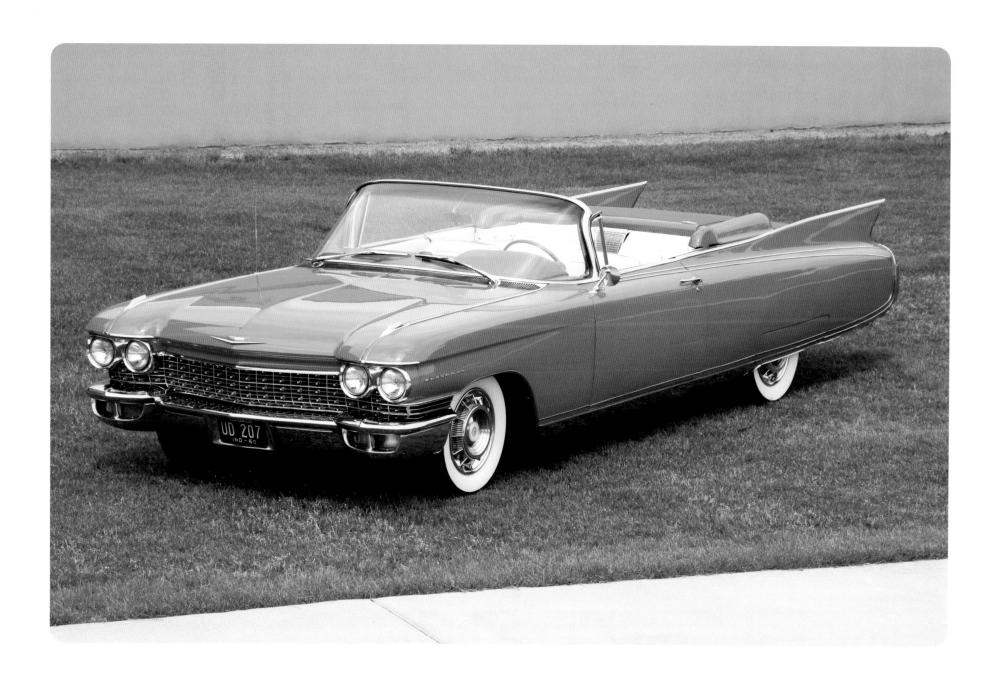

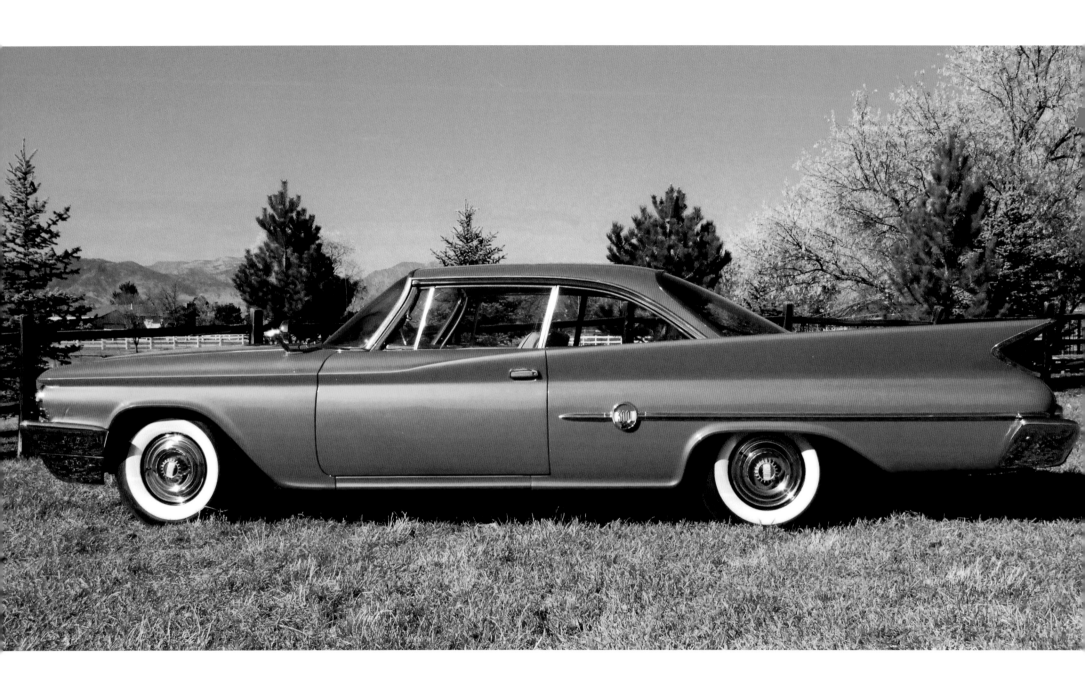

1960 CHRYSLER 300F

onsidered by many collectors to be the most desirable of the 300 series, the 1960 300F was the hottest and most exciting of the series. Wider and sleeker in appearance than the previous model, it was the last of the aggrandized tail fins and the first to fully use the lightweight unitized construction instead of the old, heavier body on frame. The 1960 was cleanly sculptured. Body contours were gracefully handled, and the inverted grille and

outward-tilted rear fins gave an illusion of speed. As with the Imperial, the trunk had the Flight Sweep round hump in the middle, suggesting a spare tire where none existed.

The 300F was the most exciting yet, with four sporty, individual leather bucket seats, where the front two swiveled outward when the doors were open. There was a racy, full-length center console that ran from the dash to the rear seat back. There was a modern, dash-mounted push-button automatic

transmission. A new suspension allowed the coupe to hug the road and corner better than any other big car on the market.

Under the hood, the new "Golden Lion" 413 wedge motor was a thing to behold, with its new, exotic cross-ram induction manifold. It was the envy of Chrysler's competitors. This beast put out 375 horsepower, ran the quarter mile in sixteen seconds, and hit the timing light at 85 miles an hour. Those bemoaning the loss of the heavier and more expensive Hemi engines of the past were soon impressed with the 300F registering over 144 miles per hour at the Daytona Flying Mile.

In a most attractive Toreador Red, this car was beautifully restored by a shop in Michigan. Only 964 hardtop 300Fs were built. I bought mine at the Imperial Palace auction in 1989 and didn't have to touch it. It was in near-perfect condition and needed nothing.

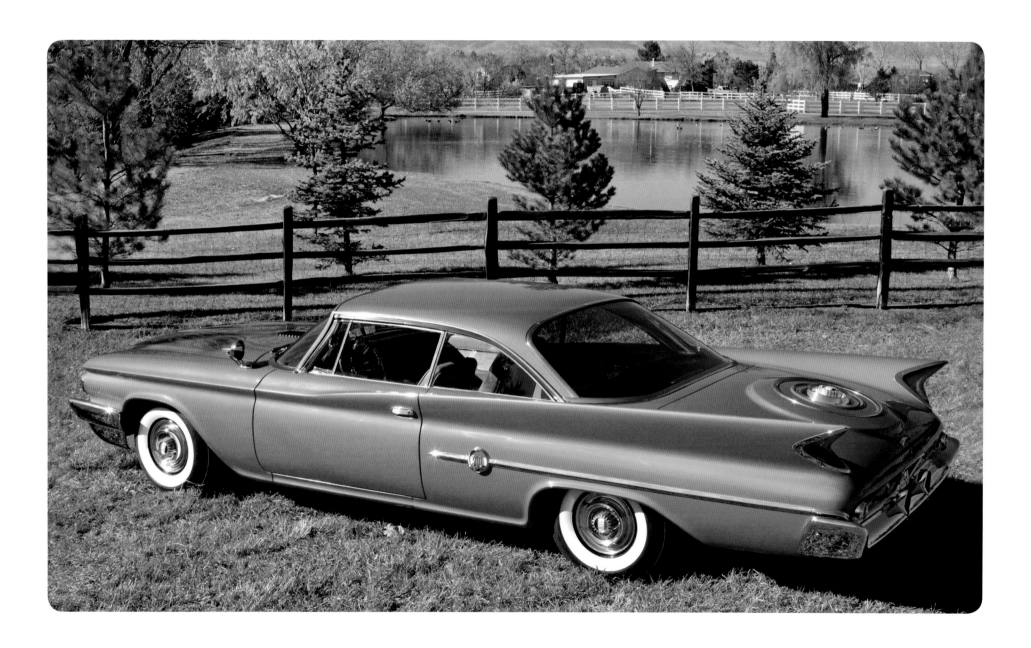

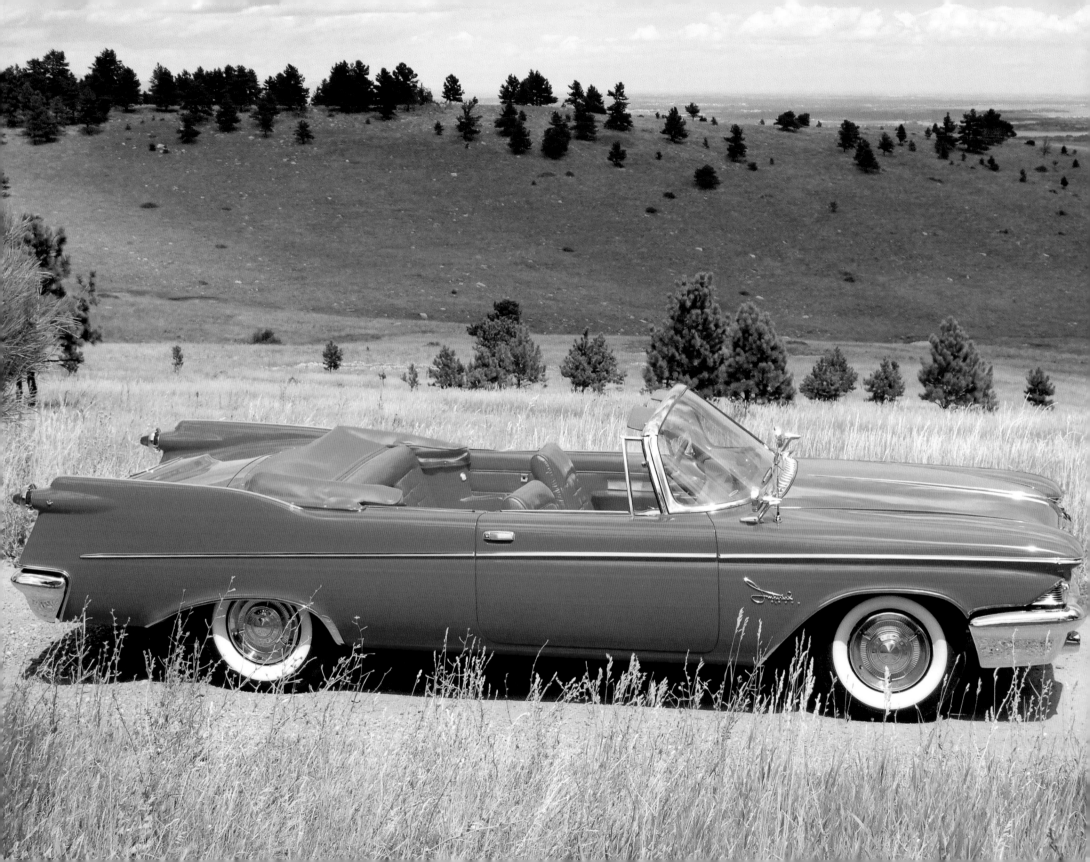

1960 IMPERIAL CROWN CONVERTIBLE

mperial touted its exclusively produced vehicles as "America's most carefully built car." They continued with designer Virgil Exner's "Forward Look" theme, despite the body being a throwback to the preceding decade of high, eagle-like fins. Though rear ends were somewhat muted on the 1960 Chrysler cars, Imperial, as an independent division, clung to the obtrusively conspicuous upswept tail fin style while adding curious bullet taillights with chrome rings like gunsights atop the rear of the fins. Also carried over from the previous year's design was the "Flight Sweep" deck lid that mimicked a spare-tire cover or Continental kit.

The windshield was enlarged, there was an unusual elliptical-shaped steering wheel, and the interiors remained as ornate as ever, with a variety of upholstery patterns in either wool, vinyl, leather, or nylon. New for 1960 was a "High Tower" driver's seat that was raised above the passenger seating and was individually contoured to increase back and shoulder support for enhanced comfort.

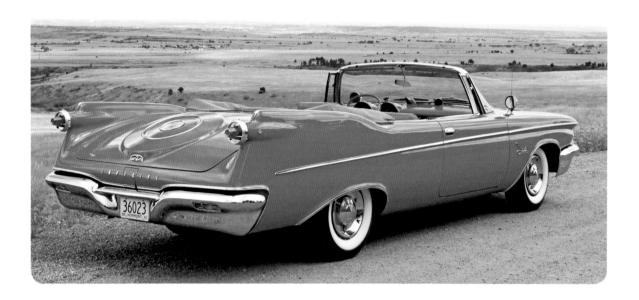

The big 413-cubic-inch, 350 horsepower V-8 Wedge-head engine, with the dash-mounted push-button transmission, remained the same as what was in the '59s. The Imperial was still regarded as a powerful, luxury-class road car. According to the admen, "The Crown Convertible seasons its dash with dignity."

For 1960, the Imperial remained an impressive-looking automobile, but the creative styling had faded. It was a big, gorgeous car, in an odd manner and trim. You can stand and stare at it for a long time, contemplating what might have been.

I bought this convertible, one of 618 built, from a shop in Santa Ana, California. It was beautifully restored. In the long run, it's usually better to buy a car that somebody else has spent the time and money restoring than to do it yourself.

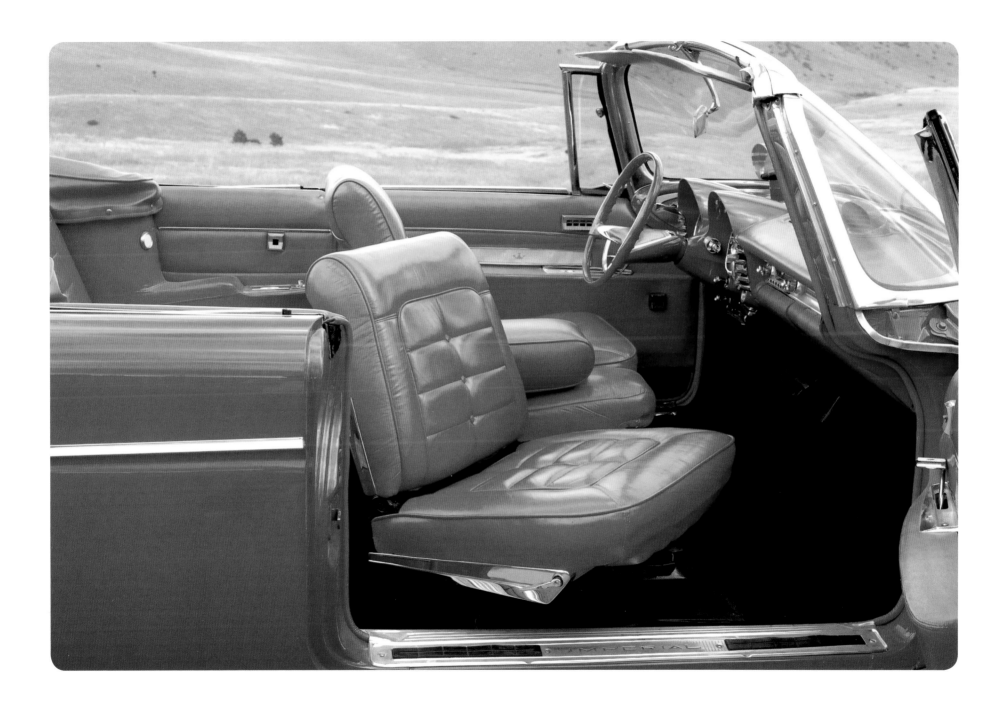

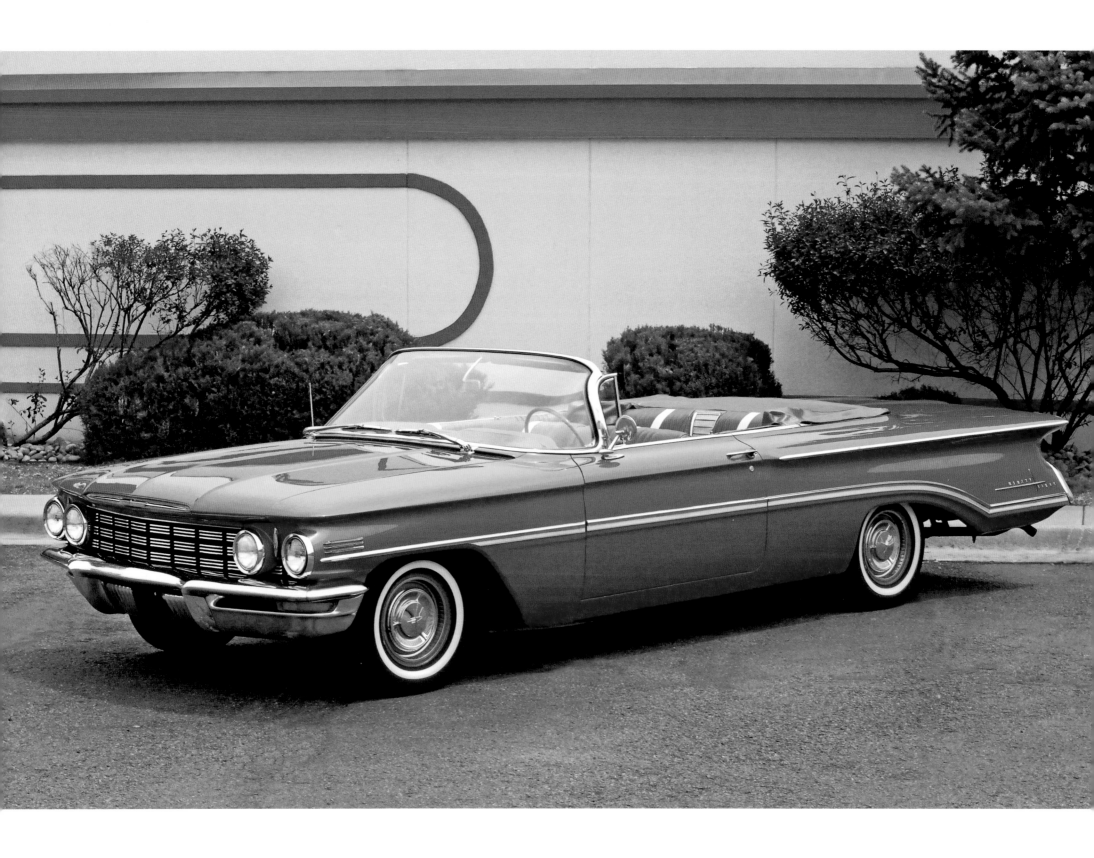

1960 OLDSMOBILE 98 CONVERTIBLE

The new 98s were ten inches longer and nine inches wider and yet they looked lower and sleeker than the earlier models. They were the top-of-the-line for Oldsmobile, sporting their new "Linear Look." The 98s had a host of standard amenities for comfort and safety, plus new features such as Roto-Matic power steering and Air-Scoop brakes.

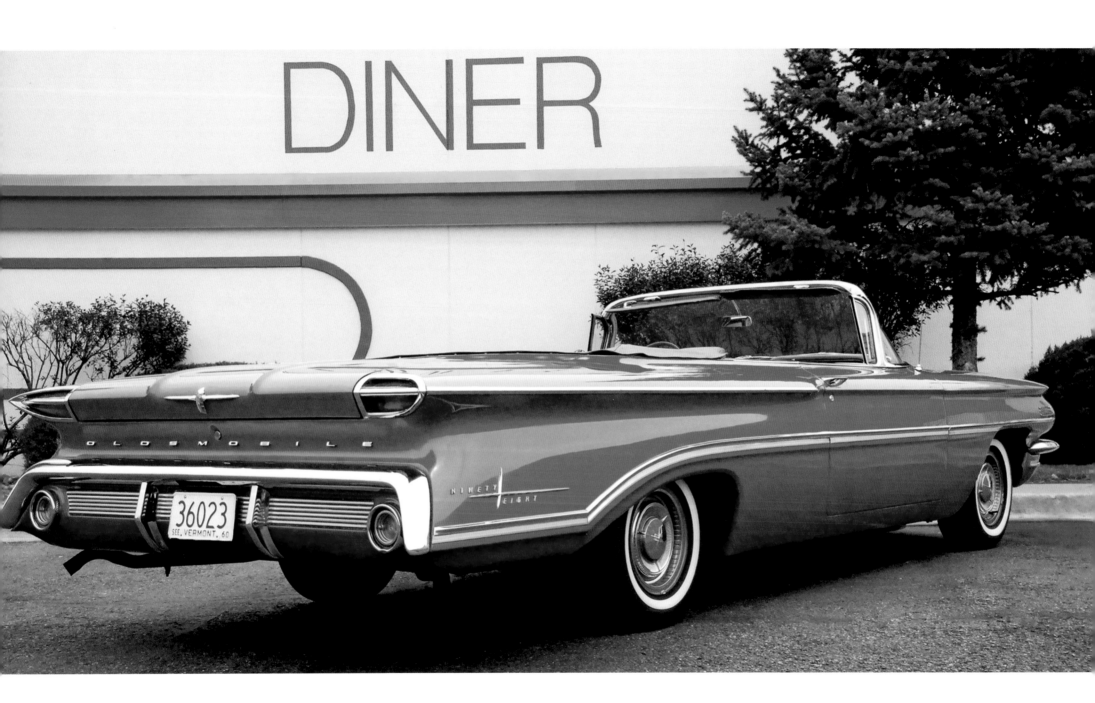

Less flamboyant than body shapes of other big cars from General Motors, the 1960 Olds is, in retrospect, more classic and less trendy, with its simpler "Balanced Design" styling. The grille was often called a dumbbell due to the shape of its four widely separated headlights. The body trim sloped and was concave toward the rear fenders, which had small horizontal fins over oval taillights.

The Rocket V-8 engine was a big 394 inches, giving 315 horsepower. Hitting 0 to 60 in a little over ten seconds, the big convertible still gets off the mark with most cars from the present. It's a sister of the 1960 Indianapolis 500 pace car.

I bought this 98 convertible from a private party in Arizona sometime in 1992. A pretty-appearing car with much cleaner lines than the big barges that came earlier, she's very original, with barely 60,000 miles on the speedometer. All I've done is rewire the electrical system. I hate dirty wiring.

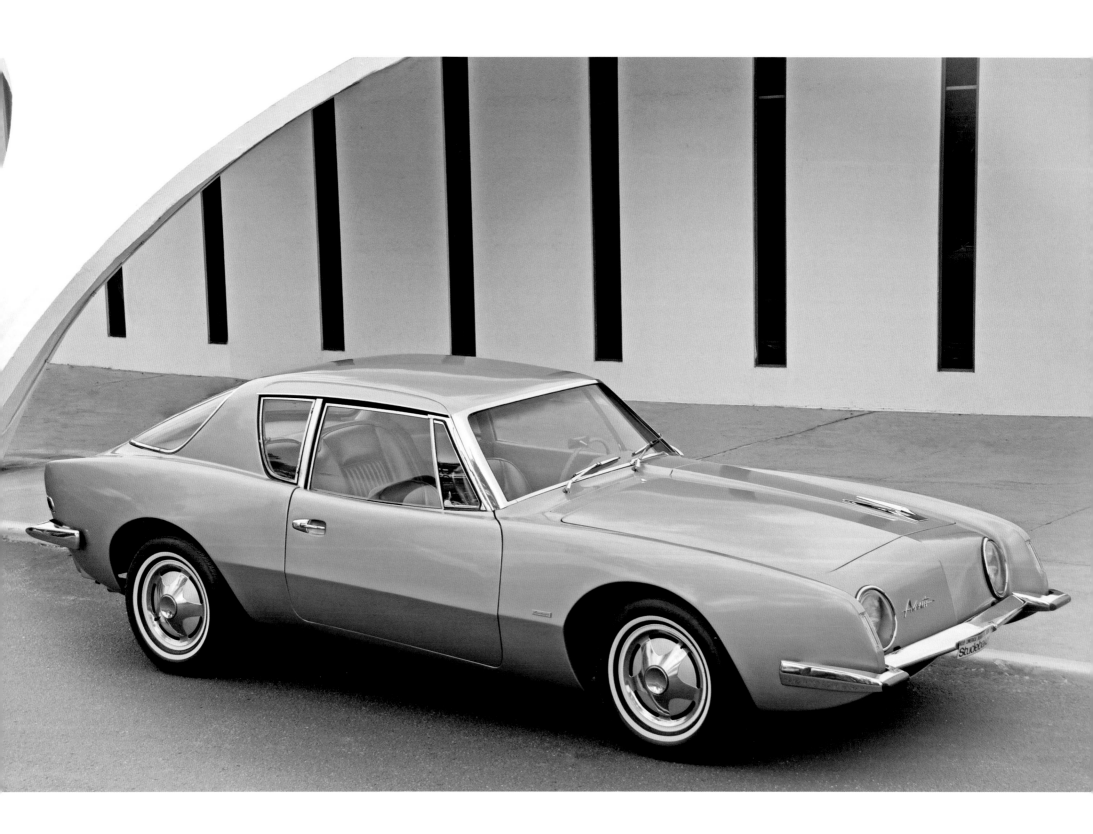

1963 STUDEBAKER AVANTI R2

I f Raymond Loewy created a genesis with the 1953 Studebaker, he performed an absolute miracle with the daring 1963 Avanti. Except for the minimalist blade bumpers, chrome was nearly nonexistent, and the real shocker to dyed-in-the-wool auto designers was the total absence of a grille between the headlights. Nobody had ever seen anything like it before. It was a rakish, aerodynamic, four-passenger luxury grand tourer with a well-built fiberglass body.

The interior felt like a private plane, with a stylized cockpit,

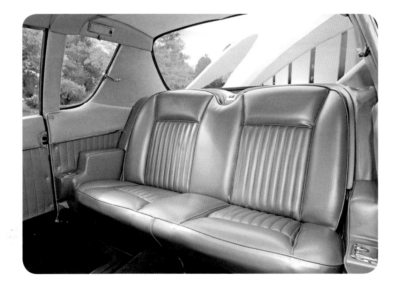

four bucket seats, aircraft-style controls on an overhead console, a padded interior, and an oversize wraparound rear window. For safety, a roll bar came as standard equipment, and Avanti was the first American production car with British Dunlop-designed disc brakes.

The R2 model with a Paxton supercharger could coax 290 horsepower out of the venerable "Jet Thrust" 289-cubic-inch engine with dual exhaust. The Avanti R2 was the world's fastest production car in 1963, scorching the time clocks at over 168

miles per hour in the Flying Mile, obliterating twenty-nine speed records at the Bonneville Salt Flats.

The original Studebaker Avanti was upscale, well equipped, and more expensive than a Corvette Sting Ray. Like so many other innovations that have ridden over the horizon into the future, it was ahead of its time but not what buyers wanted in 1963. Still, Loewy's Palm Springs, California, design team created a milestone in automotive innovation.

The model shown here is a 1963 R2, very complete and very sound. It is one of only 277 supercharged R2s with Avanti Turquoise exterior and interior. Looking like it was just driven from a dealer's showroom today, it all goes to show that creative design is ageless.

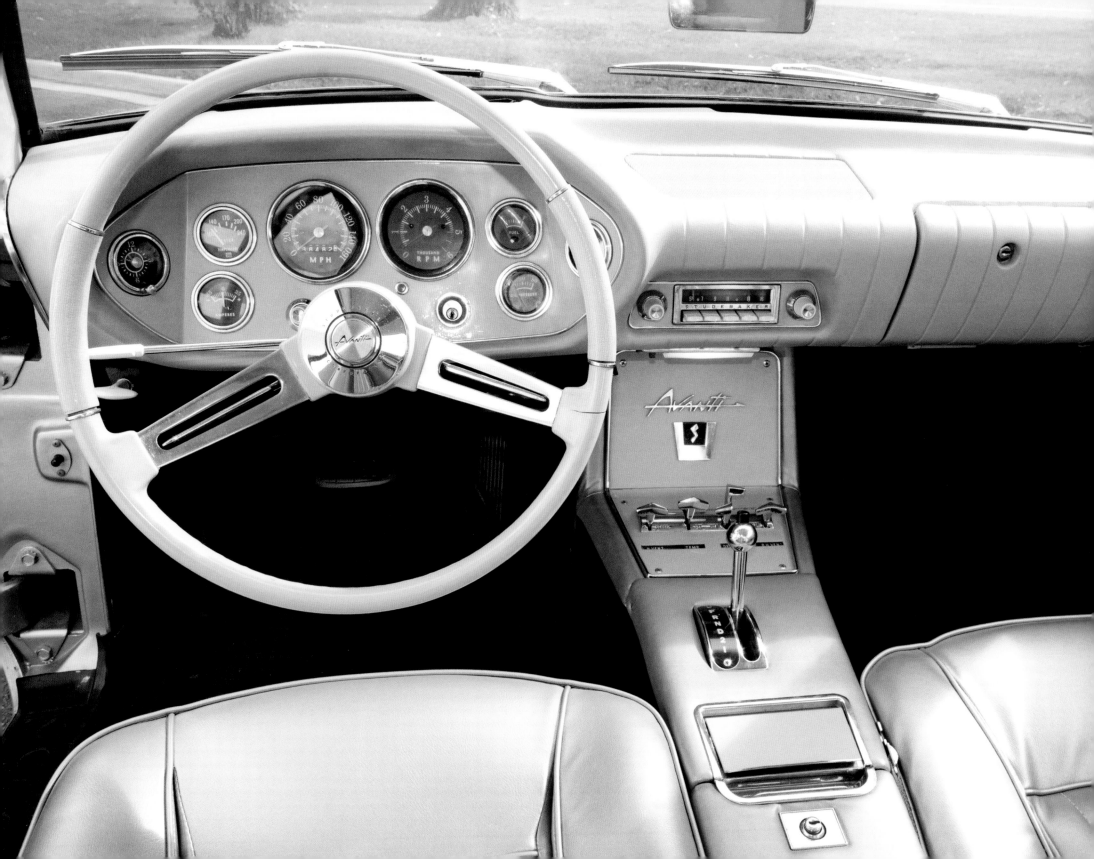

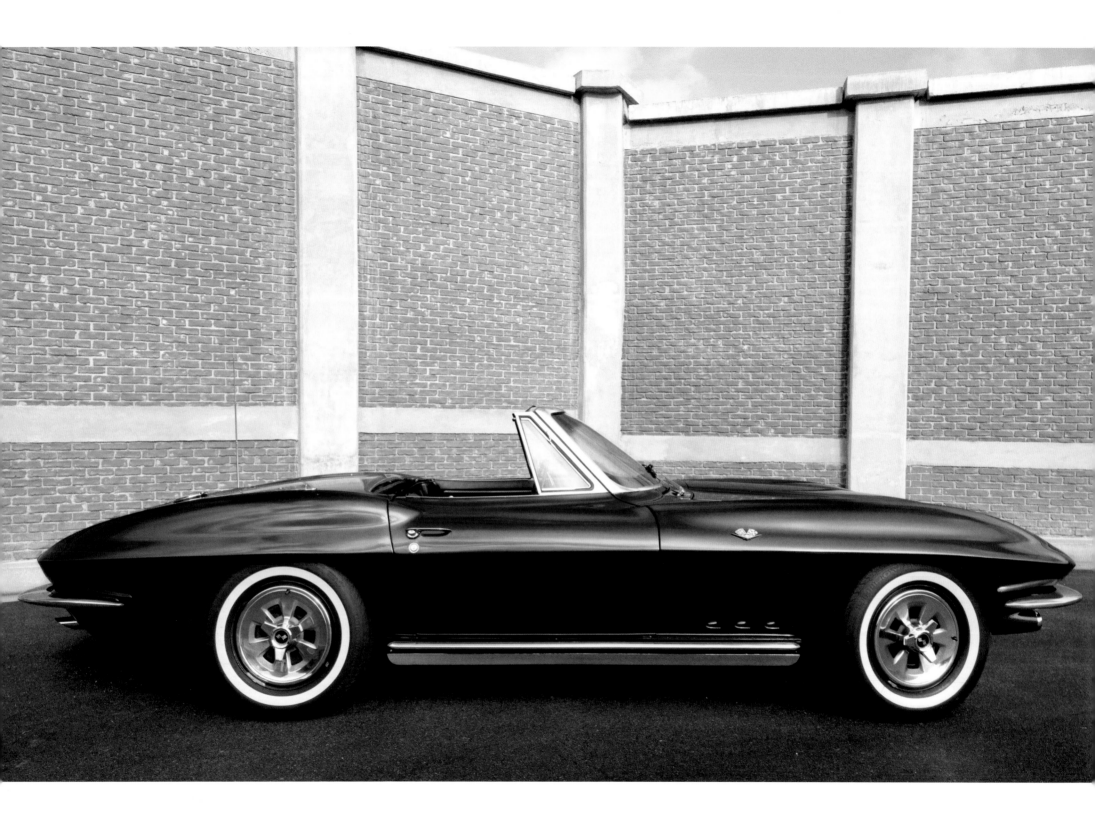

1965 CORVETTE STING RAY CONVERTIBLE

The new, second-generation Corvette for 1965 was baptized the "Sting Ray." Fittingly, a long list of improvements and innovations showered the most popular of America's sports cars.

The new, stunning look of the Corvette came more from unseen conceptions such as the newly hidden quad headlights, huge, round speedometer and tachometer gauges, improved luggage space, a new alternator that replaced the old generator, and many other enhancements like four-wheel disc brakes and improved suspension. Gone were fake vents and grilles; now there were racy and functional vents in the fenders to dissipate engine heat. The Sting Ray was becoming a real, modern American sports car. The 'Vette had eight available colors in 1965 and six power plant choices.

Muscled engines came in five different small-block sizes, beginning with 327 cubic inches and horsepower climbing from 250, with fuel injection as an option, to a ferocious 425-horsepower big-block monster.

Many were the young boys who dreamed of impressing the girls by driving a Chevy Bel Air convertible in high school but grew up wishing for the Chevy Corvette as they aged, especially the Sting Ray coupe with its split rear window.

The car shown here was purchased by my late wife, Barbara, after

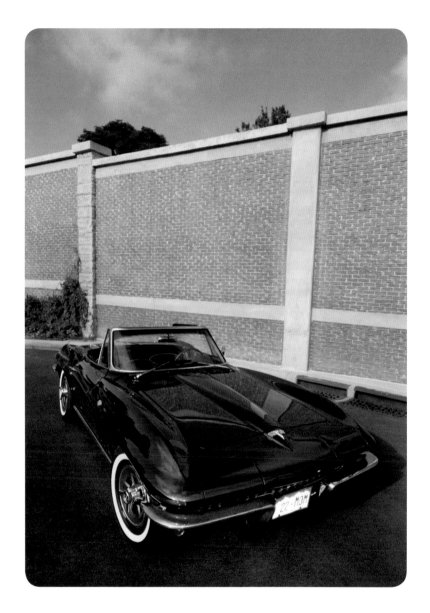

having it restored as her favorite driver. She especially enjoyed the glorious winding mountain highways around Telluride, Colorado, in her Corvette convertible. The '65 is a wonderful driving car, one of 3,782 Sting Rays finished in Glen Green in 1965. It is still being driven in Colorado, now by my daughter Teri, the creator and manager of the Cussler Museum.

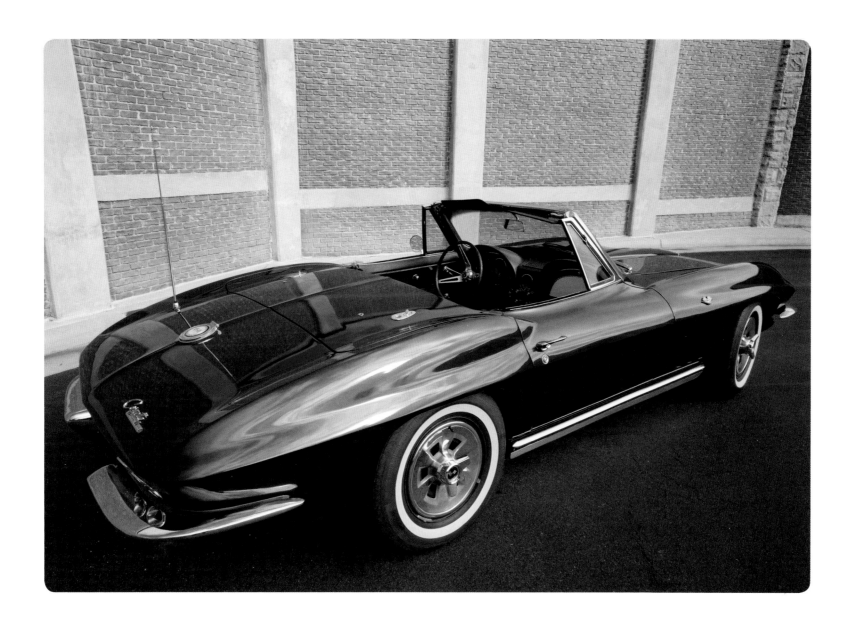